APOCALYPSE

BEAUTY AND HORROR IN CONTEMPORARY ART

Norman Rosenthal
with
Michael Archer
Michael Bracewell
James Hall
Nathan Kernan

Special photography by Norbert Schoerner

ROYAL ACADEMY OF ARTS

First published on the occasion of the exhibition

APOCALYPSE
BEAUTY AND HORROR IN CONTEMPORARY ART

Royal Academy of Arts, London
23 September – 15 December 2000

Sponsored by in association with
www.eyestorm.com

The Royal Academy of Arts is grateful to Her Majesty's Government for its help in agreeing to indemnify the exhibition under the National Heritage Act 1980, and to the Museums and Galleries Commission for their help in arranging this indemnity.

EXHIBITION CURATORS
Norman Rosenthal
Max Wigram

EXHIBITION ORGANISATION
Emeline Max
with Annette Bradshaw

CATALOGUE
SPECIAL PHOTOGRAPHY
Norbert Schoerner
assisted by
Timur Celikdag
Leon Chew
Digital artists
Anthony Crossfield
George Lewis
Dan Maloney
Dan Richardson
Scanning
Paul Diamond
Mike Sheldon
All at Metro Imaging, Soho

DESIGN
Why Not Associates

PICTURE RESEARCH
Celia Dearing

COPY-EDITING
Rosemary Amos

COLOUR ORIGINATION
DawkinsColour Ltd, London

PRINTING
Graphicom srl, Italy

Royal Academy Publications
David Breuer
Sophie Lawrence
Soraya Rodriguez
Peter Sawbridge
Nick Tite

British Library Cataloguing-in-Publication Data
A catalogue record for this book is available from the British Library

Distributed in the United States and Canada
by Harry N. Abrams, Inc., New York
ISBN 0-8109-6632-8

Distributed outside the United States and Canada
by Thames & Hudson Ltd, London
ISBN 0-900-946865

Exhibition edition
ISBN 0-900-946938

ACKNOWLEDGEMENTS

Over the fifteen months' preparation for this exhibition many people
have contributed knowledge, generosity and time to help us; homes
have been opened and studio visits organised. We have received original
and considered advice from curators at the Royal Academy and from
those in or outside the world of art across America and in Europe.
We would especially like to thank the artists, Norbert Schoerner, The
Broad Art Foundation, Sadie Coles, Jeffrey Deitch, Anthony d'Offay,
Simonetta Fraquelli, Cornelia Grassi, Max Hetzler, Dakis Joannou,
Jay Jopling, Camilla Lowther and Nick Bryning at CLM, Miuccia Prada,
Shaun Caley Regen, Charles Saatchi and Nick Serota for their advice
and encouragement, and Calum Storrie for his openness, skill and
sensitivity to the artists' work whilst designing the exhibition.

We also wish to thank Michael Archer, Michael Bracewell, David
Breuer, Mr and Mevr Kees J. de Bruin, Massimo di Carlo, The
Carnegie Museum of Art, Pittsburgh, James Cohan, Pauline Daly,
Frank Demaegd, Emi Fontana, Filippo di Giovanni, Barbara Gladstone,
Marian Goodman, James Hall, Nathan Kernan, Raphael Jablonka,
Christos Joachimides, Marie-Louise Laband, Mr and Mrs J-P. Lehmann,
Sarah Lucas, Gary McGraw, Mr and Mrs Lewis Manilow, all the staff
at Momart, Tim Neuger, Jérôme de Noirmont, Maureen Paley, Eva
Presenhuber, Mr A. Remmers, Burkhard Riemschneider, Nathaniel
Rothschild, Peter Sawbridge, Stuart Shave, Valerie Shields, Mike
Smith, Catherine Sullivan, Astrid Welter, Anne Winton, Daniel Woolf
and David Zwirner.

Finally we would especially like to thank Professor Phillip King PRA,
Tom Phillips RA, Chairman of the Royal Academy's Exhibitions
Committee, and all members of staff of the Royal Academy for their
support in this project.

'Apocalypse: Beauty and Horror in Contemporary Art' has been conceived as part of the Royal Academy's own millennium project which began with '1900: Art at the Crossroads', an exhibition which showed aspects of the world of art at the beginning of the twentieth century. 'Apocalypse' shows, from a very different perspective, some of the most significant art being made at the beginning of our new, twenty-first, century.

The Royal Academy is perhaps not generally known for its presentation of the most radical art of the moment. But at least two exhibitions held in Burlington House's galleries over the past twenty years have been recognised as defining moments of their age. 'A New Spirit in Painting' (1981) was a seminal exhibition that presented for the first time the work of many little-known artists, who have since established themselves as the most significant of contemporary artists. Many, indeed, are now Honorary Members of this Academy. 'Sensation: Young British Artists from the Saatchi Collection' (1997) is equally remembered as the show that opened up the world of the so-called Young British Artists to unprecedented international public attention. Now, it is our hope that 'Apocalypse' will once again stimulate and provoke the debate about the nature of contemporary art, both in this country and abroad. We are living at a moment of visible change in the world, a period in which we are all consciously and subconsciously reflecting on the positive and negative legacy of the last extraordinary century, looking forward, with a mixture of excitement and apprehension, towards an uncertain future.

All of these contemporary exhibitions, as well as those devoted to German, British, Italian and American art of the twentieth century, have been spearheaded by Norman Rosenthal, the Royal Academy's Exhibitions Secretary, who over a period of almost a quarter of a century has contributed greatly to the Royal Academy's perceived position as a broad church for the presentation of art, both new and old. For 'Apocalypse', he has been joined by the young curator

Max Wigram. Together they have conceived and brought to fruition an exhibition that gives each artist a gallery in which to present work that addresses powerful and dramatic issues of our time through the ever-expanding possibilities of contemporary art. Each of the thirteen artists has contributed work of great intensity and originality that will stretch visitors' imaginations to the full. We at the Royal Academy hope that our excitement will be shared by a very wide audience.

Our thanks must go first and foremost to the artists participating in 'Apocalypse'. Their willingness to share their work with us has placed great demands on them, and we very much appreciate their generosity. We extend our grateful thanks to the lenders, and to the many artists' agents whose often-misunderstood role as both mentors and mediators of artists has been a decisive factor in our understanding of art through the years. We acknowledge with gratitude the authors and the many people involved in the production of this catalogue. This exhibition has put great pressure on many departments within the Royal Academy; I would like to record here my appreciation of their commitment.

Sponsorship provides much-needed support for our varied exhibition programme. We would like to thank eyestorm for their sponsorship, as well as Time Out, who have generously agreed to be media sponsors of this show, as they were of 'Sensation'. We are also most grateful to Mr Ivor Braka and The Broad Art Foundation for their additional support.

As the new President of the Royal Academy at a time of ever-increasing interest in art and especially contemporary art I have no doubt that 'Apocalypse' will make a lively contribution to the continual discourse about the meaning and necessity of art in all our lives. I hope that this exhibition will help to keep the Royal Academy at the forefront of that debate.

Professor Phillip King PRA

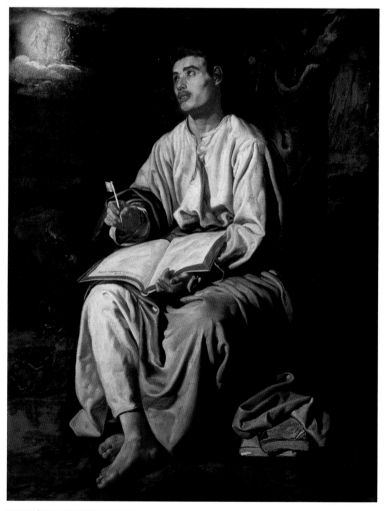

DIEGO VELÁZQUEZ, *ST JOHN THE EVANGELIST ON THE ISLAND OF PATMOS,* c. 1618
Oil on canvas
135.5 × 102.2 cm
National Gallery, London

APOCALYPSE
BEAUTY AND HORROR IN CONTEMPORARY ART

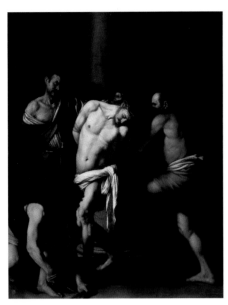

MICHELANGELO MERISI DA CARAVAGGIO, *THE FLAGELLATION OF CHRIST,*
1607
Oil on canvas
286 × 213 cm
Museo di Capodimonte, Naples

It was a queer, sultry summer, the summer they electrocuted
the Rosenbergs, and I didn't know what I was doing in New
York. I'm stupid about executions. The idea of being
electrocuted makes me sick, and that's all there was to
read about in the papers – goggle-eyed headlines staring
up at me on every street corner and at the fusty, peanut-
smelling mouth of every subway. It had nothing to do with
me, but I couldn't help wondering what it would be like,
being burned alive all along your nerves.
I thought it must be the worst thing in the world.
Sylvia Plath, *The Bell Jar*, 1963[1]

We no longer belong to the twentieth century. We can
imagine that we no longer belong to the past and have
perhaps arrived in a completely new present. But the
twentieth century, of which the Rosenbergs and so many
others were victims, still informs our culture. For all the
massive leaps that technology of immense complexity and
penetration seems to be making, coming to terms with the
past as well as the present decisively affects the actions
and values that run throughout our lives.

The unveiling of an exhibition of the art of our time seen
from the perspective of London should, if possible, come as
a jolt to the assumed pattern of art, which is, in fact, always
fragile and in constant flux. 'Apocalypse' is the title of this
exhibition and its catalogue. The re-evaluation that it aims
to achieve is meant neither to be certain nor easy, rather it
aspires to achieve a mood of catharsis. This is something
we take for granted as a primary function of literature,
theatre or film, but tend to turn away from in the visual
arts, looking at best for a pleasurable experience that arises
from preconceptions about what constitutes beauty in art.
However, beauty needs also to be found through new
revelations. This is what artists as seers and inventors of
visual metaphors have always attempted. The shock and
genius of a still-life by Chardin lies in the existential
revelation that balances brush strokes with a perception
of reality that transcends its Rococo age to act as a moral
imperative. A mid-eighteenth-century moment is abruptly
frozen. A painting of a brown coffee pot, a glass of water
and some garlic, seen at the Royal Academy in spring 2000,
is shockingly apocalyptic because it gives us the illusion of
suspended time, a moment of obsession that has been the
aim of all artistic production from the beginning of time.
Works of art assume the properties of the *memento mori*,
the souvenir of fleeting life that is the ambition of even the
lowliest snapshot. We have rapidly acquired the ability to
freeze time by using technologies that record our actions
and activities, whether we like it or not, as we walk down
high streets and on and off trains and planes. Such images
can be transmitted instantly across continents.

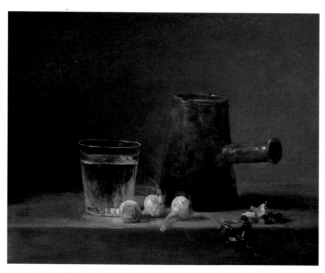

JEAN-BAPTISTE-SIMÉON CHARDIN, *GLASS OF WATER AND COFFEE POT, c.* 1761
Oil on canvas
32 × 41.3 cm
Carnegie Museum of Art, Pittsburgh; Howard A. Noble Collection

So what indeed is the use of art today? Is its function to represent the order, balance and security that we all desire? Or ought it to be like a fractured mirror of the disorder that we all know to be the fact? The paradox seems to be that the greater our scientific and technological achievements, the greater is the potential for chaos. In our minds, after all where our entire consciousness resides, we can look away from reality and from art to ignore the world around us and its accumulated history, to view it at best as a source of diversion and entertainment. Or we can reflect on the historical, social and psychological complexities that inform every artwork of quality. Of course, we usually end up doing both. There is nothing inherently wrong with entertainment as such except that, in itself, it contributes nothing to the process of self-knowledge that makes the viewing of art such an enriching experience. The apparently endless surfeit of art imagery that bombards us daily, often without our noticing it, and that has exponentially exploded with the onset of new information and virtual technologies, has made so much visual information available that all is reduced to reference as in a dictionary or encyclopaedia.

Apocalypse is in the first instance a revelation of the future granted in legend to St John the Divine on the island of Patmos (see p. 12). The Book of Revelation, an exemplary text written around 190 AD, is a poetic and empowering Christian tract against the all-evil Roman Empire which envisages the terrible slaughter that would be followed by a new Jerusalem, free of pain and suffering with Christianity triumphant. As much as anything a political poem and a work of art full of the most graphic visual imagery, the Book of Revelation has continued to stimulate writers and artists down the centuries.

And I stood upon the sand of the sea and saw a beast rise up out of the sea having seven heads and ten horns... And it was given unto him to make war with the saints, and to overcome them; and power was given him over all kindreds, and tongues, and nations....
And I beheld another beast coming up out of the earth... And he doeth great wonders...and deceiveth them that dwell on the earth by the means of those miracles which he had power to do in the sight of the beast...

And I saw heaven opened, and behold a white horse; and he that sat upon him was called Faithful and True...And out of his mouth goeth a sharp sword, that with it he should smite the nations...

And I saw a new heaven and a new earth; for the first heaven and the first earth were passed away; and there was no more sea. And I John saw the holy city, new Jerusalem,

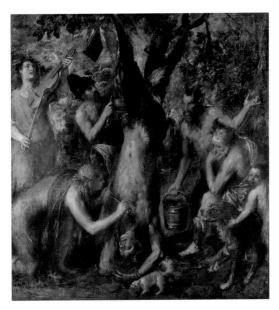

TITIAN, *THE FLAYING OF MARSYAS*, 1570s
Oil on canvas
212 × 207 cm
Archiepiscopal Palace, Kroměříž, Czech Republic

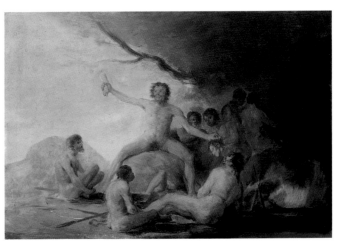

FRANCISCO GOYA, *CANNIBALS CONTEMPLATING HUMAN REMAINS*, c. 1800–08
Oil on panel
32.7 × 47.2 cm
Musée des Beaux-Arts et d'Archéologie, Besançon

coming down from God out of heaven, prepared as a bride adorned for her husband.[2]

Since these words were written nearly two thousand years ago and modelled on even earlier Jewish texts, above all 'the Book of Daniel come to Judgement', every generation in our Western culture has had its version of the Apocalypse, usually stimulated by war, famine or revolution, those leitmotifs of human history. In the generally satiated and complacent society that has flourished in the Western world over the last fifty years or so, many fear that we are sitting 'Under the Volcano' or on top of a time bomb, be it nuclear or environmental. For all our apparent prosperity this sensation contrives to make us as uneasy, if not more so, than the Cassandras of past generations, all of whom, in a manner appropriate to their time, foresaw the end of the world, and described it in words and pictures.

A regular visitor to Royal Academy exhibitions over the last twenty years can reflect on unforgettable images that have been shown in its galleries, images of enormous visual power and horror which serve to remind us of moments of apocalyptic terror and finality. Titian's *The Flaying of Marsyas* (1570s), Caravaggio's *The Flagellation of Christ* (1607, see p. 14), Goya's *Cannibals Contemplating Human Remains* (c. 1800–08), Cézanne's *The Murder* (c. 1867–68,

see p. 18) and Max Beckmann's *Birds' Hell* (1938, see p. 23) are only some of the horrifically beautiful apocalyptic images made over the last five hundred years that see into places where most of us usually fear to look but which are all personal and political witnesses of their time, peering with both horror and curiosity into a particular existential abyss. And there are also visionary representations of both earthly paradise – Poussin's *The Kingdom of Flora* (1631, see p. 22) – and transfiguration – Murillo's *The Immaculate Conception* (c. 1650, see p. 24). The earthly paradise we know to be fragile and the transfiguration is probably an illusion, but of horror's existence there can be no doubt. Is it the stillness and silence of the imagery of horror that audiences find so troubling? A Christ who is forever crucified is a terrifying metaphor. But in a culture that is less and less convinced of biblical truth and in the face of the horror of much recent history it is perhaps significant that many twentieth-century artists took refuge in depictions of the *horror vacui*, such as the abstractions of painters like Kandinsky, Malevich, Rosanova or Rothko (see p. 27). Alternatively, the haphazard metaphors of collage by artists like Schwitters (see p. 26), Rauschenberg (see p. 25) or Beuys, each of whom faced in their work their own private and political apocalypses, used chance detritus to create images that hold their own beauty and resonance, located in the past, yet, as art, containing both a present and future.

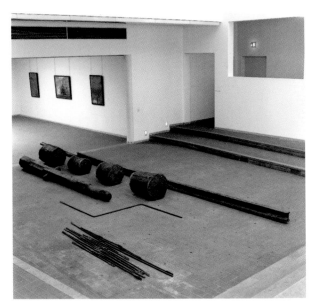

JOSEPH BEUYS, *TRAM STOP (STRASSENBAHNHALTESTELLE)*, 1961–76
Rail (iron) 860 × 15 × 10.5 cm; four cylinders (iron): 61 × 47 cm, 59 × 38 cm, 51 × 44 cm,
73 × 51 cm; barrel with mouth and head: 376 × 45 × 29 cm; 22 stanchions (iron), longest:
107 cm, shortest: 55.5 cm; 1 crank (iron): 103 × 101 × 104 cm
Kröller-Müller Museum, Otterlo

What therefore of the present? Whether we like it or not, the coming of the twenty-first century – two thousand years after the birth of Christ, whose existence modified our culture and perception of time in such a startling way – is a subliminally apocalyptic moment. How are younger artists today reflecting the inevitable contemporary abyss? In what new ways are they accepting and describing contemporary realities that suggest the uncertain and insecure future that has always existed for humankind? Are there also grounds for optimism? For artists are surely here to assert life and its overwhelming value as well as to commemorate the inevitability of death. Is there a contemporary subject matter that is becoming a new mythology for our time?

My colleague and co-curator Max Wigram and I set ourselves the task of looking around the world of art, and constructing an exhibition that would feel contemporary within the august galleries of the Royal Academy. An academy, a garden of learning, is a place devoted by definition to the idea of continuity. Continuity, however, implies renewal and the object of any academy or museum of art must be to fuse the modern with the traditional. Art must always combine a sense of history and a sense of modernity. Any selected grouping of art such as this exhibition is by its very nature a form of criticism, an attempt to identify affinities while maintaining the integrity of its components. Sir Joshua

Reynolds may seem an unlikely authority to invoke for a contemporary show with the title 'Apocalypse', but, in his Thirteenth Discourse, delivered to the students of the Royal Academy in December 1786, he observed pertinently:

Gentlemen,
To discover beauties, or to point out faults, in the works of celebrated Masters, and to compare the conduct of one Artist with another, is certainly no mean or inconsiderable part of criticism; but this is still no more than to know the art through the Artist. This test of investigation must have two capital defects; it must be narrow, and it must be uncertain. To enlarge the boundaries of the Art of Painting, as well as to fix its principles, it will be necessary that that art, and those principles, should be considered in their correspondence with the principles of the other arts, which, like this, address themselves primarily and principally to the imagination.[3]

If Reynolds was referring to the immutability of art, its striving after permanence, at least in our imagination, he understood also the importance of what might be termed 'crossover', and that the visual arts survive by feeding off all the other arts and essentially off imagination rather than imitation. The contemporary apocalypse will always exist in the imagination. Imagination is a complex space with many

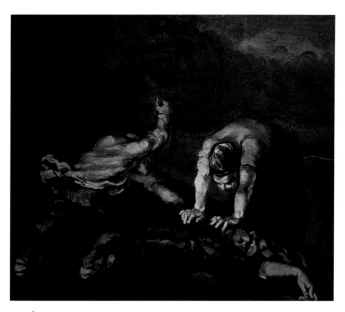

PAUL CÉZANNE, *THE MURDER*, c. 1867–68
Oil on canvas
65.5 × 80.7 cm
Walker Art Gallery, Liverpool

compartments that encompass not only horror and beauty but also humour in all its forms, sexuality and transgression, childishness and banality, dreams and nightmares, the virtual and the real, transcendence and metamorphosis and, above all, a sense of history and a sense of the present. Each artist in this exhibition addresses at least one, and usually many, of these compartments of the mind. In each gallery the spectator can visit an imaginative island, the whole exhibition hopefully forming an atlas, a map of metaphysical spaces, each of independent character. But the exhibition is, of course, only one map of many. The possibilities of exploration are endless and just as it is unachievable, even for the most assiduous, to read all the books worth reading, to hear all the music worthy of attention, so it is impossible to absorb all the art, even contemporary art, that demands to be seen. An exhibition such as this is, as much as anything, an exhortation to explore other worlds. In one exhibition we can but confine our attention to a few.

So 'Apocalypse' implies facing history and the present. It brings with it a sense of finality, culmination and the unimaginable horror that has been realised all too often within living memory. We all carry the history of the last century in our heads. In the West that history has been informed by the trenches of World War I, the Holocaust and other genocides, and the threat of nuclear destruction that seemed until quite recently to hang over our heads. The Holocaust as an accomplished fact of unspeakable horror seemed, until not long ago, to be almost impossible to deal with directly. We have seen how artists took refuge either in abstraction or in a kind of fuzziness, as though the Holocaust were an oblivion, an emptiness: Daniel Libeskind describes the spaces within his Jewish Museum in Berlin as 'voided voids'; Theodor Adorno stated, 'After Auschwitz, to write a poem is barbaric';[4] Walter Benjamin, however, observed, 'There is no cultural document that is not at the same time a record of barbarism.'[5] For those who lived through its terror, the Holocaust exceeded in its bestiality the most horrific nightmares imagined by Bosch or Bruegel in the sixteenth century. Bruegel, in his apocalyptic and comfortless *The Triumph of Death* (c. 1562, see pp. 20–21), is one rare, exceptional artist who describes the psycho-logical terror of war, graphically depicting the marching armies of death overwhelming the world. The equally rare existence of *Hell* (see pp. 218–225), a work in progress by Jake and Dinos Chapman made obsessively over a period of the last two years and now shown for the first time, determined that the exhibition as it is presented here had to take place. Artists not directly born into the crises that beset Europe in the last century are working on behalf of us all through collective memory to fathom the depth

CHARLOTTE SALOMON, *LIFE? OR THEATRE?*, 1940–42
Gouache no. 147 in first series
32.5 × 20.5 cm
Collection Jewish Historical Museum, Amsterdam
© Charlotte Salomon Foundation

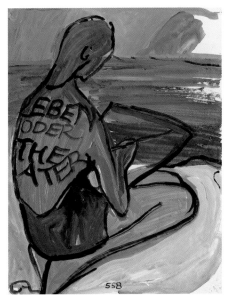

CHARLOTTE SALOMON, *LIFE? OR THEATRE?*, 1940–42
Gouache no. 558 in second series
32.5 × 25 cm
Collection Jewish Historical Museum, Amsterdam
© Charlotte Salomon Foundation

of horror to which mankind in our own time has descended. But their metaphors only skim the surface of reality. The only recourse and possible expiation is to present a drama, an enactment in the form of a Pasolinian panorama, which we, like gods, survey, wondering at the folly and bestiality of humankind. As in Bruegel's Christian *Triumph of Death*, our eye travels compulsively from one incident to another, barely able to absorb the many paradoxes of behaviour, the lust for power, the pent-up sexual frustration and the sadistic bestiality that has broken out in this Salò-like landscape in which evil devours evil amidst the ruins of an already destroyed imaginary fascist empire. It is a remorseless dream of revenge. It forces us to question and be witness to a madness that has turned in on itself in the form of a mass psychological theatre that has surely never been depicted so graphically. Only the obsessiveness of a victim caught up in the all-too-real drama of the Holocaust, Charlotte Salomon, whose extraordinary cycle of over seven hundred paintings entitled *Life? or Theatre?* was shown at the Royal Academy in 1998, could describe in poetic and intense personal detail, from the perspective of a young adult, the abnormality that became all too normal and culminated in the ovens of Auschwitz. To this apocalyptic question, Life? or Theatre?, there is no answer other than the repetition of the question. It runs through all the art of our time. The function of the artist is to look, to enter the

minds of those operating the machinery of death and to contemplate how this came about. In other words, the artist can add a profoundly illuminating perspective that even the most assiduous historian cannot. One major task of the artist is to say that, as human beings ourselves, we are all implicated. It is important that we do not look away and merely take refuge in superficial beauty.

Public interest in the details of the Holocaust is burgeoning, with museums being set up in Europe and all over North America containing graphic depictions of its historical evolution up to and including the mass hysteria of the final years of the war when the Nazi death factories were in full operation – the industrial world completely turned on its head. It is also no coincidence that a number of the artists in this exhibition have quite independently produced works of imaginative empathy, choosing to peer into the abyss. This stems no doubt partly from a kind of fascination but, above all, from a desire to prevent the obliteration of the meaning of the recent past. Is this recent past, at this millennial moment, a culmination and an ending of tradition – both Classical and Romantic, Roman and Gothic – which to all intents and purposes is now exhausted and is inevitably consuming itself? Are we witness to a Twilight of the Gods, a *Götterdämmerung*, as was Richard Wagner, who in his *Ring of the Nibelungen* imagined with extraordinarily

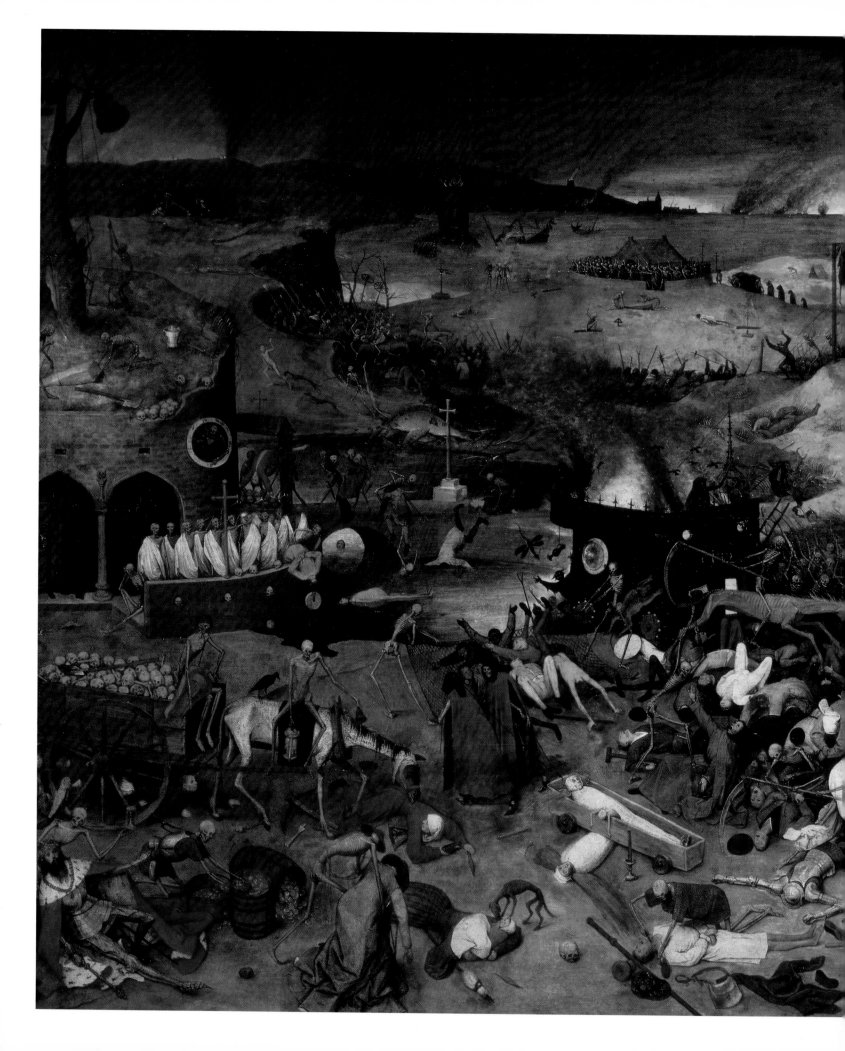

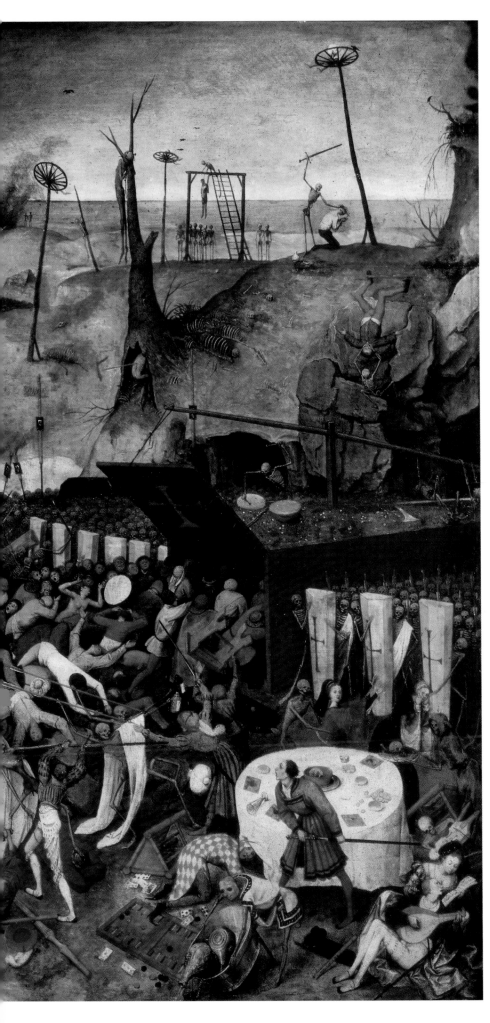

PIETER BRUEGEL THE ELDER, *THE TRIUMPH OF DEATH,* *c.* 1562
Oil on panel
117 × 162 cm
Prado, Madrid

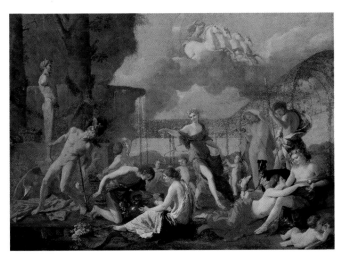

NICOLAS POUSSIN, *THE KINGDOM OF FLORA*, 1631
Oil on canvas
131 × 181 cm
Staatliche Kunstammlungen, Gemäldegalerie, Dresden

ambitious aesthetic foresight a world in which those who had ruled forever were consumed in their own self-destructive holocaust?

Time and its history are more than ever huge questions. Artist and audience find themselves in a world of imagination, where positivist values mean little. The experiment of the Enlightenment has been extinguished and we are witness to a brutish or at best melancholic world picture, where the potency of a bus timetable seems quite enough to evoke the poetry of history. Grand Guignol or Melancholia are two reactions to a history that overwhelmed all others, certainly from a European perspective. Until now only a few participants, mostly writers such as Primo Levi or Paul Celan and, of course, their Russian counterparts Alexander Solzhenitsyn and Osip Mandelstam, have given adequate description to this. In *Beyond Good and Evil* (1886) Nietzsche gives the highest priority for achieving personal freedom – the ultimate goal of the individual – to emphasising knowledge and above all not looking away from difficult knowledge, although it may be ugly and even deadly. Knowledge, scientific and above all psychological, emancipates the mind, and artists, working in whatever sphere and appealing to whichever of our senses, are best positioned to affect our knowledge by confronting us with a synthesis of new and often shocking realities. Nietzsche

wrote: 'The will to truth, which is still going to tempt us to many a hazardous enterprise; that celebrated veracity of which all philosophers have hitherto spoken with reverence: what questions this will to truth has already set before us! What strange, wicked, questionable questions!'[6] We are like Macbeth visiting the witches where 'fair is foul and foul is fair'. The beauty of ugliness is an old theme and during the last century many reactions of protest greeted modern art when it first appeared. The boos which interrupted the first performance of Stravinsky's *Rite of Spring* in Paris in 1913 and that in extreme circumstances led to censorship and the burning of books and art will from some quarters doubtless greet this exhibition, though that in itself is not its only justification. For all its apparent pessimism and depiction of human dysfunction, this exhibition is no more an argument for cultural despondency than is a startling performance of *King Lear*. Artists in a real sense are like 'birds in a cage' and our job is merely to listen or watch and allow their thoughts to enter our own heads, giving us some insight into our own existence. Anticipation of apocalypse is, after all, a permanent state. At any period of history we find artists, writers and religious visionaries with graphic premonitions of the end of the world and a possible transcendence. In the late eleventh and early twelfth centuries the central issue, one that was current even until quite close to our own times, was the struggle between the papacy of Rome and

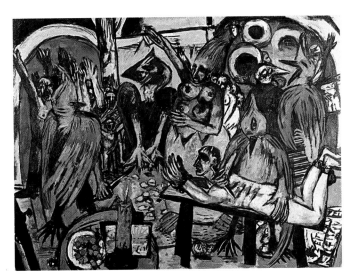

MAX BECKMANN, *BIRDS' HELL*, 1938
Oil on canvas
120 × 160 cm
Richard L. Feigen, New York

the Imperial power of the Holy Roman Empire – between
Pope Gregory VII and Henry IV, between the sacred and the
secular. Visionaries and prophets, some of whose names
if little-read today still echo throughout history – Hildegard
of Bingen, Joachim of Fiore, Roger Bacon, John Huss and
Girolamo Savonarola – are only a few of those who found
good reason to prophesy the end of the world. Such
prophecies were usually coupled with manifestoes that
demanded personal freedoms within the context and
assumptions of their time, and it is in this sense that the
seemingly apocalyptic works in this exhibition should be
regarded.

All of the installations presented here are by artists for
the most part little known except to a specialised audience.
Each confronts a moral situation of affecting ambiguity
to which we can respond in a variety of ways. Is Jake and
Dinos Chapman's *Hell* a vision of a world that has gone
forever and is now consigned to the domain of myth?
Or are we dealing with a potentially real world which, if
the situation around us were shaken up just a little, could
become part of our reality as surely as now in parts of the
world it is the mirror of our present, whether in Kosovo or
Ethiopia? Maybe the world is not exactly like the vision we
are presented with. But such a sado-masochistic presence
is closer than we care to acknowledge. Are we dealing here

with what one might term the aesthetics of revenge through
a beauty that can be found even within such an obviously
hideous experience? Thus, the questions of the artists
become our own. In this exhibition our ambition was to
find other works that could equally occupy different areas
of the contemporary mind. The execution of *Hell* is so
extraordinarily meticulous and even thrilling to behold that
it becomes an affirmation of art and the power of the
imagination, an image that keeps culture ultimately one of
the things that make us human, alive and well. The ability
to look, make and map where no-one has looked before is
the aim of every artist and exhibition – at the very least to
make manifest innovative and dislocating descriptions of
the world.

•

I Even as we ascend the staircase of the Royal Academy
we find ourselves disconcerted by the surprising work of
RICHARD PRINCE, a highly influential, even seminal, New
York artist, whose paintings are dislocating, even
schizophrenic, in their intent. Are they abstract paintings?
Are they jokes in bad taste? The painting and the joke
collide and the vision exists between art and experience,
between the real and the imaginary, between the existential
and the absurd. Each is, of course, not far from the other.

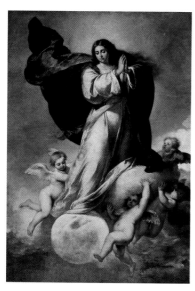

BARTOLOME MURILLO, *THE IMMACULATE CONCEPTION, c.* 1650
Oil on canvas
436 × 292 cm
Museo de Bellas Artes, Seville

The joke *is* the painting; it is also on top of the painting. Are these paintings in fact any more absurd than the paintings seen by regular visitors to Burlington House? We now take for granted the miraculous and unlikely revelations of *The Triumph of Galatea* and *Diana and Her Nymphs Bathing* by the eighteenth-century Venetian painter Sebastiano Ricci who came to London to amuse Lord Burlington, and rarely give them a second glance. Their conventions have become so much part of our visual furniture that we almost completely fail to observe them for the erotic and titillating signals they must surely have been meant to send. **II** Another kind of dislocation is taking place in the mind of **GREGOR SCHNEIDER**, in the activities that take place in his house in Rheydt, on the outskirts of a small town in Germany, in the Rhineland. His is an experience that exists in a space between the normal and the pathological. He works in an environment, to use that word most precisely. His is a space for living that has been created within the structure of an anonymous house that is both of it and separate from it; an imaginary space made all too real, more than slightly disconcerting. We all fill our houses with clutter, souvenirs of our past. We arrange furniture and objects to suit our own particular eccentricities. The content of each house is the exhibition of a life. In his house, Schneider makes it more so by building rooms within rooms separated by narrow spaces,

so that visitors moving from one to another experience an intense feeling of claustrophobia. As in Bluebeard's castle, a series of doors conceals we know not what unimaginable horrors or treasures. Schneider's house, like all others, is a place of privacy in which imagination, the most dangerous yet creative characteristic of human beings, can make itself visible without inhibition; our houses are the only place where we really are ourselves, where we sleep, where we are free to include or exclude whomsoever we wish. The house of Schneider suddenly seems quite normal – all too normal yet completely surprising, not a little sinister, as is everybody's house except our own. Schneider's house could be compared to the *Merzbau* of Kurt Schwitters (see p. 26), but it seems more pathological than autobiographical, more a house than a quasi-cathedral. Schwitters called his cluttered *Merzbau* 'a cathedral of erotic misery'. Schneider's house is more a labyrinthine place of refuge and hiding; having been invited to enter and hold off the day of reckoning, we feel unsure of the way out. **III** Painting on canvas has become a difficult art. To avoid banality it is ever more necessary to confront that very banality of everyday experience; the things which strike the painter as worthy of attention seem usually arbitrary and become startling, just because beauty (to which painting inevitably aspires) is so close to the banal and so far from the heroic. **LUC TUYMANS** has evolved his own particular low-key touch,

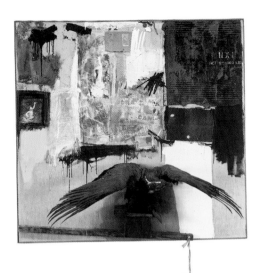

ROBERT RAUSCHENBERG, *CANYON*, 1959
Combine painting: mixed media on canvas with objects
207.5 × 178 × 61 cm
Sonnabend Collection, New York

an absence of colour that comes close to *grisaille*. Even when he uses other colours – greens, reds, yellows or blues – they all seem quite grey. A kind of fog seems to hang over his paintings that contrasts strongly with hard-edged examples of twentieth-century Belgian art, with its strong traditions rooted in Symbolism and Surrealism, not to mention the Flemish worlds of Bosch and Bruegel. Léon Frédéric, Léon Spillaerts, Fernand Khnopff, James Ensor, René Magritte, Paul Delvaux, Marcel Broodthaers have all thrived on the strange and the sinister, a fragmentary world that often suggested abuse. Maybe in time Tuymans's paintings will be seen as a continuation of that tradition. At the beginning of the twenty-first century, Tuymans makes emblems through painting that suggest an increased readiness to confront historical and contemporary questions, political and psychological questions in other words, within ourselves. Tuymans uses the power of understatement – the pillow, the flower, the Maypole, the face that says, or at least suggests, everything – that ultimately only has full meaning for the artist himself, and onto which we are entitled to project our own interpretations. He too tells us that the world is both beautiful and a place for horror. A room can be a gas chamber, a pillow can smother, and a painting, however understated, contains within it a potential for violence that is as visually strong and yet delicate as a painting by Francis Bacon, whose deeply disturbing images

are always exquisite. **IV** A palatial red carpet. A meteorite which has crashed through a glass roof. Pope John Paul II, one of the most remarkable and influential popes of modern times, whose brilliant Jesuitical guile succeeded in manipulating the defeat of the great Communist enemy. His contribution, and that of the Catholic Church, to that apocalypse has surely not been fully explored. That the walls of Europe came down in and around 1989 was a miracle, certainly for those directly affected. Now, the artist **MAURIZIO CATTELAN** has imagined the Pope struck down, a dramatic moment of insight and conversion. With Maurizio Cattelan we have a Baroque *arte povera* (not such a contradiction as it might at first seem). His art represents the first remarkable new direction in Italian art since the beginning of the 1980s. The Baroque always embodied certain aspects of a joke, meaning to make the audience gasp at the extravagance of the illusion. The face of the Pope is irrevocably embedded in all our minds, as familiar as a waxwork at Madame Tussauds. Cattelan's moment is a vision. The Pope has around him an aura of infallibility, a myth authorised by a tradition of almost two thousand years that still carries great potency. That alone is the source of his power. Yet he is still but a man, a representative of an organisation of surprising power which can and always has been questioned. The idea of absolute moral authority was, even in the Middle Ages, a source of unease; deep unease

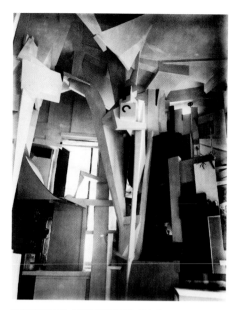

is evident here on the part of Maurizio Cattelan, himself a Catholic, if not by choice then certainly by upbringing. The power of art here acts as a thunderbolt, synthesised and encapsulated in a single image, simple but dramatic, which, in this case, was created last year for a museum in Basle, home of Erasmus and other great figures of the Reformation. The Papacy, the quintessential embodiment of tradition, will as always have to move on in order to survive. Perhaps that is the revelation that resides in this work of art. **V** Where is paradise? Where do we stand when we come to reflect as we all do, even the most rational of us, on the possibility of eternity as consciousness in flux suspended in a kind of ether? Is heaven a place of kitsch or even boredom? Or is it a place which offers hope even at the onset of this new dawn, this new millennium, this age of technological dreams that pretends to connect us instantly with all thought and all reality? The work of Salvador Dalí pictures a Freudian dream located in a threatening culture of Europe in the 1930s. Maybe, for **MARIKO MORI**, the *Dream Temple* represents a contemporary paradise based on timeless Eastern models fused with advanced technological and consumerist materials. The work is realised with a perfection that is beautiful but also horrific, as real and unreal as Jake and Dinos Chapman's *Hell* and possibly to some of us even more spooky and nightmarish. For, however much we may wish to be encased in the time capsule that

gives us the illusion of a contemporary Nirvana, in which floating bodies suggest a paradise garden of endless metamorphosis, we confront a bright night of hallucination which, like all contemporary consumerism connected to fashion and ambient music, provides an ersatz life on earth that is at best questionable as a desirable human experience. The robotic world, however seductive, is deceptive and this heaven may just be another department of hell. Nevertheless, we feel compelled to try everything and we have in the *Dream Temple* a momentary glimpse of a possible enlightenment that we can accept or reject. We choose whether or not to enter. It is compelling to watch: a seemingly total synthesis of both East and West, past and present, high art and kitsch, consumerism *in extremis* and a religious vision of a new age which dreams of total harmony between all peoples. Kandinsky, for his Geistreich, wished for nothing less. **VI** As extreme a position between heaven and hell informs the much more urban vision of **MIKE KELLEY**. On the other side of the Pacific Ocean in Los Angeles he has developed a consciously subversive aesthetic that, together with those of his contemporaries Paul McCarthy, Charles Ray and Chris Burden, seems to hark back to the world of 1950s beat poetry, informed by a total rejection of the extreme consumerist environment of Los Angeles. Kelley's world is one without make-up or disguise in a world where make-up and disguise count for everything,

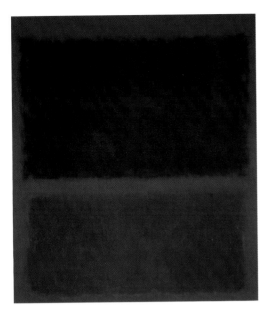

MARK ROTHKO, *BLACK ON DARK SIENNA ON PURPLE,* 1960
Oil on canvas
303.5 × 266.7 cm
The Museum of Contemporary Art, Los Angeles. The Panzer Collection

where cultural traditions from Plato via Nietzsche to Wittgenstein signify nothing against the existential nightmare of the everyday world of the disadvantaged common man trapped in the humdrum existence of the underclass, which also has its own legitimate aesthetic. The essence of Kelley's apocalypse lies in a highly puritanical morality that finds evil and a lack of love everywhere, a morality that takes refuge in the fantasy of cheap, mass-produced soft toys and finds no way out except through death or suicide and another banal Nirvana. He describes a culture in which success feeds on success and failure on failure. Once again we are reminded of Pasolini's world view in which the homogenisation of culture throughout the world, much of it exemplified by Los Angeles, with its dominant film industry, has produced an alienation in which 'the worst evil in the world is poverty'[7] and the authentic culture of the poorest classes must be replaced with a cheap version of the culture of the rich. Kelley presents us with another life or theatre that crosses the desperate comedy of the *Rocky Horror Show* with the cheap movies of Andy Warhol; his is a genuine if campy reality which has its own value. **VII** From a mood of total pessimism, relieved only by the ecstasy of banal suicide, we next find a moment of optimism. Using imagery seen through the lens, **WOLFGANG TILLMANS** finds beauty in nature even when it is damaged, in objects however humble,

and in people – all kinds of people as long as they are suffused with love, whatever their class or their background. Perhaps one of the best things that the Western world has evolved in the last generation or so is a greater toleration of diversity and an openness to the new kinds of beauty to be found in the mundane as well as in the fashionable. Sunsets may be tainted with pollution but nonetheless we can appreciate and even celebrate their beauty in a kind of post- rather than pre-industrial romanticism, so that life can be celebrated even when suffused with tragedy, poverty and disease. Through the eye and the camera lens we can perceive a paradise on the writing table, surrounded by books and empty tea mugs, in the kitchen contemplating the washing-up, in the streets, on the grass, on the sea and in the air. We should not worry overmuch, but rather celebrate real life as it exists on this planet. Tillmans's photographs may appear casual, but they record the little details of the world as it really is. The composer John Cage, an important influence on contemporary art, made a distinction between chance and arbitrariness. He exhorted us all to: 'Act in accord with obstacles, using them to find or define the process you're about to be involved in, the questions you will ask. If you don't have enough time to accomplish what you have in mind, consider the work finished once it has begun.... Free the mind from its desire to concentrate remaining open to what you can't predict.

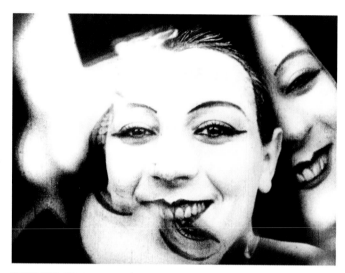

FERNAND LÉGER, STILL FROM *BALLET MÉCANIQUE*, 1924
British Film Institute, London

"I welcome whatever happens next."[8] If that all sounds too easy, we should remember that to perceive poetic beauty in everyday life, in everyday sounds, in the casualness of being, and never be bored is the most difficult thing of all. In the sky and in the stars, unconsciously perhaps, Tillmans discovers a new romanticism that is not far away in its mood from that of the painter Caspar David Friedrich or even William Wordsworth: 'At length a pleasant instantaneous gleam / Startles the pensive traveller while he treads / His lonesome path, with unobserving eye / Bent earthwards; he looks up – the clouds are split / Asunder – and above his head he sees / The clear Moon and the glory of the heavens.'[9] It is no accident that the eclipse, a major obsession of Tillmans, should always have been a classic symbol of the Apocalypse and the end of the beautiful world as we know it. **VIII CHRIS CUNNINGHAM** is a celebrated young maker of advertising and music videos, who is now choosing quite deliberately to enter the discourse of contemporary art in just this context of post-industrial romanticism informed by contemporary popular music, by life on the streets with its constant energy and erotic potential, never completely repressed but also never fully realised. Love can perhaps be more easily expressed by robotic figures performing in a ballet that seems for those with long memories to recall the mechanical films of Fernand Léger or the Triadic Ballet of Oskar Schlemmer made in the Bauhaus in the 1920s.

The world of advertising is extraordinarily slick but can also be complex and artful. Its chief disappointment is that its climax is inevitably a product – a pair of jeans, a brand of cigarettes, a make of car or a Vodka label. Can such technical virtuosity – hundreds of cuts taking place within seconds, complexities as dextrous as those in a Cubist painting, so that the viewer can barely perceive how it has been done – be transferred to the context of an art gallery in a story of love both violent and tender depicted with a romantic chiaroscuro, culminating in oblivion? As with Tillmans, the mystery of landscape and solitude, of everyday life with its harshness and its capacity for love and ironic wit, is transferred to the art of film, now increasingly and inevitably being absorbed as a medium of expression by artists, distinguished by their independence from the commercial imperatives of the cinema industry. If Cunningham is making a contribution to our map of a contemporary apocalypse, it is because his work so far makes legitimate his ambition to achieve a new transcendence which manifests that, in spite of the assault of mechanical stimuli, the greatest power of all lies in love at its most extreme and ecstatic. **XI** Time is the essence of **DARREN ALMOND**'s obsession. The train and tram timetable, the ticking of clocks, the second hand in perpetual motion, the implications of even simple digital technology, the idea of incarceration and the prison, all represent forms of

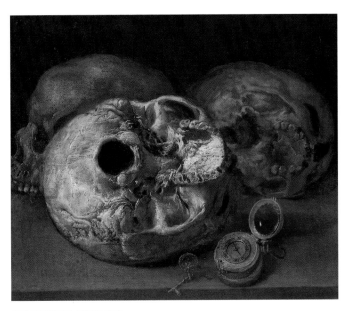

ANTONIO DE PEREDA, *VANITAS*, 1640s
Oil on canvas
31 × 37 cm
Museo de Bellas Artes, Zaragoza

oppression and apocalypse. The clock is an essential prop in the alchemist's laboratory, featuring alongside the skull and candle in the classic *Vanitas.* But does time exist unless we measure it? With no other objective presence, it is the ultimate oppressor, even as the earth moves around the sun, only to start up the cycle once again. Almond found himself standing under a bus shelter – a poignant souvenir of the sameness of everything – in Oswiecim (formerly Auschwitz) in 1997 when he decided to go by himself to absorb and observe the vibrations of the landscape there, now eternally scarred by the imprint of the death camps that functioned more than half a century ago. These bus shelters are like any others, yet they cannot now avoid the particular poignancy of their own destiny which is to be erected after this exhibition is over, complete with their own clocks, as replacements for those which Almond took away as material for another sculptural installation. What are the thoughts that will pass through this space in the future? Thinking and waiting are two related activities. When taken from the artificial world of the art gallery these sculptural presences will become somehow normal. Yet on the street outside the death camp, itself now a museum, they achieve further meaning, waiting perhaps for the end. **X** We move on to more theatre, to the fairground in fact, and the beautiful world of **TIM NOBLE AND SUE WEBSTER**, who have constructed a unique world of pleasure and sleaze. In their

case illusion is constructed from a mountain of rubbish piled up to project a shadow of themselves so delicate and refined that it amazes us as much as a conjuror performing tricks at a party. These are the aesthetics of astonishment that Diaghilev demanded of Jean Cocteau, earlier achieved by artists like Arcimboldo (see p. 30) and Bernini. Even Leonardo da Vinci is said to have devoted much energy to the ephemeral. Faces made of fish or fowl, of vegetables or seashells, representations of the seasons, of philosopher-kings and magicians – these were the apparitions with which Arcimboldo delighted Emperor Rudolf II in Prague at the end of the sixteenth century. Noble and Webster represent themselves and their love for each other, but their assemblages are so artful and skilfully constructed that we gaze and marvel with pure pleasure and delight at a paradise that they have manufactured for themselves, using corrupted and discarded materials. Their paradise is non-judgemental, hedonistic even, and contains within it an anarchic streak that is both a critique and a celebration of an apocalypse that is everywhere around. **XI** Humour, above all black humour, engages us in the imagination of **ANGUS FAIRHURST**. His is a world in which the *perpetuum mobile* of the second hand is constantly engaging and compelling. The circle of consumer culture manifested by the label attachments that define our everyday appearance; the absurdity of the media whose endless

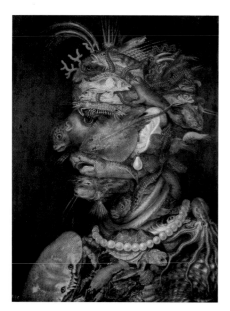

GIUSEPPE ARCIMBOLDO, *WATER*, 1566
Oil on canvas
66.5 × 50.5 cm
Kunsthistorisches Museum, Vienna

repetition masquerades as compelling variation; the ability of a human being dressed up as a gorilla in the circus or fairground to be ever so slightly sinister but fundamentally comic; the unconvincing joke about the banana skin: all these are motifs of Fairhurst's stock-in-trade. He is little known by a larger public that has adopted Damien Hirst and Tracey Emin as the most spectacular representatives of the so-called Young British Art scene; active for well over a decade, a long time in the history of art, it is not so young any more. Angus Fairhurst was there at its beginning, showing in the 'Freeze' exhibition in 1988. He has acted as a kind of moral preceptor to a whole group of artists whose reflections on contemporary life call into being a metaphysical and lyrical world that can in turn invoke Samuel Beckett's obsession with circular repetition, De Chirico and the metaphysical, and, with his loop of male and female legs intertwining in an endless dance, Matisse and lyrical colour. Fairhurst's work encompasses drawing, painting, sculpture, video, installation and music – all presented with a touch of the ridiculous but managing at the same time to be beautiful. **XII** We have already spoken of *Hell*, the installation by **JAKE AND DINOS CHAPMAN** – a reaction of artists to the idea of the abyss. Although the trenches of World War I were all too real, imaginable even, World War II, from Stalingrad to Auschwitz, from Japanese prisoner-of-war camps to the sadistic Northern Italian state

of Salò, seems even now to defy all belief. Its political barbarities have entered the realm of myth, as terrifying, if not more so, than the descent by Dante with Virgil into the lowest regions of hell: 'Who even in the freest forms of prose / however often he attempted it / could ever give an adequate account of all the blood and wounds that I saw now? / for surely every tongue that tried would fail; / our faculties of speech, our mental grasp, / just can't conceive of such enormity.'[10] But depiction is a form of therapy and this work represents an attempt to tame if not to overcome the reality that it represents. **XIII** At the end of the Apocalypse comes the New Jerusalem, after the insane complexities of a modern hell comes the simplicity of childhood and a new beginning. In two of the key pieces of his most recent and ambitious body of work, 'Celebration', **JEFF KOONS**, in *Moon* and *Balloon Dog* (see pp. 238–239, 240) offers us a naïve but original vision of paradise. As with the other stations of this exhibition, we can wander around and in and out of these works, enjoying them without restraint. In these most perfect and polished representations of a toy world we see another idealism to that of, say, Brancusi's *Maiastra*, which in many ways Koons's pieces recall. Brancusi's aspirations lie outside ourselves. Koons's approach an ideal paradise that we have already encountered during our childhood, those moments of naïve ecstasy at birthdays or Christmas which, with their

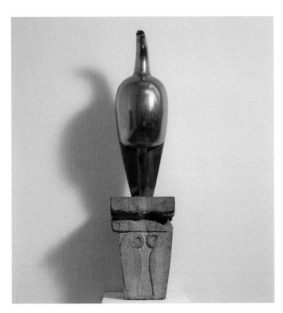

CONSTANTIN BRANCUSI, *MAIASTRA*, 1911
Bronze and stone
90.5 × 17.8 cm
Tate Gallery, London

attendant anticipation of presents, allow children to feel themselves at the very centre of the universe. These are moments of pure magic which even the simplest toy can bring. This is not the paradise of angels and saints, but it is a moment when we can perhaps for a second forget the real, virtual or ironic worlds and enjoy the perfection of a form and thought, a naïve wonderment and sense of scale, and the exhilaration that a child experiences when holding a balloon. The three-metre-high dog, exquisitely cast in stainless steel, is a monument to the only dream of paradise that we can legitimately grasp. And yet there is still a touch of ambiguity – the ambiguity of the contemporary pleasures which engulf the West and much of the East, whose values we transmit too easily to our children. But perhaps after all we should enjoy wonderment for itself, even in our contemporary world.

•

Are *Hell* and 'Celebration' the opposite sides of the same coin? This exhibition with all its inherent theatricality remains one that takes place within the dialogue we have always called 'art', whose field of legitimate activity is increasing exponentially. Artists exist solely to make representations of the world using whatever means are available to them. They are there to draw attention to

images and visual metaphors, to areas of the mind that we have not yet fully penetrated – not as scientists, not to tell us how things work, but rather to tell us what is actually at stake, to pull aspects of knowledge into a visual essence that can affect our perceptions. In this sense we can argue that all art is essentially apocalyptic: it challenges us, perhaps against our will, to look at the inevitable. We need to confront evil visually; we need to enjoy dreams; we need to be aware of the difference between reality and the virtual; we need to understand the absurdity in all things; we need to laugh; and we need to understand and be tolerant of the borders of the mind, the heart and the spirit. This exhibition aims to present art for our time, to take us to new frontiers and to remind us in a positive spirit, even, that our minds are forever preoccupied with premonitions of the Apocalypse.

Norman Rosenthal

RICHARD PRINCE
GREGOR SCHNEIDER
LUC TUYMANS
MAURIZIO CATTELAN
MARIKO MORI
MIKE KELLEY
WOLFGANG TILLMANS
CHRIS CUNNINGHAM
TIM NOBLE AND SUE WEBSTER
DARREN ALMOND
ANGUS FAIRHURST
JAKE AND DINOS CHAPMAN
JEFF KOONS

RICHARD PRINCE

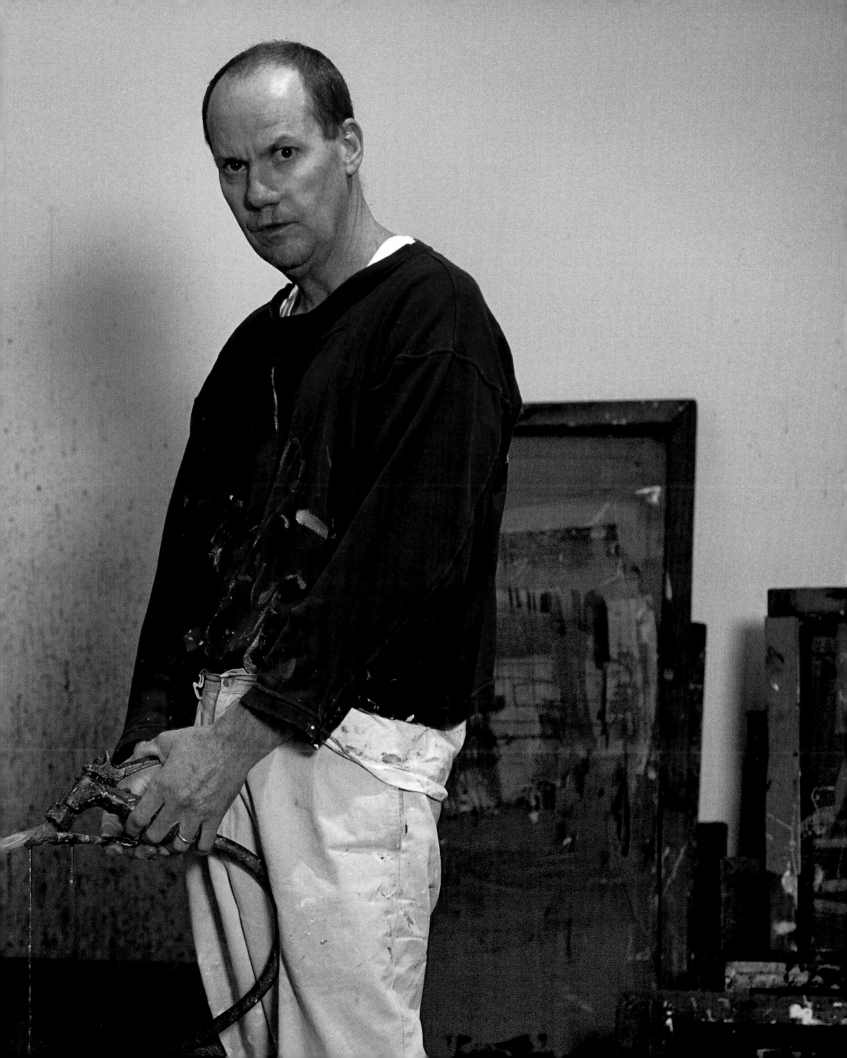

THE LIKES OF RICHARD PRINCE

A lot of people wish they were someone else.[1]
Richard Prince

I think presidential candidates should list their likes and dislikes.
I think it would make it easier for people to cast a vote. Like the Dewars
profile. Favorite book. Favorite movie. What kind of sex they like.[2]
Richard Prince

Perhaps the central fact of Richard Prince's art is its elusiveness, and his own. In his work personal identity is often attached to sets of likes and dislikes – the products we buy, the movies we watch – or points of view, which can be stepped back from, turned around, or looked at from another side. If 'Pop Art is about liking things', as Andy Warhol said, then Richard Prince is a Pop artist at one remove. Although the nominal subjects of his work – cowboys, biker chicks, car hoods, jokes – recur almost obsessively, the work itself is 'not as much about liking it', Prince said recently, 'but it's *almost* liking it. It's, like, *Can* I like it?'[3] By assuming provisional likes, Prince is able to move in and out of provisional identities, as his artistic identity, too, continues to shift ground – from photographer to sculptor to painter to writer (he has even exhibited works under a pseudonym). 'There's nothing there that seems to be him',[4] Prince wrote in his 1983 collection of short fictions, *Why I Go to the Movies Alone*. His highest encomium for his own works is when they achieve 'that sent-away-for look', as though he had 'sent away' to some unknowable side of himself, or to the culture as a whole, to find whatever it takes to make his work.

Richard Prince was born in 1949 in the Panama Canal Zone, a place that 'isn't even there any more',[5] and grew up in a suburb of Boston,

during a time when, 'with the Kennedy and King assassinations… nobody told you the truth'.[6] As a teenager he used to go into Cambridge at the weekends where he discovered 'personality posters': large black-and-white blow-ups of cultural icons marketed to college students. Prince was fascinated by the way these posters seemed to promise a ready-made 'identity' to the young person presumed to be in search of one. In his own room, next to a poster of actor Steve McQueen, Prince put up photographs of Jackson Pollock and Franz Kline – 'Not, you understand, pictures of their paintings but pictures of *them*.'[7] Already he 'thought the choosing of a personality was in itself some kind of expression'.[8] Prince left home for Los Angeles on the day after he graduated from high school, drawn to the burgeoning rock scene there. But the Vietnam War was in high gear, and to avoid being drafted, Prince enrolled in a small, experimental college in Maine where he began to study art.

He moved to New York in the early 1970s, knowing nobody. He was painting figuratively and had shows of his work, but, he said later, 'I never liked my work. Ever. Because I did it.'[9] He was, however, 'really turned on by all the new stuff that was going on, like [Robert] Smithson, [Bruce] Nauman, [Vito] Acconci: a lot of minimalism, I really liked that'.[10] He got a part-time job with the Time Life corporation, where for about a year he worked in a department called 'tear sheets', cutting articles out of magazines for the authors' files. What was left over were the 'authorless pages': the advertisements, whose photographs came to fascinate him as images that were 'too good to be true. Unbelievable. Overdetermined. They had that sent-away-for look. The virtuoso real,'[11] and he began to photograph them. Challenging assumptions about the originality of the work of art, and

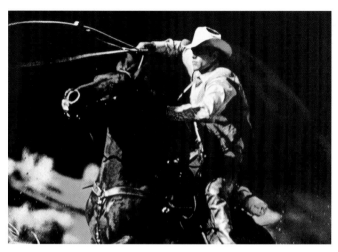

RICHARD PRINCE, *UNTITLED (COWBOYS)*, 1987
Ektacolor print
50.8 × 61 cm
Edition of 2 + 1
Private collection, New York

I never had a penny to my name, so I changed my name.

RICHARD PRINCE, *I CHANGED MY NAME*, 1988
Acrylic and silkscreen on canvas
142.2 × 122 cm
Private collection, Cologne

by extension, the authorial identity of the artist, Prince's 'appropriations' were an important influence on a generation that includes Jeff Koons, Sherrie Levine, and Louise Lawler among others, and continue to exert strong influence on younger artists today. Prince's first rephotographed images fell into categories: luxury consumer objects, anonymous-looking men and women, and cowboys from cigarette ads. The rephotographs were slightly blurred, a deliberate avoidance of precision that made them seem all the more authentic, a visual equivalent of the ubiquitous, randomly inserted 'likes' of everyday speech with which we blur and stand aside from our own statements. The Cowboys became a favourite subject and a Prince 'trademark'. If the original advertisements were lies, once isolated and represented by Prince, they were remade as fiction; and as fiction they were truer than life – hyper-real images of macho, American freedom of movement and metaphors of sexual pursuit. The Cowboys were in a sense fictional self-portraits, with a subliminal homage to Jackson Pollock, from Cody, Wyoming, and his 'ropes' of poured paint.[12] 'One's identity it seems is easily changed when what's in front of you is reversed and transparent, directed and produced.'[13]

In about 1984 Prince started printing groups of nine photographs together on single large sheets of paper which he called 'Gangs', a term derived from the 'ganging' together of colour slides by the lab for proofing. The images, separated by wide white margins corresponding to the white slide mounts, were usually similar or of a kind. By the time Prince started making 'Gangs', his range of rephotographed imagery had expanded to include what he calls the 'Girlfriend' pictures (see p. 43), or 'biker chicks'. 'The biker boys take pictures of their girlfriends and then send these pictures to a biker magazine, get them

published, and then go out and buy the magazine. ...I imagine it's about wanting to be recognised by yourself.'[14] Also around 1984 Prince began redrawing cartoons from magazines, a natural corollary to his rephotographing the photographs and a roundabout way for him to start drawing the figure again. Then he dropped the cartoon images and began handwriting corny jokes on small pieces of paper. '"My brother just married the two-headed lady from the sideshow," says Bozo. "Is she pretty?" asks Cooky. "Well," says Bozo, "yes and no."' The first reaction to these from friends and dealers was incredulity: 'Is this it? Is this your art?' Prince began to enlarge both the cartoons and jokes and silk-screen them onto canvas in various permutations: a cartoon with the gag line – or the gag line from a mismatching cartoon – written or printed underneath; or just a joke by itself in the middle of a monochrome canvas. Over the past decade and a half, Prince's Jokes have infiltrated almost every aspect of his work. They are the kinds of jokes found in magazines in the 1950s and 1960s, from *Reader's Digest* to *Playboy*, and evoke, with Proustian immediacy, the flavour of the suburban America milieu in which Prince grew up; a time when, for him, 'movies and magazines became the reality'.[15] 'It wasn't really that I *liked* jokes, it's more that I *do* like magazines and I like the stuff that's in the magazines,' said Prince.[16] The voice of the tiny, absurd, affectless, gauche, authorless narrative that is the Joke is completely 'sent-away-for'; not fiction but the look of fiction.

Prince enjoys seeing chains of connection in his work between people, images, words – especially connections that traverse the fictional and the real world. As an example he cites his Hoods, which he started making in about 1987. He would send away for fibreglass automobile hoods which are advertised at the back of car magazines, 'cut them,

RICHARD PRINCE, *UNTITLED (HOOD)*, 1989–90
Acrylic primer, bondo, cast fibreglass, wood
149.8 × 132 × 15.2 cm
Courtesy Barbara Gladstone Gallery, New York

My father was never home, he was always drinking booze. He saw a sign saying DRINK CANADA DRY. So he went up there.

RICHARD PRINCE, *UNTITLED*, 1990
Acrylic and silkscreen on canvas
243.8 × 190.5 cm
Courtesy Barbara Gladstone Gallery, New York

square them off, mount them on a stretcher and then paint them with car colours...and there are very specific cars too, so there's a subtext. ...Some of these cars have starred in movies that I liked. So that is another thing that I *like*. I like the car hoods, I like the subtexts... Eventually you find out that, Oh, it's a 1970 Dodge Challenger, wasn't that in the movie *Vanishing Point*? Oh, that's one of your favorite movies.'[17] Positioned exactly at the intersection of Pop Art, minimalism and conceptualism, of landscape, still-life and the figure, the Hoods are, among other things, a homage to Los Angeles, a city to which Prince periodically returns. Sleek and reductively sensual, they seem to hold imaginary converse with – little as they resemble – the shadow-casting discs of Robert Irwin, and humorously confound the high seriousness of Donald Judd's wall boxes and other minimalist works by Prince's early art heroes.

'I always thought my work would look like a giant magazine', Richard Prince said in 1993. 'There'd be a joke section, a photography section, a painting section....'[18] By the time of his 1992, mid-career retrospective at the Whitney Museum, the 'painting section' of Prince's 'magazine' had come to dominate his new work. In addition to the monochrome Joke paintings and the painted Hoods, by the late 1980s Prince had also begun working on what came to be called the White paintings. With their mixtures of silk-screened cartoons or cartoon fragments in shifting orientations, handwritten or printed jokes, brushy washes of white paint, gestural scribbles and the occasional screened photographic fragment, the White paintings almost seemed to be a continuation of the New York School painting tradition of Cy Twombly and Robert Rauschenberg. 'It's been great to try and make a painting that's got this kind of New York traditional feel about it, this large

expressionistic '50s feel to it. I like the idea...that it finally looks like art,' Prince said[19] – except there were always those subversive Jokes pulling the rug out from under it. In 1995 Prince began a series of what have been referred to as 'landscape' paintings, because of the curved 'horizon lines' dividing their mostly white top sections from dark jumbles of massed forms below, patchwork 'fields' of roughly painted rectangles and silk-screened scribbled balls. Along the bottom edges of the canvases handpainted jokes were screened onto attached predellas. More recently, Prince's paintings have incorporated all-over patterns of various elements, including silk-screened images of spirals and children's drawings of stick figures and flowers. Sometimes there are shopping lists among the images:

Diapers	Toothpaste	Potato chips
Wipes	Toilet paper	Olive oil
Diet Coke	Dish soap	Kit Kats
Molsen Excel	Video return	Light bulb

There's a bomb-shelter feeling to this repeated catalogue of likes and necessities: everything keeps. Prince is a cataloguer; a collector not only of jokes. In his studio, along with paintings in progress or in transit, stacks of actors' headshots for his new Publicity Pictures works (see p. 42), an indoor basketball hoop, and an electric piano and guitar, there is a carefully chosen selection from his collection of rare books (modern first editions). 'I like having the lives of these things around me', he has written. 'I like having lives I can go into and out of when I'm alone.'[20] Prince has also been making sculpture: casting flip-flop sandals and most recently rubber tyre planters in translucent coloured urethane. The planter, with its zig-zag flange, looks like a frozen splash. 'They always said you couldn't reinvent the wheel – well I think it's just been reinvented,' he said.[21] His photographic activity has moved into the 'real' world, and recently he has been taking

RICHARD PRINCE, *UNTITLED*, 1994
Acrylic and silkscreen on canvas
243.8 × 190.5 cm
Courtesy Barbara Gladstone Gallery, New York

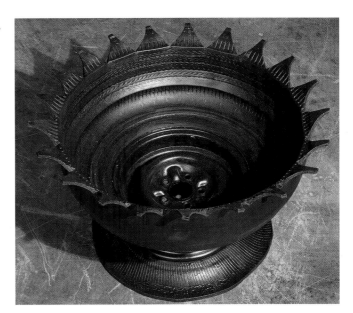

RICHARD PRINCE, *UNTITLED (FLOWER PLANTER)*, 1999
Tyre and paint
66 × 38.1 cm
Courtesy Barbara Gladstone Gallery, New York

informal inventories of vernacular structures found in the yards of his neighbours in upstate New York, his home for the past four years. These objects, above-ground swimming pools, basketball hoops and rubber tyre planters, attract Prince, both for their intrinsic weirdness as constructions, and for the way they are displayed and read as clues to their owners' identities. The 'Upstate' pictures, as he calls them, have been exhibited in galleries a few times but their intended presentation is in books, such as *Adult Comedy Action Drama* (1995) and *4 × 4* (1997), where they mix with indoor photographs of his works leaning against studio walls, other artists' works, piles of books, close-ups of magazine pages, 'Girlfriends', friends and family, old snapshots. Everything's there, 'life' and 'art', one firmly located within the other, though it is hard to say which is where.

'I'm interested in the fiction becoming true. It wouldn't surprise me if the day came when the earth really *did* stand still.'[22] For 'Apocalypse' Prince has made two huge new paintings: *Crazy* and *Jokes*, which will be installed on the staircase at Burlington House, temporarily replacing Sebastiano Ricci's canvases *The Triumph of Galatea* and *Diana and Her Nymphs Bathing*. Each painting is a horizontal diptych with a joke painted in large capital letters running from edge to edge like a horizon line across the middle, where the two panels meet. The backgrounds of both paintings consist of subtle near-white washes applied over painted images, leaving only faint traces of colour, pinkish, cloudy – an 'assumed state of invisibility'.[23] The joke in *Crazy* goes: 'YOU KNOW, I WAS UP THERE IN PRISON TALKING TO CHARLIE MANSON AND HE SAYS TO ME HE SAYS "IS IT HOT IN HERE OR AM I CRAZY?"' (The answer to that joke is Yes, and yes: Manson may be crazy but the 'straight' world is getting hotter all the time.) Two jokes are run together without

pause in *Jokes*: 'I TOOK MY WIFE TO A WIFE-SWAPPING PARTY. I HAD TO THROW IN SOME CASH. OKAY OKAY, WITH ALL I'VE HEARD ABOUT A-BOMBS THAT'LL DESTROY A CITY AND H-BOMBS THAT'LL DESTROY THE WORLD YOU KNOW I JUST HAVN'T [*sic*] ANY INCENTIVE TO BUY A TWO PANTS SUIT.' The truncated beginning of the third line, 'TROY A CITY', reminds us of the kind of devastating chain reaction wife-swapping can lead to. The background of *Jokes* is more defined and less washed-out than that of *Crazy*, and in conjunction with these particular jokes it suggests both the pastel prettiness of an eighteenth-century boudoir and something like the radioactive glow of a post-nuclear dawn.

Because the paintings were to be site-specific, Prince chose to work with jokes that seemed to have apocalyptic connotations. Yet the subject of a joke is not really what a Prince painting is about. It's more like what the painting is up against. It's more like, *Can* it be about that? 'He liked to think of himself as an audience and located himself on the other side of what he and others did...looking back at it.'[24] 'The possibility of a meaning was enough.'[25] NK

(pp. 34–37)
RICHARD PRINCE, 2000
Photographs by Norbert Schoerner

(p. 42)
RICHARD PRINCE, DETAIL OF *UNTITLED*, 1999
8 × 10" publicity photographs
104.1 × 83.8 cm
Courtesy Barbara Gladstone Gallery, New York

(p. 43)
RICHARD PRINCE, DETAIL OF *UNTITLED (GIRLFRIEND)*, 1993
Ektacolor print
162.6 × 111.8 cm
Edition of 2 + 1AP
Private collection, New York

(pp. 44–45)
RICHARD PRINCE, DETAIL OF *UNTITLED (COWBOYS)*, 1993
Ektacolor print
121.9 × 182.8 cm
Courtesy Barbara Gladstone Gallery, New York

(pp. 46–47)
RICHARD PRINCE, *CRAZY*, 1999–2000
Acrylic and silkscreen on canvas
175.3 × 452.1 cm
Courtesy Sadie Coles HQ, London, and Barbara Gladstone Gallery, New York

(pp. 48–49)
RICHARD PRINCE, *JOKES*, 1999–2000
Acrylic and silkscreen on canvas
175.3 × 452.1 cm
Courtesy Sadie Coles HQ, London, and Barbara Gladstone Gallery, New York

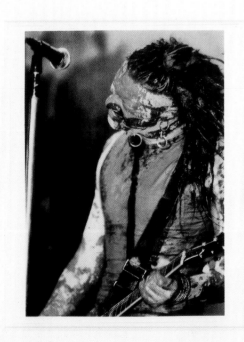

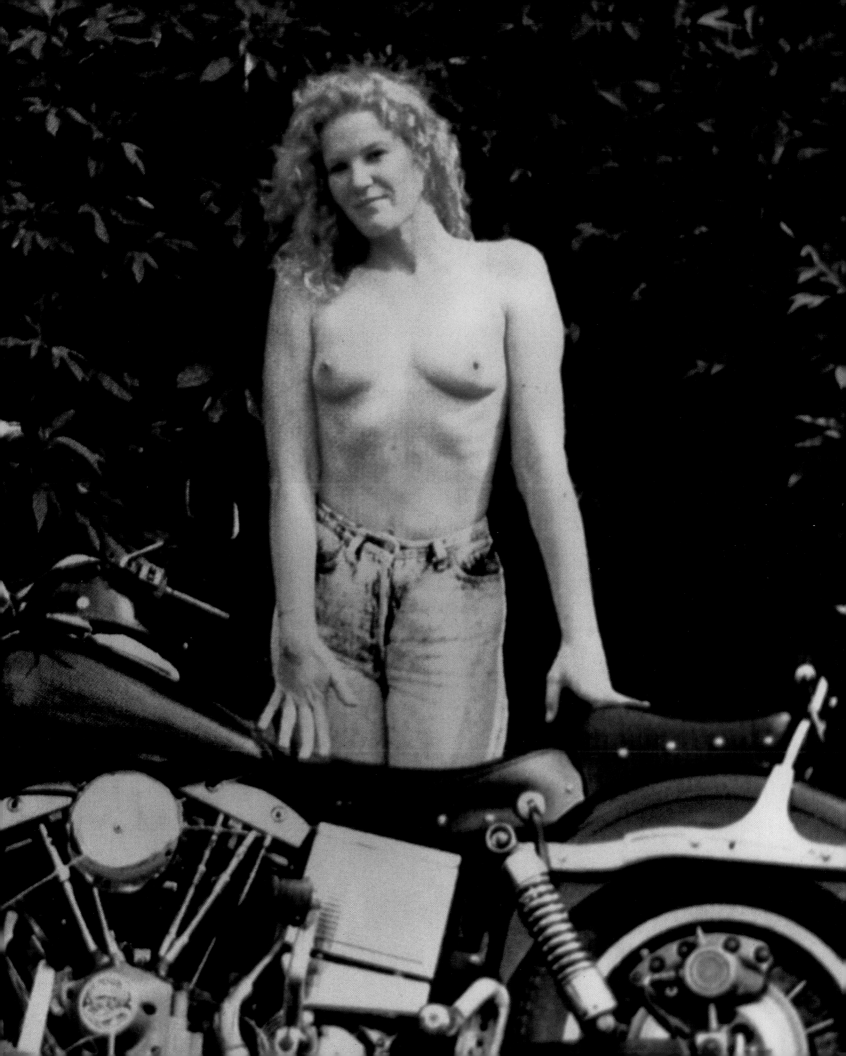

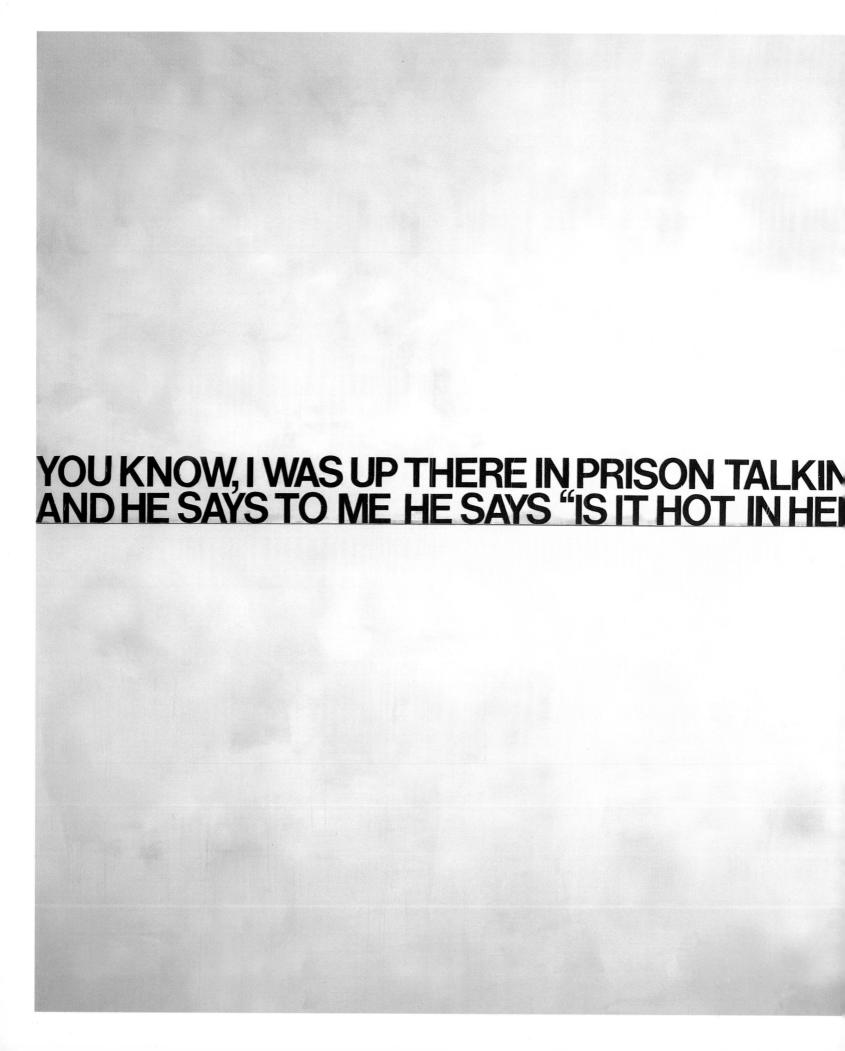

YOU KNOW, I WAS UP THERE IN PRISON TALKIN
AND HE SAYS TO ME HE SAYS "IS IT HOT IN HE

O CHARLIE MANSON
OR AM I CRAZY?"

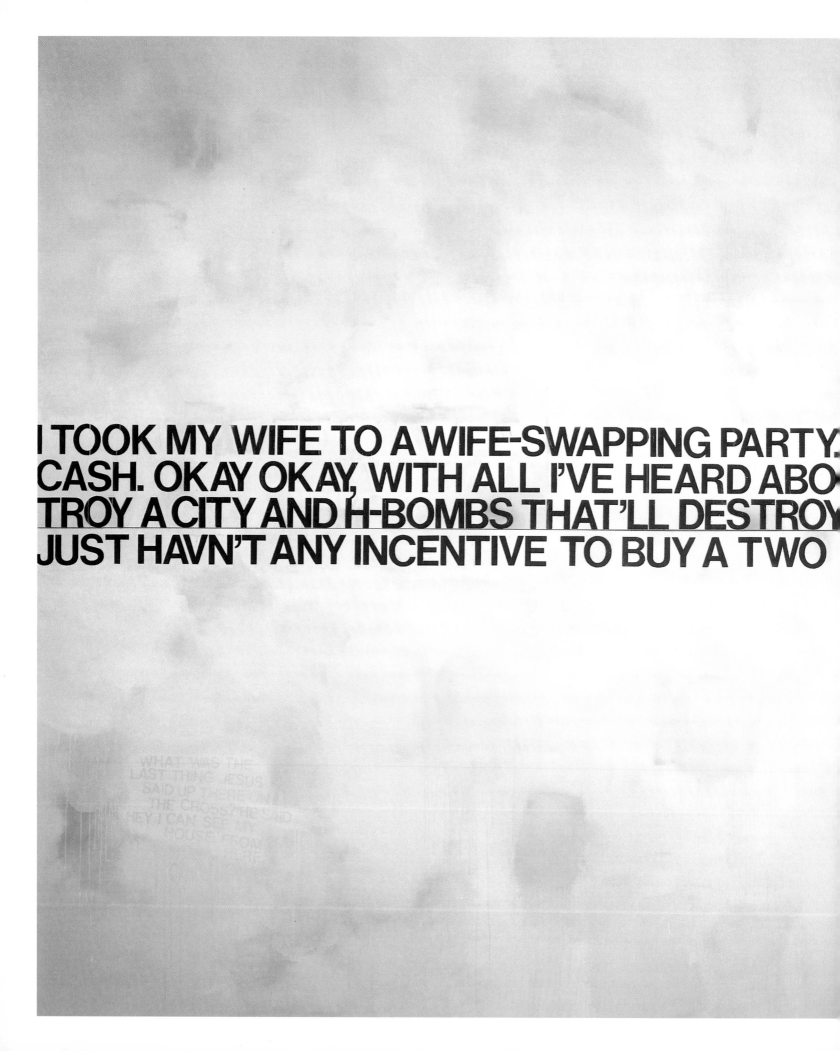

AD TO THROW IN SOME
A-BOMBS THAT'LL DES
E WORLD YOU KNOW I
ITS SUIT.

GREGOR SCHNEIDER

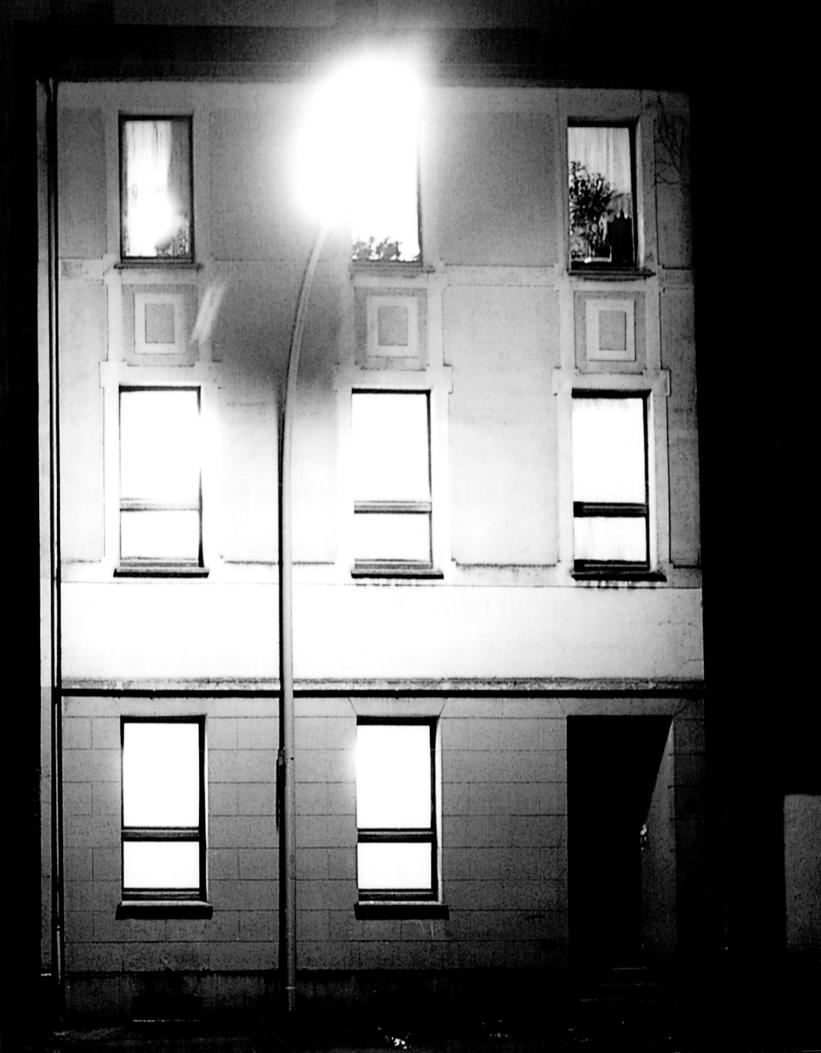

POSSIBILITIES AND UNCERTAINTIES

'It's not about signposting,' says Gregor Schneider, 'the work exists purely in the work.'[1] The focus of this work for the past fifteen years has been Schneider's house, Haus ur, in Rheydt, near Mönchengladbach. He moved in during 1985 at the age of only sixteen, having been born in Rheydt in 1969. Slowly over this period he has conducted a series of alterations and reconstructions, such that it would now be impossible to restore the structure to its original state without completely dismantling the house and starting again. Walls have been built in front of existing walls, doorways altered, windows blocked up, among other reconfigurations, resulting in a habitation that thoroughly disorients the visitor and confounds all expectations of how buildings work. What may appear as daylight flooding a room, for example, is in fact the backlighting behind a false window, and the gentle breeze that flutters curtains at a window is no more than the work of a similarly hidden electric fan. Stepping outside after drinking coffee in the 'daytime' of this room, one is just as likely to discover that it is in fact the middle of the night. There are doors, floors and walls of a thickness quite out of proportion to their structural function, a ceiling that dips and rises by a few centimetres, and a room on wheels with a mechanism that slowly turns the entire space so that exiting by the same door through which one entered could lead one to a completely different part of the house. There is a *Wunderkammer* full of objects and sculptural forms, and piles of junk, building materials and debris wait in the often cramped behind – and between – spaces of the house for their turn to be incorporated into its substance.

The presence of rubble and other materials attests to the persistently non-completed status of Haus ur. Schneider began work on the building without any conscious plan. He certainly had no interest in constructing a room, and in fact only became aware that he had done so when someone else pointed out to him that that is what had happened. The drive, above all, is to be continually active, to do something other than intellectualise, since for Schneider 'doing is higher than thinking'. Work ceases on a space when it becomes usable, and, precisely because it is usable, is accepted as a room. Schneider says that he never throws anything away. Things are constructed, dismantled, altered and reconfigured; but none of this can be understood as a straightforward process of creation and destruction. The important feature is that the process is continuous. Things treated as finished are only so temporarily, until such time as they are, too, reabsorbed back into the larger procedure of living in and with the house.

Schneider is not satisfied with the standard terminology that might be used to describe his activities. In the field of art, the building of a room inside a room would more often than not be categorised as an installation, and the construction of a more extensive space, within which a variety of functions could be carried out, might be called an environment. The term installation would suggest that the spaces Schneider constructs should be seen primarily as rooms within other, previously existing spaces, a dependence, both temporal and spatial, which sets up a hierarchy that places the fabric of the gallery, or the original house into which he moved all those years ago, at its head. Neither term is of much use to Schneider. What he does, in contrast, is to build *Räume* – rooms. (This is just what he told the interviewing panel when he was called up for National Service. Their response to such straightforward truthfulness was to class him as psychologically unfit to serve.) The rooms Schneider makes are, by contrast,

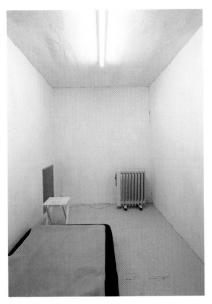

GREGOR SCHNEIDER, COMPLETELY INSULATED GUEST-ROOM,
HAUS UR, RHEYDT, 1995
275 × 402 × 304.5 cm
Courtesy Sadie Coles HQ, London

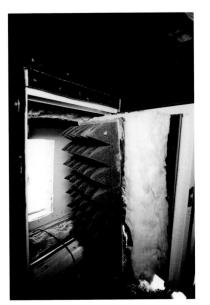

GREGOR SCHNEIDER, DETAIL OF EXIT FROM THE COMPLETELY
INSULATED GUEST-ROOM, HAUS UR, RHEYDT, 1995
Door measurements: 60 × 80 cm
Courtesy Sadie Coles HQ, London

rooms that exist. Insofar as this is the case, they are unquestionably perceptible, and yet, because they are simply rooms, they may also go quite unnoticed. Naturally, load-bearing walls remain in Haus ur, otherwise the entire edifice would collapse; but access to storage or crawl spaces between or behind the rooms reveals not a primary, supporting structure, but a narrative of passage through, and presence within, the construction as a whole. However real, narrative is always a fiction too – full of possibilities and uncertainties, and fuelled by desires and anxieties.

Erecting a wall in front of another wall obscures what was there in the first place and makes it invisible; but the simple fact of its being out of sight is not the issue. Someone in the room may well not know that they are looking at a wall that stands in front of another wall. What is of more concern to Schneider is the way in which our behaviour is guided by conscious or subconscious bodily perceptions. Having a sense of how a space makes us feel, without being able quite to put our finger on why, is what matters. As we have seen, Schneider places other things – such as the daylight bulb or the electric fan that could fool the unsuspecting visitor – behind some of his walls. He builds stones, for example, into the gaps behind his walls or into the walls themselves. These are of various colours – black, red, yellow – and significantly have this colouring right through them. They are not merely surfaces, a fact that is also importantly true of the walls themselves. Schneider speaks of looking at a wall and being intrigued by some slight unevenness in it. This imperfection gives a clue to its existence as a mass, as a substantial and present collection of materials, and as a presence that is productive in making a room. Similarly, the stones are of interest not as colours that rest on the surface of a mass, but

as the reality of those masses or voids. After a wall's construction, no indication is given that hidden things such as these stones exist. At the time of construction their incorporation is a part of what is going on, but subsequently they are not singled out to be captioned. Instead, over time, their precise location is forgotten and they become shadowy. Perhaps, in the end, they were never there at all, and only ever existed in Schneider's, or someone else's, imagination.

Some time ago Schneider bought some apples and dropped them, one after the other, onto the floor, 'because that thing about an apple falling to earth doesn't have to work with every apple'. He tried to film one before it fell, an impossibility that could nonetheless be imagined as a possibility. The action brings to mind the character of the murderer Moosbrugger in Robert Musil's long and incomplete novel *The Man Without Qualities*, who, when asked by his doctors to do a simple sum, gives a hazy answer, because even though he knows what the answer should be, he nevertheless wonders whether that is what the answer will always be. Musil wrote that if society could dream collectively, it would dream Moosbrugger. Schneider has moved away from such experiments, but the sense that a thing could become its opposite is still important to him. A room within a room is an uncanny doubling, a sheltering that could as easily be an imprisonment – he has even built a small, completely insulated space with a steel reinforced door that would swing shut if you entered and could not be reopened either from inside or out. This is a life choice, life as 'the difference between a full and an empty box'. There is a parallel here, perhaps, with Joseph Beuys's *Plight 1958–1985* (1985), a work that began as a joke with Beuys's London dealer that he should make an installation that would keep out the incessant noise from a nearby building site. The resultant

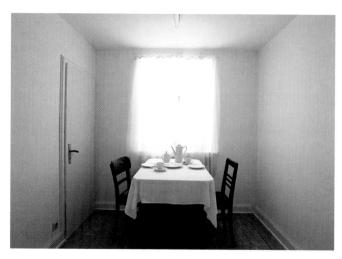

GREGOR SCHNEIDER, REVOLVING COFFEE ROOM, HAUS UR, RHEYDT, 1993
246 × 289 × 234 cm
Courtesy Sadie Coles HQ, London

space, lined with rolls of felt, engendered similarly ambivalent feelings of both warm, comforting enclosure, and suffocating entrapment.

For Schneider, the ultimate human expression is the scream. It is a vocalisation outside language, and while it might signify pain, it could equally well suggest exuberance, joy, or some other intense emotion. Whatever, though, the scream is emitted as an emotional response to the world, rather than as a wish to articulate a considered intellectual position. The house in Rheydt stands near an old lead works, and this context has been absorbed by the building. As well as various insulating materials placed within the walls, in part as a means of isolating the space from 'the screaming outside', Schneider has also lined some walls with lead. Thus it would be impossible to ascertain the original structure of the house even with X-rays: the lead would resist any attempt to penetrate the walls.

Certain references present themselves as practices that begin to provide some sort of context for Schneider's endeavours: Kurt Schwitters's *Merzbau*, for example, an ongoing incorporation of found materials into a living space as artwork, or Gordon Matta-Clark's building cuts. In Matta-Clark's *Splitting* (1975), a house in suburban New York scheduled for demolition which the artist cut in half, the desire was largely to open up the discourse of architecture to examination in the light of conflicting social and economic pressures. There is less in Matta-Clark of the play between the possible and the real, and of the overlapping of potential, imagined, fantastic and past spatial experiences characteristic of Schneider's rooms. The labyrinthine character of the house, as witnessed in Schneider's video of himself navigating his way through the tortuous, often restricted spaces of

the building, has perhaps more in common with the experiences of virtual space, with its logic-defying shifts of place and orientation, and with science fiction, through such well-embedded fantasies as teleportation. The idea of teleportation comes particularly to the fore in the way in which Schneider makes exhibitions in the more conventional surroundings of an art gallery. In 1994 he began this aspect of his work by building a space almost identical to one of the rooms of the Rheydt house in the Galerie Andreas Weiss in Berlin. Returning home he was able to enter the room and imagine himself into an awareness of what was going on in the gallery. He subsequently removed various parts of the house and reconstructed them on site. In each instance the room, or rooms, ignore, obstruct and generally undermine the architectural rationale of the host building.

An added layer of intrigue and of spatial and temporal uncertainty is present in 'Apocalypse', in that the cellar rebuilt here could quite recently have been entered, not by visiting Rheydt, but by going to the Secession Pavilion in Vienna. In the same way that a room can make an impression on those who occupy it, might the reverse be true? Is it possible to leave behind the trace of one's presence in a room? And if so, how much has this cellar changed on its journey to London from Rheydt via Austria? It could indeed be exactly the same space that we are entering; although maybe, too, there are some differences, some additions, that would make themselves apparent through the way in which we behave in the space. Describing his dream for the house, Schneider talks of dismantling it, taking it somewhere else and re-erecting it for his family to live in with others 'who don't quite know where else to go'. These people would occupy most of the house, but in the cellar we would find only the bodies of older relatives.

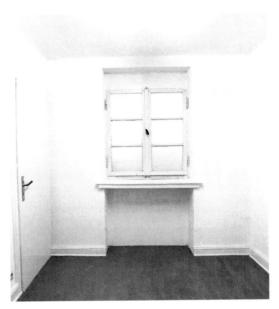

GREGOR SCHNEIDER, UR 3, DOUBLED ROOM, HAUS UR, RHEYDT, 1988
245 × 263 × 243 cm
Courtesy Sadie Coles HQ, London

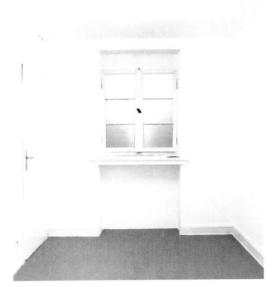

GREGOR SCHNEIDER, UR 3A, DOUBLED ROOM, BERLIN, 1994
247 × 332 × 249 cm
Installation Galerie Andreas Weiss, Berlin

At the end of a tour of Schneider's house, the curator Ulrich Loock, wondering what was behind the final window, was told that it was merely a blank, white wall. It is the sight of this wall, Schneider says, that makes visitors afraid and anxious to leave; and while he often wants to prevent them from leaving, he has never yet found the courage to do so: 'Corpses always lie in the cellar. Perhaps I am the one who can't get away.' In another sense, too, the cellar itself stands as a kind of death. Plucked from the flow of construction and remodelling, it is reified as an exhibit, embodying the death of work itself. It is the failure of work, a hiatus, until such time as there is a return home and a re-engagement. MA

(pp. 50–51)
GREGOR SCHNEIDER HANGING DOWN THROUGH THE CEILING, 1997
Photograph Wonge Bergmann

(pp. 52–53)
GREGOR SCHNEIDER, HAUS UR, RHEYDT, 1985–99 (DETAIL)
Courtesy Sadie Coles HQ, London

(pp. 58–59)
GREGOR SCHNEIDER, 8 VIDEO STILLS, DETAILS OF HAUS UR, RHEYDT, 1997
Courtesy Sadie Coles HQ, London

(pp. 60–61)
GREGOR SCHNEIDER, UR 16, IN THE CORE, RHEYDT, 1996 (DETAIL)
Courtesy Sadie Coles HQ, London

(p. 62)
GREGOR SCHNEIDER, CELLAR ENTRANCE, MILAN, 1999
Installation Galleria Massimo de Carlo, Milan
Courtesy Sadie Coles HQ, London

(p. 63)
GREGOR SCHNEIDER, THE CELLAR, RHEYDT, 1985–99 (DETAIL)
Courtesy Sadie Coles HQ, London

(p. 64)
GREGOR SCHNEIDER, 16 DETAILS OF THE CELLAR, RHEYDT, 1999
Courtesy Sadie Coles HQ, London

(p. 65)
GREGOR SCHNEIDER, THE DUMP, RHEYDT, 1995 (DETAIL)
Courtesy Sadie Coles HQ, London

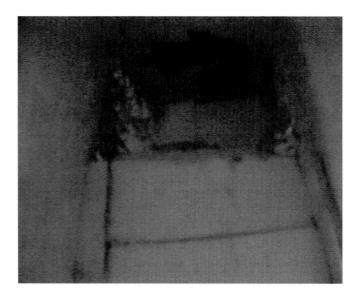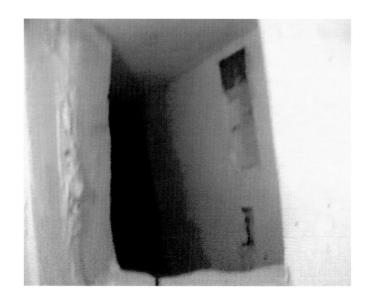

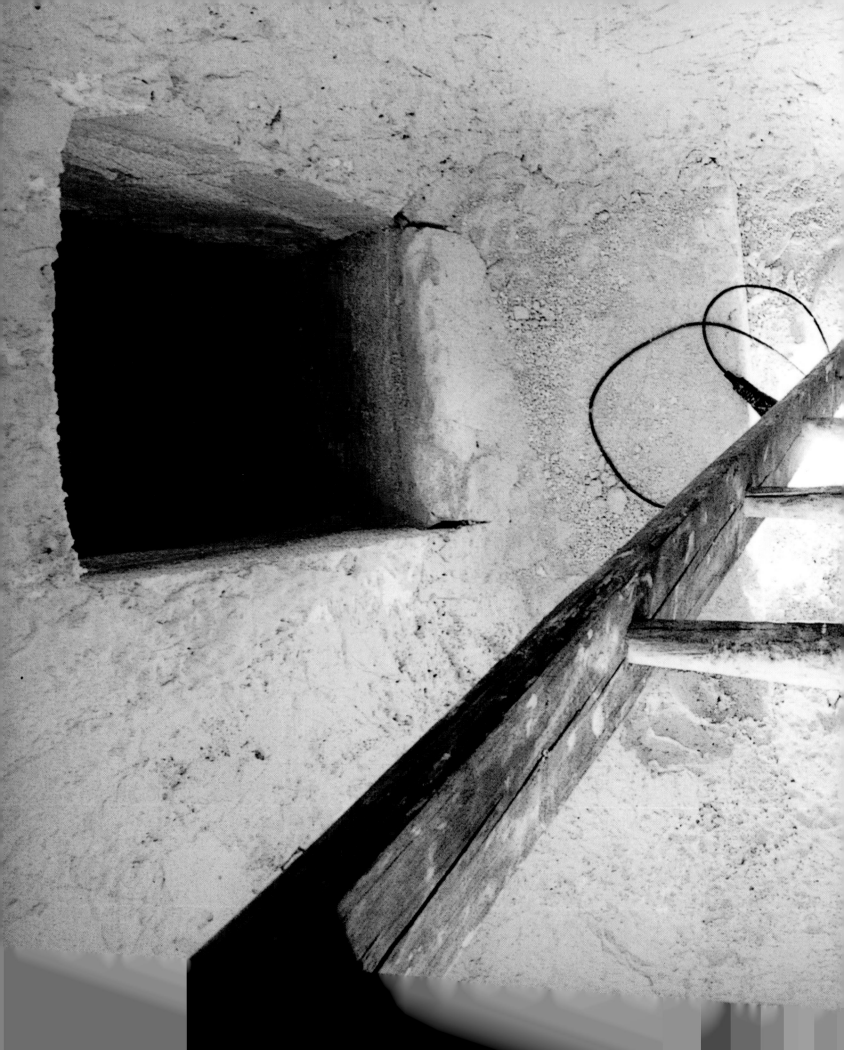

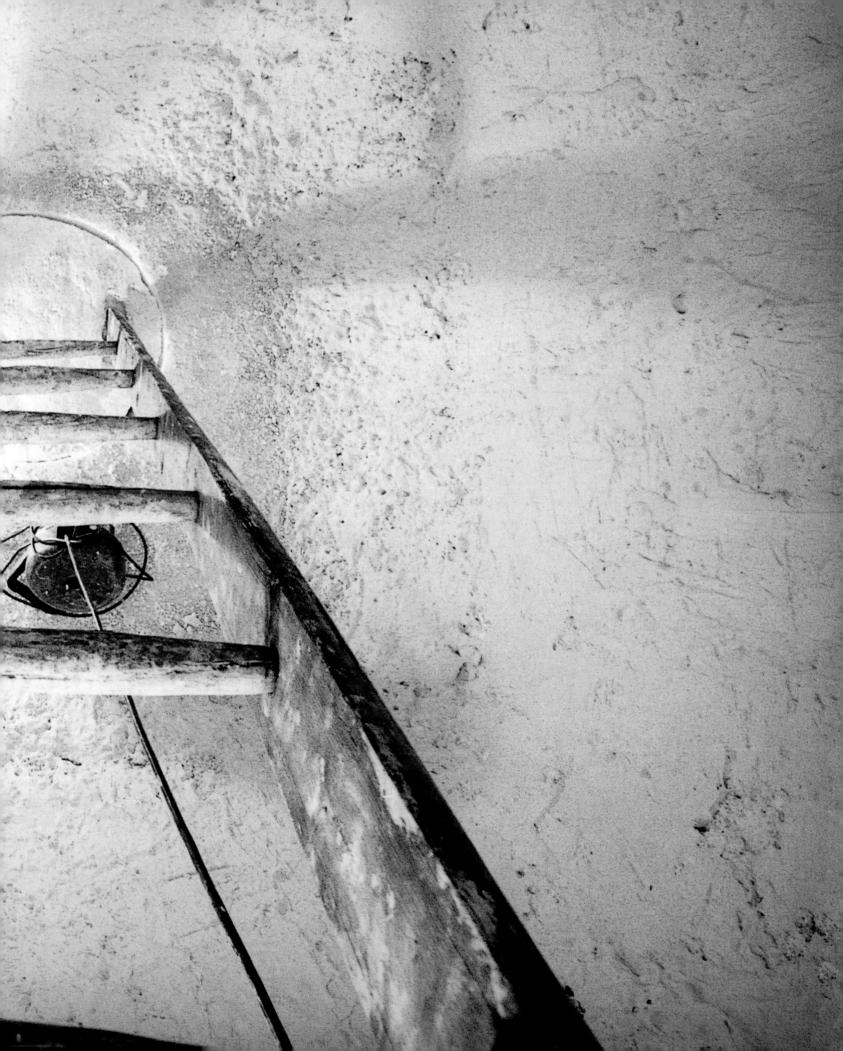

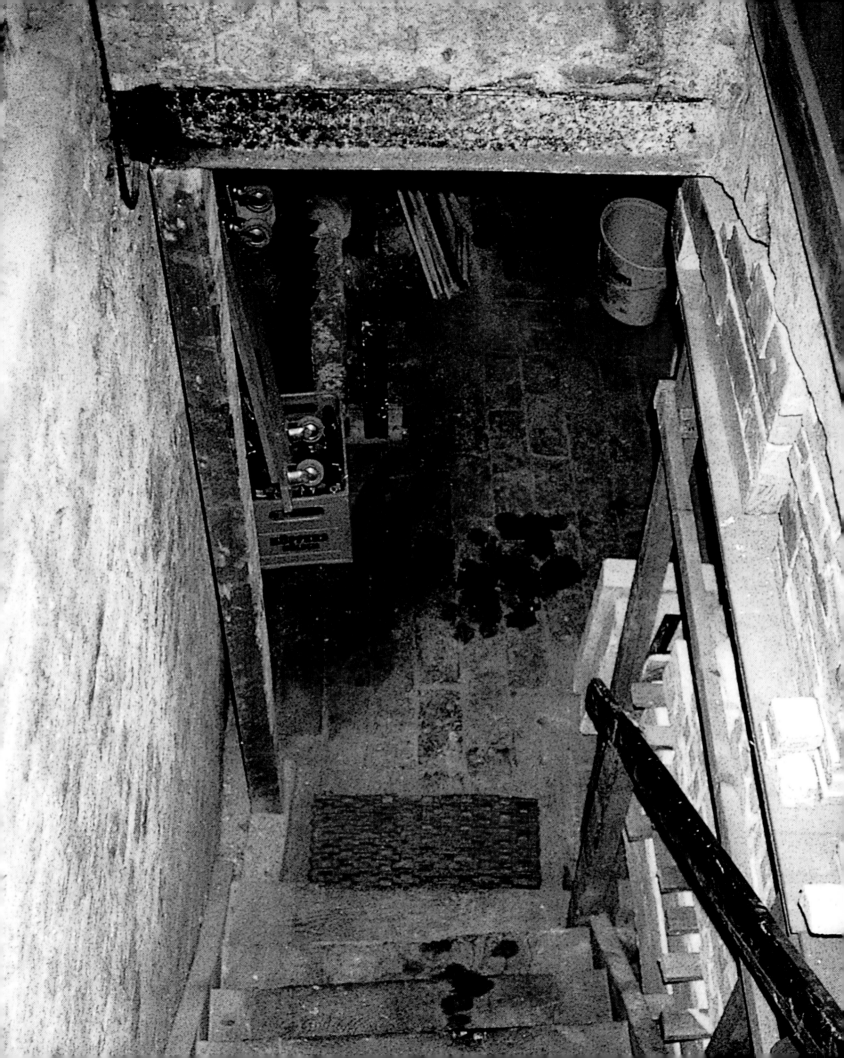

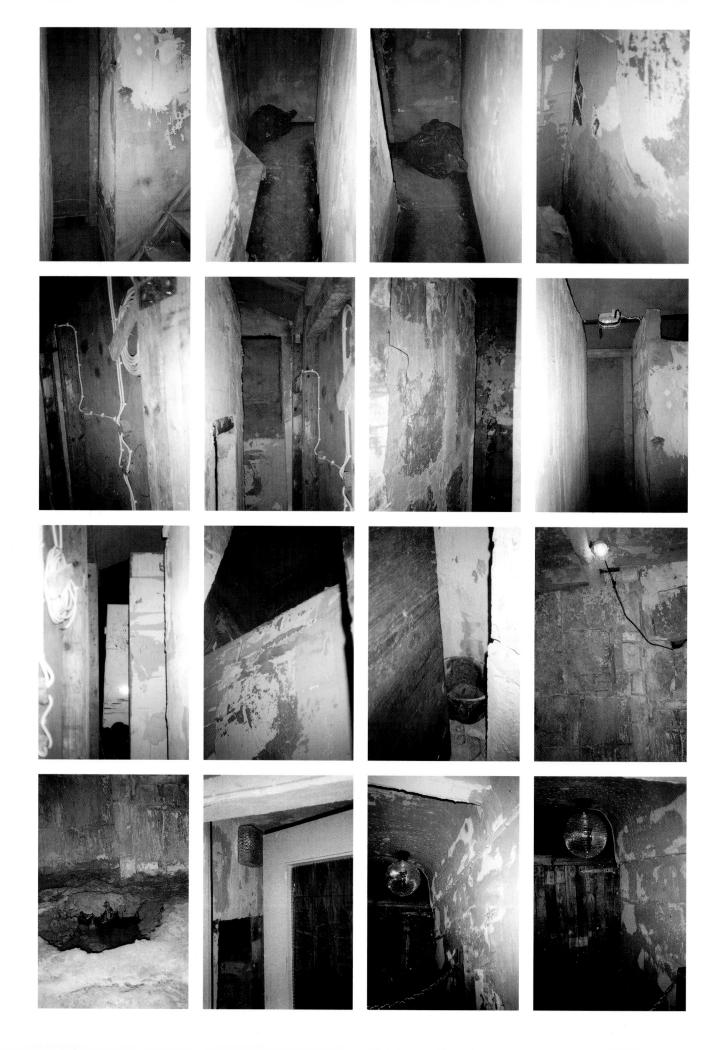

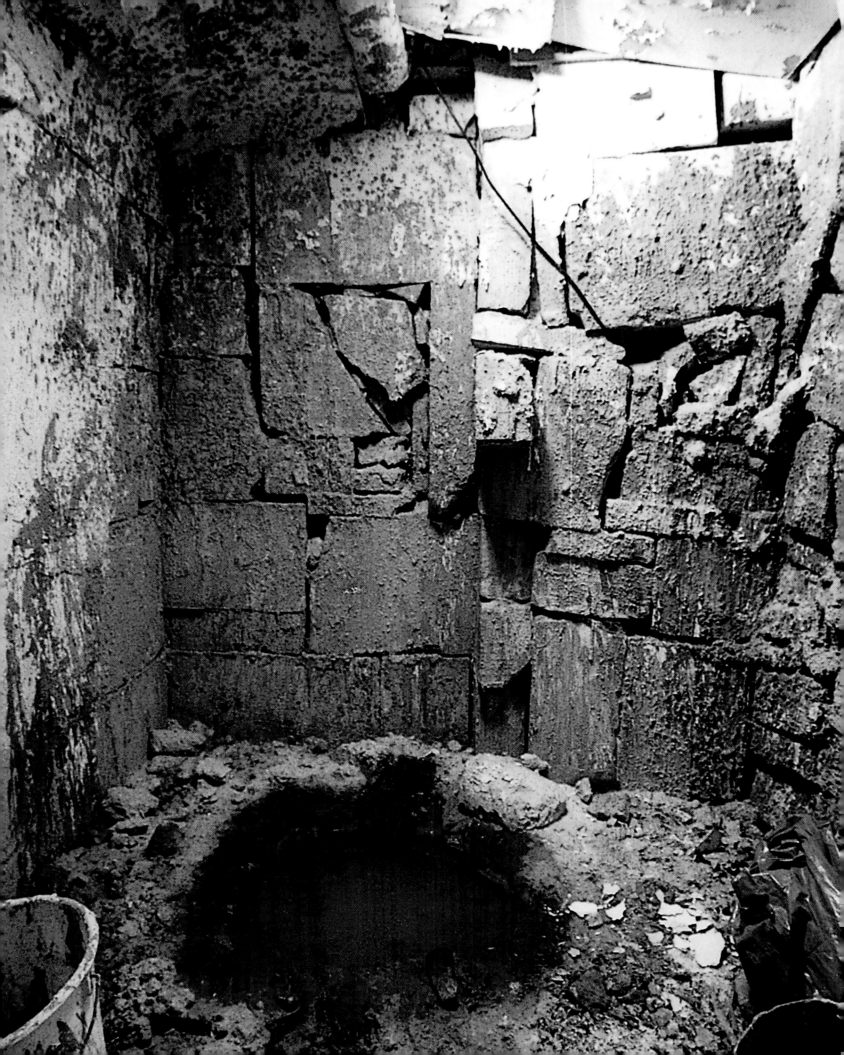

LUC TUYMANS

BEHIND THE MASK

Luc Tuymans once said, 'For me, it's impossible to make a joyful painting.'[1] Painting, for him, is not, and cannot be, a form of escape from reality. It does not prettify the world, making it acceptable for visual consumption; rather, it reveals the harshness and cruelty of things. A child's room is prepared. The bed is yet to be made but there is already a pillow propped carefully against the headboard. A small chest of drawers and a wardrobe stand against the far wall and a table and chair are placed in the middle of the floor. The colour scheme involves the pastel shades of blue and pink traditionally associated with childhood. *Silent Music* (1993) could be an uncontentious image of nurture until we notice that the table isn't really suitable for a child, and that anyway the chair is slightly too large in proportion to it. Then the flat plane of the wardrobe door becomes a blank, mute presence, as threatening as the substantial shadow of the table and chair that falls across the carpet; a shadow whose direction conflicts with that cast by the wardrobe behind. Soon this room comes to seem like a place of confinement – almost of horror – and, since all children's rooms are prepared for them by adults, childhood itself becomes a site of coercion and subjugation.

Tuymans was born in Belgium in 1958 and continues to live and work in Antwerp. Although far from traumatic, his own childhood is something he recalls as unhappy, and in talking about his work he returns again and again to a language of conflict, describing painting as an act that 'requires a kind of aggression and violence',[2] and stating elsewhere that 'violence is the only structure underlying my work'.[3]

Sometimes his titles alone are sufficient to signal this violence. *Gas Chamber* (1986), taken from a photograph of the eponymous room at Mauthausen concentration camp, shows a bleak and empty space. In the foreground there is a drain in the floor, and in the far, shadowed corner, a darkened doorway. On the ceiling above, several dark brush marks suggest fixtures and fittings whose function we can easily guess at. In another canvas, the colourful, simplified imagery – a stylised cat silhouette, a sandbox and some other rectangular and circular shapes – is given the title *Child Abuse* (1989). Surrounded by a solid black line, the otherwise pleasant pastel-blue cat shape becomes, in the light of the title, an over-large, minatory presence.

Violence is visible, as we have seen, in the subject matter and content of Tuymans's paintings. But it is also a part of the process of their making. The succulent fullness of the flower in *Orchid* (1998, see p. 82), for example, is cropped sharply by the painting's edges. To top and bottom, left and right, the space of the canvas is insufficient to accommodate either the full spread of the petals or the length of the stem. Its cramped dimensions sever the flower in a way which Tuymans refers to as almost sexual. At the same time, the surface is suffused with a greenish light that intimates both the desirability of organic naturalness and the poisonous loathesomeness of artificiality. An affinity exists between the cropped and truncated forms which appear in Tuymans's paintings, and the painful but effective cut-and-suture process of film editing. In the 1980s, Tuymans stopped painting for a short time and began to work with film. Although he soon returned to painting, the experience was significant for the development of his work. Tuymans sees film and painting as akin in that the imagery in both media has to be created through selection, isolation, framing, juxtaposition, foregrounding and so on. There is, too, in Tuymans's painting, a sense of distillation that accords with his habit of trying

LUC TUYMANS, *CHILD ABUSE*, 1989
55 × 65 cm
Oil on canvas
Private collection
Courtesy Zeno X Gallery, Antwerp

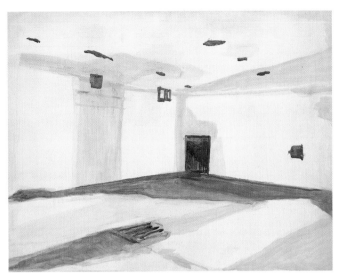

LUC TUYMANS, *GAS CHAMBER*, 1986
50 × 70 cm
Oil on canvas
Private collection
Courtesy Zeno X Gallery, Antwerp

to fix upon the one image from a film that will serve to unlock the rest of its narrative flow to the imagination. Tuymans uses photographs extensively as source material for his works. They help, he says, 'in the search for the stability of the picture'.[4] Unlike, say, Gerhard Richter, though, Tuymans does not project them onto the canvas to be copied. That would be to succumb to the idea of art as representation, art as the aestheticising of the world. Images are instead explored through drawing and watercolour until the composition is finalised. The paintings themselves are usually done in one go, but always within the space of a single day. Only then are they stretched, only then, as Tuymans says, can the image become an object.[5]

The divergent possibilities in the green of *Orchid* are neither merely the product of a playful ambiguity, nor are they an instance of the kind of estrangement from the things of the world that we normally refer to as uncanny. Uncanniness pulls us into the realm of the psychological, and asks us to consider motivations and desires, to reach into mental and emotional depths, in order to understand. But understanding offers explanations, it assuages terrors and guilt, leaving us more comfortable with ourselves. Tuymans's paintings – those of people as much as of objects and spaces – do not delve in that way. They reduce detail and pare down features until we are left not with the mere surface of things, but with that surface as mask, a mask that blindfolds 'a space of mirrors'.[6] A portrait of the Belgian writer Ernest Claes, *A Flemish Intellectual* (1995, see p. 73), depicts him as just such a mask. Originally shown as part of a group of works under the overall title *Heimat*, the figure presents the idea of national identity as hollow and without substance. As if to corroborate this suspicion of any kind of nationalist rhetoric, when the painting was shown in Berlin the glasses

and facial hair were sufficient for people to assume it was a portrait of Sigmund Freud. The ambiguity of the painting offers us an icon as nothing more than a form, an empty shell to be filled with bile and divisiveness. Getting behind the mask, penetrating Tuymans's 'space of mirrors', is more a surgical than a psychological process. Walter Benjamin was right to describe the eye that sees through the lens of a film camera as functioning like a surgeon's scalpel, opening up the body of a space.[7]

The development of the detached involvement in things that Tuymans achieves in his art reached an important point in 1992 with the series *Der diagnostische Blick* (see p. 72), which used a medical textbook as its source material. The photographs in the book showed no interest in their subjects as individuals, revealing instead the objective, appraising examination of the diagnostic eye that could treat each incidence of a disease as a simple case study rather than as an affecting human tragedy. This deliberate avoidance of emotional engagement is carried over into the ten paintings of Tuymans's sequence. The gaze of the subjects is not captured. Even when they appear to be looking straight out of the canvas there is an emptiness in their expressions that rejects any attachment on the part of the viewer. Later in the sequence, faces give way to isolated body parts such as a breast, or an area of skin with lesions, and this shift reinforces the fact that all the paintings – including the heads – are of bodily fragments and not details of a whole. A diptych, *Repulsion* (1991, see p. 73), from the year prior to this series, sets up a different relationship with the viewer while still using the viciously cropped body. Here it is closeness to the subject that strikes one. Flesh from some indeterminate part of the body fills one canvas, while

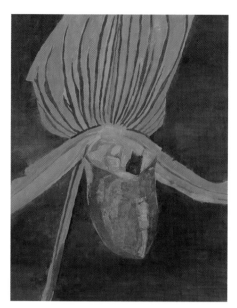

LUC TUYMANS, *ORCHID*, 1998
99.5 × 76.7 cm
Oil on canvas
Private collection, New York
Courtesy Zeno X Gallery, Antwerp

LUC TUYMANS, *DER DIAGNOSTISCHE BLICK VII*, 1992
65.5 × 45.5 cm
Oil on canvas
Collection Kaiser Wilhelm Museum, Krefeld
Courtesy Zeno X Gallery, Antwerp

the other shows a girl's knee in the extreme foreground set off against a flat, featureless landscape by the shadow it throws on the ground. Brought into such close proximity, we are forced to become accomplices to the brutalising gaze that appropriates, victimises and chops this body into pieces, instead of experiencing it in its wholeness. One feels the suffocating obscenity of extreme close-up that makes monsters of us all.

There is a connection here with the dehumanising gaze of pornography. In his notes on *Repulsion*, Tuymans wonders about the problem of how to avoid cliché in the depiction of the sex act.[8] One way, evident in the canvas *Pillows* (1994, see p. 75) that is included in 'Apocalypse', is through the use of metonymy. Derived from an image in a pornographic magazine, this painting of pillows on a double bed is rendered somewhat in the style of a landscape by Cézanne. While there is no visible human presence in the painting, its space is nonetheless peopled by those from whose stories this image is a still. What those stories are though, as Nancy Spector has written, will not and cannot be revealed: 'Conjecture prevails over clarification... suspicion looms and questions are never answered.'[9]

With *Pillows*, as with, for example, *Silent Music* or *Child Abuse*, the disturbing aspects of the painting – the things that happen, as it were, before, after and around what we see on the canvas – do not strike us immediately or forcibly, but reveal themselves slowly, through a growing awareness of the implications of what is visible. Accompanying *Pillows* in 'Apocalypse', we see other canvases depicting a broad range of subject matter: a deceased woman wearing orange-tinted glasses; a bush with red flowers; a youngish, bearded man; a maypole; some make-up; and an X-ray of the spinal column. Together they make

a grouping that offers no simple, immediate unifying theme. Within an exhibition whose title is as bombastic as 'Apocalypse', though, Tuymans is concerned to assert a presence without being similarly over the top: 'The place should be muted and silenced.' He talks much of the bleeding of colour, something which is evident in the suffusing greenness of *Pillows*, the orange-tinted glasses in *Portrait 'Old Lady'* (see p. 76), the blue make-up blobs of *Cosmetics* (see p. 78) and the red flowers of *Embroidery* (see p. 80), a painting which confounds the precision implied in its title, with its smudged forms produced by the wiping away and repainting characteristic of Tuymans's wet-on-wet technique. *Portrait* (see p. 77), a man with a beard who is conceived as a kind of perverted image of an Oberammergau Christ, is not so much smiling as smirking, a self-indulgent image with maybe a sense of the homoerotic about it. Originally taken from a photograph of a man having a tattoo – though this is not seen in the painting – this image has again a heightened sense of colour. Seen across the collection of paintings, the bled colour might be representative or indicative of a 'certain type of loss', or 'a failed preservation'.

Maypole (see p. 81), the most recent painting, is a small, focused image on a larger, grey/white backdrop. Taken from a photograph Tuymans has used once before, in 1987, it shows a group of people in white shirts, leather shorts and knee-length socks erecting a maypole on open ground in front of a church. The scene celebrates aspects of folklore, and was originally printed in the German propaganda magazine, *Signal*. Finding several years' worth of back numbers of the publication, which had been translated into Flemish during the war, in a second-hand bookshop, Tuymans was struck by the particular quality of the illustrations. Colour printing was still

LUC TUYMANS, *A FLEMISH INTELLECTUAL*, 1995
89.5 × 65.5 cm
Oil on canvas
Collection Musée des Beaux-Arts de Nantes
Courtesy Zeno X Gallery, Antwerp

LUC TUYMANS, *REPULSION*, 1991
Diptych: 31 × 37.5 cm, 42 × 41 cm
Oil on canvas
Private collection, Switzerland
Courtesy Zeno X Gallery, Antwerp

relatively new then, and the overprinting of the various separations
needed for the image had produced a result which Tuymans describes
as airless. Coupled with a slight indistinctness in the detail, this stifling
quality presents the folkloric revivalism which the photograph aims to
celebrate as an overbearing menace. Originally Tuymans showed the
print itself, subverting the obscene seamlessness of its propagandistic
message by cutting two small squares out of it. Set against the much
bigger background in this new painting, the small image becomes
larger than life. The reference Tuymans suggests is to Géricault's
huge *Raft of the Medusa* (1819) – a failed masterpiece, or perhaps
a masterpiece of failure.

'Nostalgia', as Tuymans says, 'is horrific', and, as a counter to its
pernicious, debilitating and destructive energies, he quotes a line
from Robert Wilson: 'A tree is best measured when it is down.' MA

(pp. 66–69)
LUC TUYMANS, 2000
Photographs by Norbert Schoerner

(p. 74)
LUC TUYMANS, *LAMPROOM*, 1992
48.5 × 55.7 cm
Oil on canvas
Courtesy David Zwirner Gallery, New York

(p. 75)
LUC TUYMANS, *PILLOWS*, 1994
54.5 × 67 cm
Oil on canvas
Carnegie Museum of Art, Pittsburgh. A. W.
Mellon Acquisition Endowment Fund, 1998

(p. 76)
LUC TUYMANS, *PORTRAIT 'OLD LADY'*, 2000
67 × 39 cm
Oil on canvas
Private collection, Chicago
Courtesy Zeno X Gallery, Antwerp

(p. 77)
LUC TUYMANS, *PORTRAIT*, 2000
56.5 × 30 cm
Oil on canvas
Private collection, Holland
Courtesy Zeno X Gallery, Antwerp

(p. 78)
LUC TUYMANS, *COSMETICS*, 2000
85 × 60 cm
Oil on canvas
Private collection, Belgium
Courtesy Zeno X Gallery, Antwerp

(p. 79)
LUC TUYMANS, *REUNTGEN*, 2000
111 × 81 cm
Oil on canvas
Courtesy Zeno X Gallery, Antwerp

(p. 80)
LUC TUYMANS, *EMBROIDERY*, 1999
Oil on canvas
143.5 × 183.5 cm
Private collection, Los Angeles
Courtesy Zeno X Gallery, Antwerp, and David
Zwirner Gallery, New York

(p. 81)
LUC TUYMANS, *MAYPOLE*, 2000
234 × 118 cm
Oil on canvas
Courtesy Zeno X Gallery, Antwerp

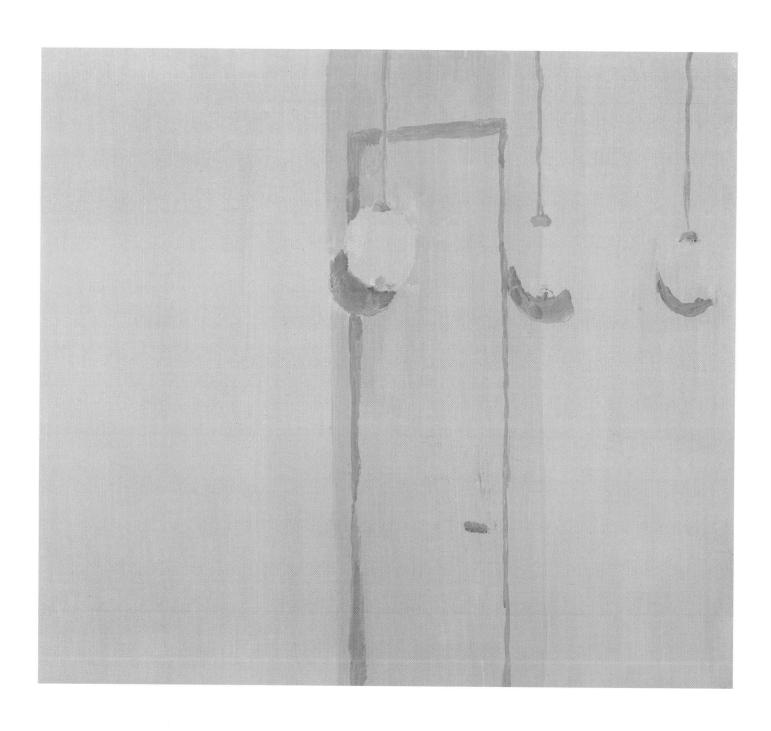

MAURIZIO CATTELAN

TRAGIC PANTOMIME

In one of the most celebrated manifestos of the postwar period, *Arte Povera: Notes for a Guerrilla War* (1967),[1] the Italian critic Germano Celant urged the contemporary artist to 'shift his position continuously, to throw off the cliché that society has attached to him'. Only in this way would he be a 'guerrilla warrior' with 'an asystematic way of existence, in a world in which the system is everything'. Since then, many Italians have aspired to the condition of cultural guerrilla, but few have espoused this credo with the zeal of Maurizio Cattelan – a factor which may explain why Celant selected him for the Italian Pavilion at the 1997 Venice Biennale.

Cattelan was born into a working-class family in Padua in 1960. He did not go to university, and changed jobs several times, working variously as a cook, gardener, nurse and mortuary attendant. He only started to make art in the mid-1980s, and his first exhibition took place in 1989. His earliest pieces were a series of anthropomorphic objects, and he also designed some furniture which was commercially produced.

Although many of his anthropomorphic objects had a quasi-domestic function, they were not fully domesticated. Cattelan made an armchair from a discarded rusty metal frame covered in chicken wire (*King for a Night*, 1988); he mounted light bulbs on prickly iron stalks (*Triffids*); and he constructed a folding screen from sheets of plate glass which incorporated soil, out of which plants sprouted (*Hinges*).

These furniture sculptures draw on the tradition of the Surrealist 'disagreeable object'. The chair brings to mind a remark by Salvador Dalí, himself an occasional designer of chairs: 'A chair can be used to sit on, but on condition that one sits on it uncomfortably.'[2] In Cattelan's artistic universe – for better or for worse – you are not supposed to settle. To this end, he claims to have no permanent base, and says that he prefers to live and work *in situ*.

In Cattelan's subsequent work, a chair is often a trap and sitting still is a kind of death. In *Charlie Don't Surf* (1997) a mannequin of a boy sitting at a desk has had his hands nailed to the desk by pencils; in the lugubrious *Bidibidobidiboo* (1996), a taxidermised squirrel seated at a miniature dining table has just shot itself with a toy gun. Cattelan has also made lifelike but shrouded effigies of tramps who sit on boxes in city streets, slumped against a wall (*Andreas e Mattia*, 1996).

Cattelan made his name with *AC Forniture Sud* (1991), his most ambitious piece of furniture sculpture. Exhibited at the Galleria d'Arte Moderna in Bologna, this was a table-football game which had been massively elongated and adapted for use by two teams of eleven male players. One of the teams was made up of Senegalese immigrants and called AC Forniture Sud (AC Southern Supplies), an allusion to the exploitation of immigrants as cheap labour; the opposing team was made up of Northern Italians. The contest was overseen by a referee. This elaborate spectacle drew attention not only to racism, but perhaps also to the ability of sport to overcome it. In subsequent museum showings, visitors were allowed to play – on their own, or in teams, as they wished – and several balls were in use at the same time. Although the game was now played in a less structured way than before, it made a more general point about entrapment. The massively elongated table, with its numerous anonymous skittle figures, implies that the players may be involved in some endless, Sisyphean struggle.

MAURIZIO CATTELAN, *KING FOR A NIGHT*, 1988
Found metal armchair frame, chicken wire
Child size
Private collection
Courtesy Marian Goodman Gallery, New York

MAURIZIO CATTELAN, *AC FORNITORE SUD (SOUTHERN SUPPLIERS FC)*, 1991
Wood, glass, metal, iron
700 × 100 × 120 cm
Installation at the Galleria d'Arte Moderna, Bologna
Private collection

Escaping from one's allotted role and obligations is one of Cattelan's central themes. In 1989, he avoided participating in an exhibition by sending a doctor's report to the museum director, and this became his exhibit: *Untitled (Doctor's Certificate)*. In 1992, unable or unwilling to produce a work for an exhibition, Cattelan reported the theft of an invisible artwork to the police on the night before the opening. He then framed the police report and exhibited that in the gallery (see p. 88). It carefully noted the theft of a work entitled 'INVISIBLE' from Cattelan's girlfriend's car. In *Una domenica a Rivara* (1992), he 'escaped' from a gallery the evening before his exhibition was due to open by using a rope of knotted sheets hung from a window; this remained his only contribution (see p. 90). Pathos underpins the humour, however, for in all these works the artist is envisaged as a victim – of illness, robbery and injustice.

On other occasions Cattelan has arranged for his dealers, gallery attendants and other artists to fill in for him, thereby poking fun at the workings of the art world. For the duration of an exhibition in a gallery in Paris, Cattelan persuaded Emmanuel Perrotin, the gallery owner, to wear a specially designed costume that alluded to his reputation as a philanderer. Fabricated from bright pink material, *Errotin, le Vrai Lapin* (1995) was a pneumatic hybrid of a rabbit and male genitals (see p. 89). In *Dynamo Secession* (1997), enacted in a gallery in Vienna, two security guards rode bicycles with dynamos that were wired up to a light in the gallery whose brightness depended on the speed at which they cycled.

In 1997, Cattelan arranged for a man to attend the opening of an exhibition in Santa Fe wearing a gigantic portrait head of Georgia

O'Keefe (*Georgia on My Mind*), whose museum was situated a few blocks away. The next year at the Museum of Modern Art, New York, a man wearing a giant head of Picasso greeted visitors, and posed with them for photographs. Cattelan explained that he 'didn't understand why [museums] didn't embrace a more visible means of marketing and promotion. They shouldn't be ashamed.... In any case, they are already selling coffee mugs, T-shirts, calendars and posters.'[3] In these works, Cattelan mocks the increasing vulgarity of the art world, wondering whether art can survive on its own merits without such stunts.

Cattelan is best known for macabre yet witty installations which feature taxidermised animals. Unlike Joseph Beuys, who locked himself in an enclosure with a live coyote, or Damien Hirst, who preserved a shark in formaldehyde, Cattelan tends to use harmless working animals, minor pests, or pets and children's toys. Decidedly non-heroic, banal even, his creatures are symptomatic of a bland, bourgeois world in which nature has been more or less tamed.

In the 1970s and 1980s, many Italian artists and writers were examining what might be called the tragi-comedy of animality. This was in part a response to the huge postwar migration of Italian workers from the rural south to the booming cities of the industrial north. Italian artists and writers regretted the fact that modern man, 'exiled' to the cities, was increasingly cut off from nature, while at the same time realising that nature itself was a spent force – overcooked and emasculated rather than raw and potent.

Dogs featured prominently in the work of the artists of the so-called Transavanguardia, a group of neo-Expressionist figurative painters.

ENZO CUCCHI, *A PAINTER'S EARTH PAINTINGS*, 1980
Oil on canvas
201.5 × 220 cm
Courtesy Stedelijk Museum, Amsterdam

MAURIZIO CATTELAN, *UNTITLED*, 1992
Police report of stolen invisible artwork
29.5 × 21 cm
Private collection
Courtesy Massimo de Carlo, Milan

But in Enzo Cucchi's ultra-earthy landscape painting, *A Painter's Earth Paintings* (1980), it is only a Jack Russell that hurtles along – on a long lead. In his 1987 manifesto, *Sparire*, Cucchi lamented: 'A puppy pees in the middle of the pavement, and trembles with life...but is no longer ferocious...men can now kill it as they like, they who once defended themselves from animals.'[4]

A table designed by Cattelan for commercial production seems to encapsulate his feelings about the status of animals – and of animality – in modern society. It is called *Cerberino*, which means in colloquial Italian 'little watchdog'. The name derives from Cerberus, the three-headed dog who guarded the gates of the underworld. Now, it seems, the fearsome monster has been neutralised and turned into a piece of furniture around which the whole family gathers. The emasculation continues in *Good Boy* (1998), a taxidermised lapdog curled up on the floor of a gallery, and in *Pluto* (1998), the skeleton of a small dog that waits for its master with a newspaper in its mouth (see p. 91). The dog-owner's heaven was, it seems, pet hell. Once again, though, Cattelan implies that if you settle down – animals as well as men – you're as good as dead.

If a Tree Falls in the Forest and There Is No One around It, Does It Make a Sound? (1998) consists of a taxidermised donkey with a television set tied to its back. It looks as though television is coming for the first time to a rural community. Christ is usually portrayed on a donkey, but today TV appears to have taken the place of the great redeemer. The work expresses everything that the writer and film-maker Pier Paolo Pasolini used to rail against. Until his death in 1975, Pasolini fought to preserve regional peasant dialects, and called

for the banning of television. In an essay entitled 'Linguistic Analysis of a Slogan', he attacked the 'fake expressiveness' of slogans: 'It is the symbol of the linguistic life of the future, that is, of an inexpressive world, without particularisms and diversity of culture, totally ratified and cultivated. Of a world which to us, last holders of a multiform, magmatic, religious and rational vision of life, seems a world of death.'[5] Cattelan's title is a question that was designed to demonstrate Werner Heisenberg's Uncertainty Principle, which claimed that there is no such thing as a given reality: things can only exist if and when they are observed. The title is an ironic, if forlorn, attempt to use philosophical language that is the diametric opposite of a slogan. In this case, the answer might be that no one hears *anything* any more except the incessant din of TV.

The most troubling and controversial of these animal pieces is *Novecento* (1997, see p. 92). It consists of a taxidermised horse, hanging from the ceiling of the gallery, its unnaturally elongated legs dangling in mid-air. The work is a variation on the theme of the equestrian monument, a genre common in Italy in which horses are customarily found standing high up in the air on pedestals. One of the most celebrated, Donatello's *Gattamelata Monument*, is sited in front of the cathedral in Padua. As a child, Cattelan saw it almost every day as his school was nearby. The horse is a majestic beast, and Gattamelata a fully armed mercenary, and it is a testimony to his prowess that he can even begin to control it. Cattelan's horse, however, is a pathetic misfit. It is an equestrian monument which has lost – or been abandoned by – its rider and pedestal. The title implies that horses have been left behind by the march of history, as indeed they have. The world no longer needs them, least of all such knackered and

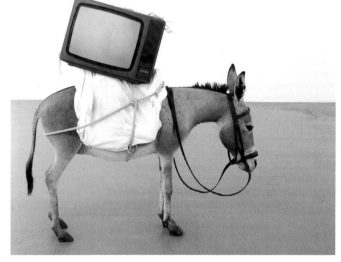

MAURIZIO CATTELAN, *ERROTIN, LE VRAI LAPIN (A)*, 1995
Costume worn by Emmanuel Perrotin
Installation at Galerie Emmanuel Perrotin, Paris
Private collection

MAURIZIO CATTELAN, *ERROTIN, LE VRAI LAPIN (C)*, 1995
Costume worn by Emmanuel Perrotin
Installation at Galerie Emmanuel Perrotin, Paris
Private collection

MAURIZIO CATTELAN, *IF A TREE FALLS IN THE FOREST AND THERE IS NO ONE AROUND IT, DOES IT MAKE A SOUND?*, 1998
Taxidermised donkey, television, rope, blanket
Life size
Installation at Museum für Gegenwartskunst, Zurich
Courtesy Museum für Gegenwartskunst, Zurich

bedraggled ones. It is as if the elongated legs have tried sadly to reach out to the ground, and perhaps even to the viewer.

Religious reaching out or yearning was tackled in two works of 1999, *Mother* and *La Nona Ora*. In *Mother* (see p. 93), a fakir was buried in earth, with only his forearms projecting out of the ground, his palms held together in prayer. It seems like an image of blind and rather preposterous faith – the kind of grotesque scenario one might find in satires such as Voltaire's *Candide* or Monty Python's *Life of Brian*. One might think that the fakir's hands would be better employed in clearing away 'mother' earth than in praying. This performance piece suggests that religion makes willing victims of us all.

La Nona Ora (*The Ninth Hour*) (see pp. 94–97) is a fully dressed life-size waxwork of Pope John Paul II who has been poleaxed by a meteorite. He lies on a red carpet with the rock embedded in his side. Broken glass, from where the meteorite crashed through the roof, lies on the floor. Like the apostle Peter, the Pope is the rock of the Church, and yet here, with tragic irony, he is crushed by a rock. The title refers to the hour of Christ's death. It sounds as though it ought to be a terminal image.

From the impassive expression on the Pope's face, he appears unaware of his predicament. He still holds a cross before him. To an extent, *La Nona Ora* is about blind faith – an elderly pope soldiering on as he and the Catholic Church are run into the ground.

There are no signs whatsoever of physical damage, however. The Pope sheds no blood, and there are no marks or tears on his white vestments.

Cattelan leaves the way open to us to think that we are witnesses to a miracle – the moment when the Pope was struck by a meteorite but emerged unscathed. The work recalls images of Saul struck down on the road to Damascus, yet there is a complete absence of emotion. He could almost be a mannequin in a game of celestial table football, with the meteorite as the ball.

After this hit, the Pope looks eminently capable of bouncing back and going on with his journey. Certainly a work dealing with a near-death experience can't be ruled out from an artist who is the author of so many tales of the unexpected. JH

(pp. 82–85)
MAURIZIO CATTELAN, 2000
Photographs by Norbert Schoerner

(p. 90)
MAURIZIO CATTELAN, *UNA DOMENICA A RIVARA*, 1992
Knotted cotton sheets
Variable dimensions
Installation at Castello di Rivara, Italy
Private collection
Courtesy Massimo de Carlo, Milan

(p. 91)
MAURIZIO CATTELAN, *PLUTO*, 1998
Skeleton of dog, newspaper
Life size
Courtesy Galerie Emmanuel Perrotin, Paris

(p. 92)
MAURIZIO CATTELAN, *NOVECENTO*, 1997
Taxidermised horse, leather saddlery, rope, pulley
200.5 × 269 × 68.5 cm
Installation at Castello di Rivoli, Museo d'Arte Contemporanea, Turin
Private collection

(p. 93)
MAURIZIO CATTELAN, *MOTHER*, 1999
Fakir buried in earth
Installation at XLVIII Venice Biennale
Private collection
Courtesy Marian Goodman Gallery, New York

(pp. 94–97)
MAURIZIO CATTELAN, *LA NONA ORA* (*THE NINTH HOUR*), 1999
Carpet, glass, wax, paint
Life size figure
Installation at the Kunsthalle Basel
Private collection
Courtesy Anthony d'Offay Gallery, London

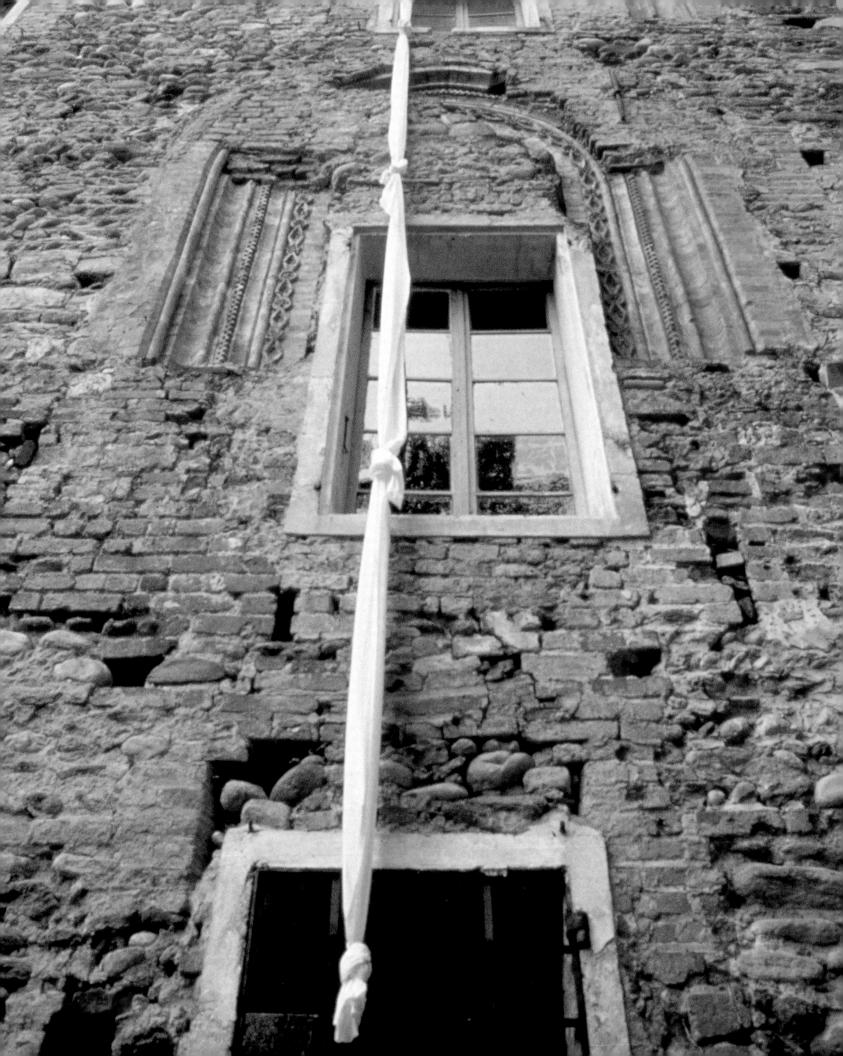

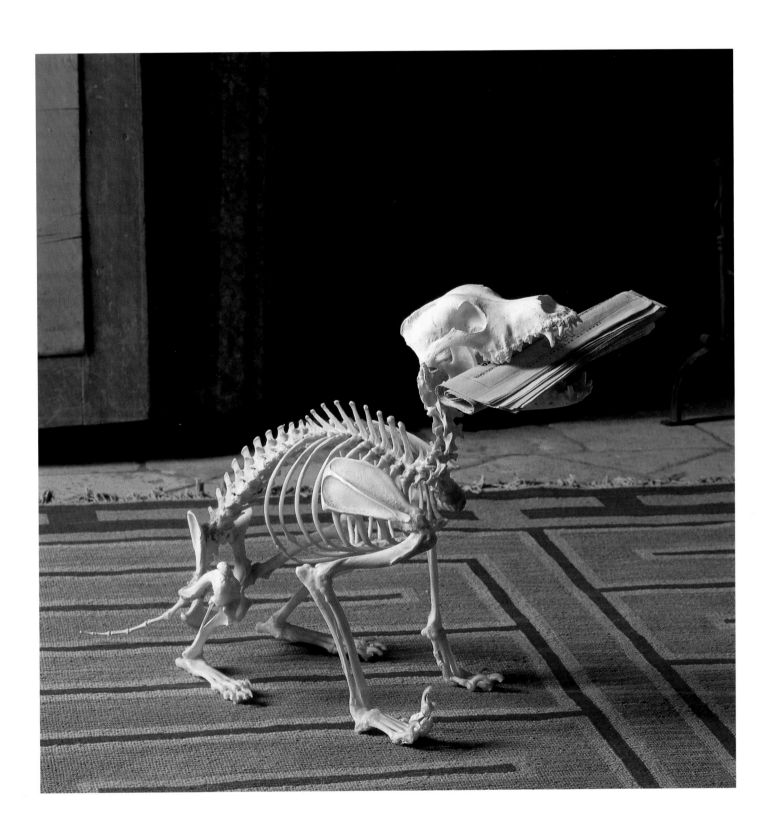

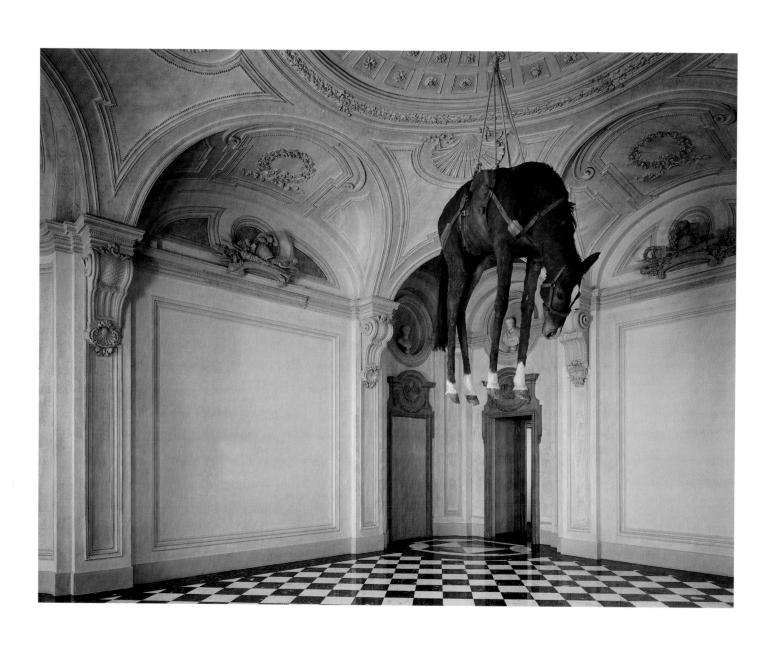

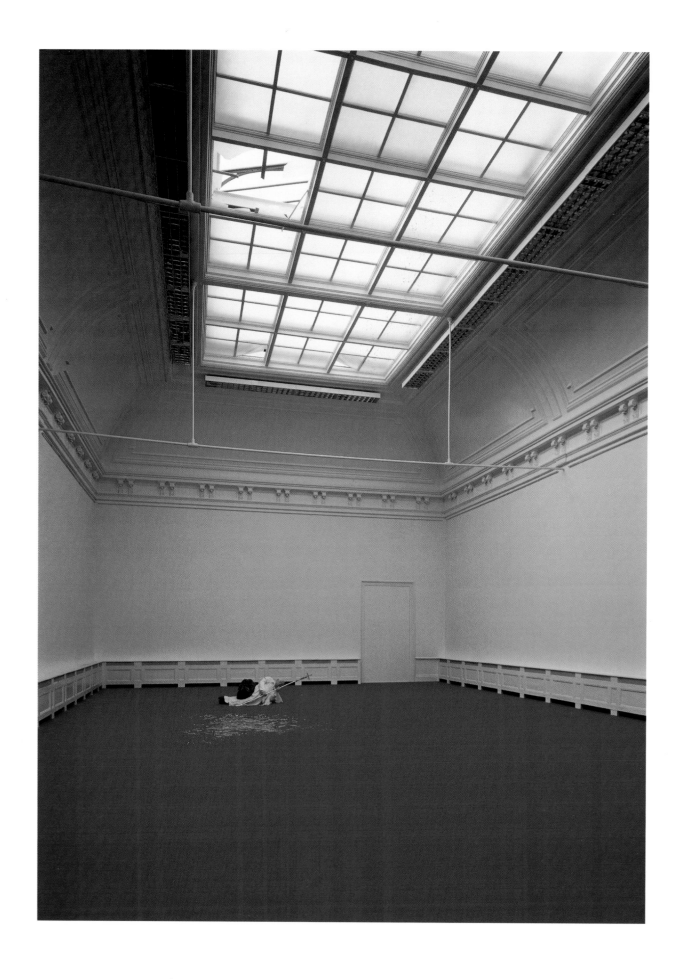

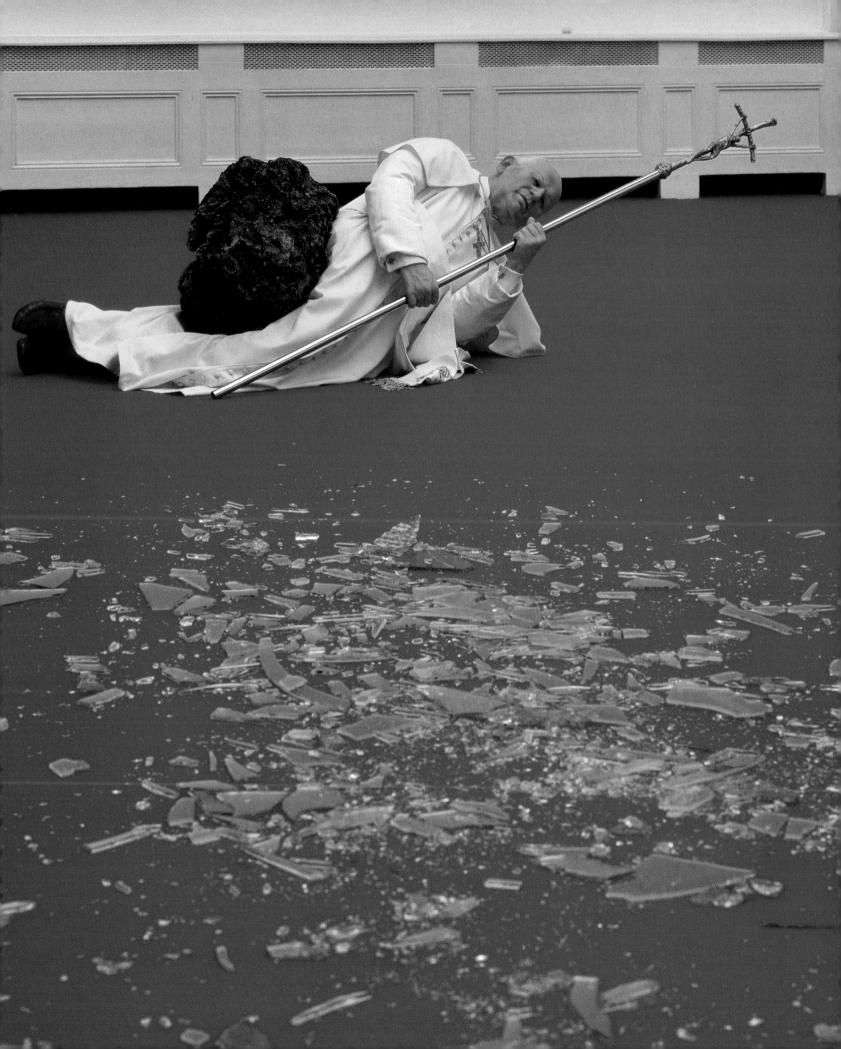

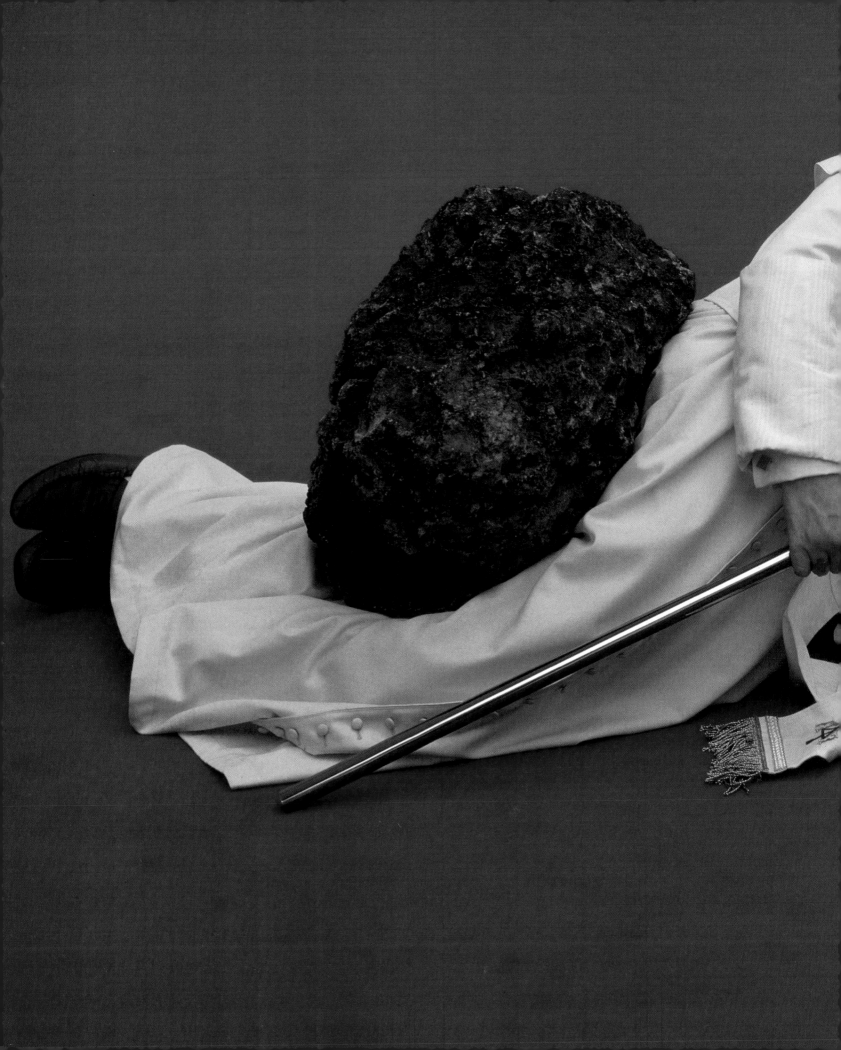

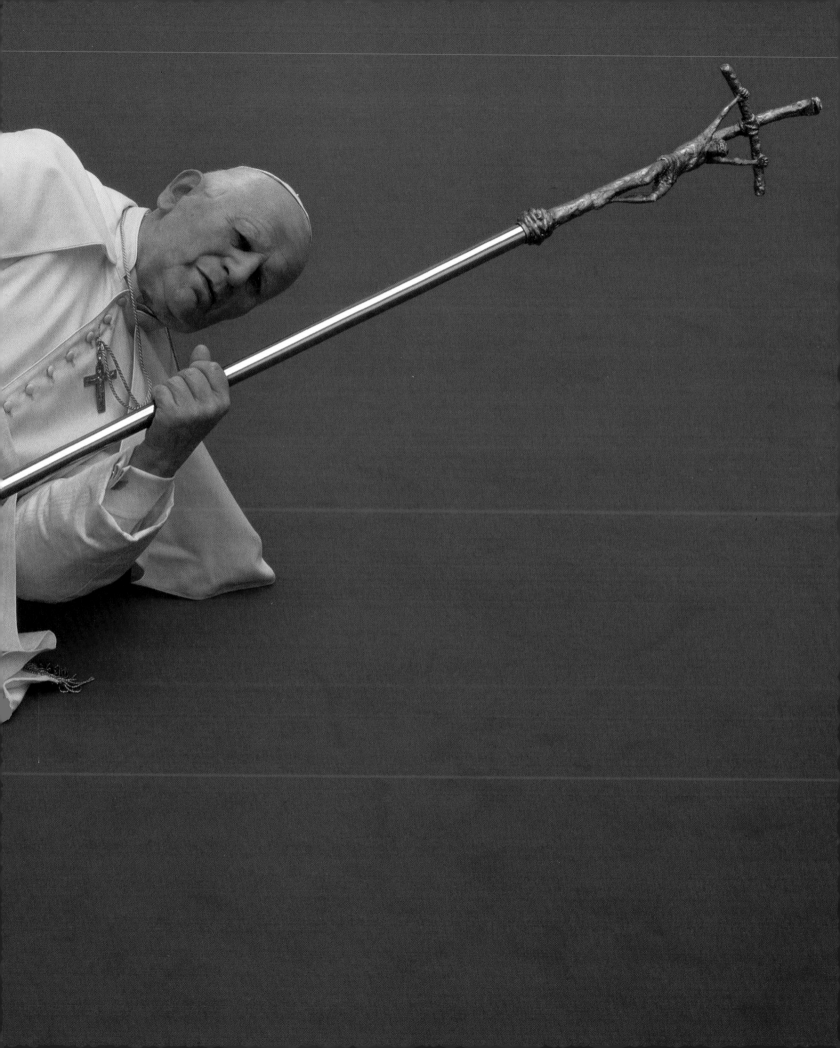

MARIKO MORI

THE EVE OF THE FUTURE

*You seem more distant than the distant boat
more distant yet as it rows out from Kumano.*
Lady Ise, *Shinkokinshū*, 1048[1]

*As he spoke, Edison's...eyes seemed to be probing imaginary
shadows....*
*But today, he resumed.... Science has multiplied her discoveries;
metaphysical conceptions have been refined.*
*The techniques of reproduction, of identification have been rendered
more precise and perfect.... Henceforth we shall be able to realise –
that is, to* MAKE REAL *– potent phantoms, mysterious presences of
a mixed nature....*
*I will reincarnate her entire external appearance... I will reproduce
this woman exactly, I will duplicate her, with the sublime assistance
of Light! ...projecting her through her* RADIANT MATTER*...I will compel
the Ideal itself to become apparent, for the first time, to your senses,*
PALPABLE, AUDIBLE, AND FULLY MATERIAL.
Villiers de l'Isle-Adam, *L'Eve future* (1886)[2]

Mariko Mori is a visionary artist who makes full use of, and expands,
the capabilities of electronic imaging and other technologies to create
works of futuristic beauty and historical resonance. In her first video,
installation and photographic works from the mid-1990s, Mori, a former
fashion model and designer, transformed herself into an ironic twenty-
first-century version of a compliant female cyborg, revisiting as
a woman artist a perennial figure of male science-fiction fantasy.
In the last few years, as the spiritual and philosophical underpinnings
of her work have become more apparent, Mori's projects have steadily
become more ambitious in scale and technical expertise.

Mori's ambition on a technical level seems to be no less than to 'rival
or surpass the forces mobilised by the contemporary image stream' of
popular consumer-driven culture, as Norman Bryson has written,[3] while
her idealism and searching intelligence have led her to look inward,
exploring the nature of consciousness and time.

Mariko Mori was born in Tokyo in 1967. While still a design student
at Tokyo's Bunka Fashion College, she worked as a part-time fashion
model, then moved to London in 1988 to study at the Byam Shaw
School of Art and the Chelsea College of Arts. In 1992 she moved
to New York City to take part in the Whitney Museum's year-long
Independent Study Program. She now maintains studios in New York
and Tokyo.

In her early twenties, Mori underwent a traumatic experience, 'a state
of nothingness' lasting for many hours. Regaining consciousness, she
recalls, '...the first thing I remembered was that I was a living thing,
a life. After that I started to think that I was a living thing with a
specific form. A long time passed before I finally remembered that
I was a human being.... I felt as if I were reincarnated.'[4] This
overwhelming experience was Mori's 'original impetus for making
artwork'[5] and its repercussions can be sensed in many of her works,
including her *Snow White* from 1993. This early piece, rich in
implications prefiguring many of her later themes, consists of a coffin-
shaped glass box containing an array of women's cosmetics. The glass
coffin hints at the tale of Snow White, with its subtext of narcissism,
and its 1937 incarnation as the animated Disney masterpiece –
an ancestor of the phantasmagoric animation that is ubiquitous in
contemporary Japanese pop culture. The fact that the absent female

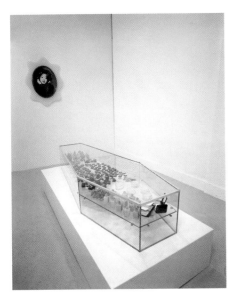

MARIKO MORI, *SNOW WHITE*, 1993
Glass, stainless steel, make-up
30.5 × 183 × 61 cm
Collection of the artist
Courtesy Deitch Projects

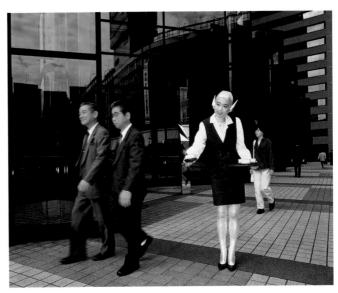

MARIKO MORI, *TEA CEREMONY III*, 1995
Cibachrome print, aluminium, wood, smoked chrome aluminum frame
121.9 × 152.4 × 5.1 cm
Editioned
Private collection

is represented by make-up – that is paint, the art supplies with which everywoman becomes a sort of artist in creating her public 'face' – is a reminder that in Heian times, glimpses of artfully chosen details of dress, such as the many-layered sleeves of a robe, were almost all that was ever seen of Japanese court ladies (including the great writers Sei Shōnagon and Murasaki Shikibu). For Mori, too, 'The clothes represent the skin, the shell of an individual; they are like an expression of my identity and ideas.'[6]

Returning to Japan after studies abroad, Mori felt somewhat estranged from, and all the more aware of, the constricted nature of Japanese society, which provided little, if any, encouragement for a young woman artist. Partly in response to this, she made the photographic works that in 1995 first brought her international attention, works such as *Subway* (1994); *Red Light* (1994, see pp. 106–107) and *Tea Ceremony III* (1995), in which Mori had herself photographed in various public places in Tokyo dressed in futuristic costumes of her own design, acting out science-fiction versions of the automata which society expected her to be. Mori's characters in these works, she has said, 'appear to be happy, because they are cyborgs, not real women'.[7] Their gaze is turned inward and, like models in advertising photographs, they appear strangely abstracted from their own image. It is unclear, in fact, whether they are even visible to the real-life 'salarymen' and women among whom they have been set down. Their distance from the worldly concerns of the humans around them foreshadows the serene Buddhist detachment that emerges as a theme in Mori's later works.

The Beginning of the End (1995–2000) is a series of panoramic photographs showing Mori lying encased within a clear-plastic, pod-

like 'Body Capsule' in the middle of major urban centres around the world. The 'Body Capsule' immediately suggests science-fiction scenarios: an unhatched alien life-form, or a recently landed vehicle for interplanetary travel. The photographs are pregnant with wondrous – perhaps miraculous – possibility, in the midst of, again, obviously self-absorbed urban crowds. These works were followed by *Empty Dream* (1995), a photo-mural 7.3 m long showing Mori, 'reborn' as a mermaid with blue scales and hair, reclining in triplicate on a Japanese indoor artificial beach: picture-perfect until you look above the blue-sky backdrop and see the roof struts of the hangar in which the whole thing has been built (see p. 104).

In 1996 Mori made her first video, *Miko no Inori* (*The Shaman Girl's Prayer*) (see p. 105). Set in the starkly futuristic Kansai International Airport, Osaka, the character of the female shaman (portrayed by Mori dressed in a white-plastic inflated carapace and knee-high white Courrèges-like boots), repeats a series of ritualistic gestures while holding and adoring a crystal sphere, which reflects the space around her, and seems to become in turn an eye, a pearl, an egg, a womb, a moon (see p. 105). The shaman's eyes appear blankly silvered and pupil-less, as though she were not 'there'; as indeed she is not, acting as she does, under the influence of unseen spirit-guides. Ever more ambitious, Mori then produced the video and installation *Nirvana* (1996–97). Exhibited at the 1997 Venice Biennale, where it won a prize, *Nirvana* consists of multiple elements, and refers to Amida or Pure Land Buddhism, whose adherents believe that after death they will be reborn in the Western Paradise or Pure Land and from there attain Nirvana. In the video itself, also called *Nirvana*, which incorporates 3-D effects when viewed through special glasses,

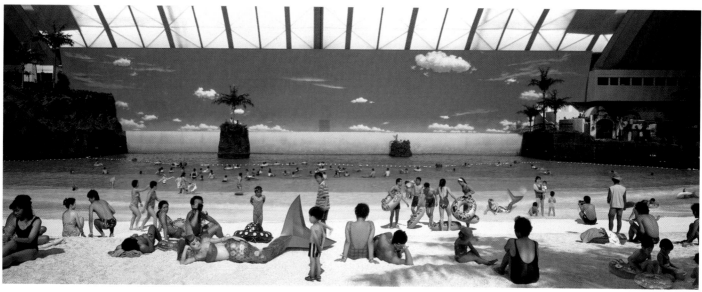

MARIKO MORI, *EMPTY DREAM*, 1995
Cibachrome print, aluminium, wood, smoked chrome aluminium frame
274 × 732 × 7.62 cm
Five panels, each 122 cm long
Private collection
Editioned

Mori depicts the goddess Kichijōten hovering in mid-air above an empty pink watery landscape, surrounded by six cute multi-coloured animated musicians which she calls 'Tunes'. The piece also includes four mural-sized digitally manipulated photographic images loosely representing the four elements of Buddhist cosmology (mandala) – wind, fire, water and earth; and 'Enlightenment Capsule', a clear-plastic teardrop which, when the technology is perfected, one will be able to sit in, suspended on a plastic lotus flower upheld in mid-air by magnetic resistance. While the iconography of *Nirvana* (and the photographic mural 'still' taken from it, *Pureland*) come from traditional Tang Dynasty (and ultimately Indian) sources, its composition, and golden, roseate palette also relate closely (intentionally or not) to Philipp Otto Runge's pantheistic painting, *Der Kleine Morgen* (1808), in which, as in Mori's *Nirvana*, a central goddess-figure floats in the air above a landscape that is part land, part water, surrounded by a circle of flying attendant cherubs playing musical instruments.

> Darkness dispelled,
> is the radiant moon that dwells
> in the skies of the mind
> drawing nearer now
> to western hilltops?
> Saigyo, *Poems of a Mountain Home*[8]

Mariko Mori's *Dream Temple* (1999), her most complex and multifaceted project to date (see pp. 110–113), is a true *Gesamt-kunstwerk* that combines architecture, computer graphics, 3-D surround sound, a VisionDome system and virtual reality in a total

work of art designed to explore the nature of human consciousness itself. The octagonal *Dream Temple* structure, about 5 m high and 10 m across, is made of glass and dichroic glass whose gently glowing iridescent surface changes in reaction to light. It is modelled on the Yumedono temple in Nara, built by Prince Shōtoku in 739 as a meditative space to house a statue of the Bodhisattva Kannon.[9] The goddess is absent from Mori's temple, however; her place is taken by the viewer, who enters the central spherical space to find him- or herself surrounded on all sides by a 'virtual-reality' video projection, in which abstract images of astral bodies devolve from and into images suggestive of germination and growth (see pp. 112–113).

The *Dream Temple* image made its first appearance in Mori's work as a digital 'drawing' in the previous video *Kumano* (1999) and its related photo-mural (see pp. 108–109). In that video, Mori visualised in a rather literal way what she calls the 'eternal present', with quick cuts between scenes of a Shinto forest spirit, a Heian pilgrim or priestess performing a ritual at the Nachi waterfall, a woman in traditional Japanese dress practising the tea ceremony and a contemporary or future woman overlooking the lights of a city at night. Mori's conception of the 'eternal present' derives partly from her study of Yuishiki teaching, which holds that nothing truly exists except as an image created within one's own consciousness.[10] The concept is probably more effectively illustrated, or suggested, through abstract imagery, as Mori does in a beautiful series of ink, watercolour and coloured pencil studies for the *Dream Temple* video, in which cellular forms seem to congeal, separate and create energised force fields, and the macroscopic is conflated with the microscopic. The drawings are similar in appearance and inspiration to those of Henri Michaux, who,

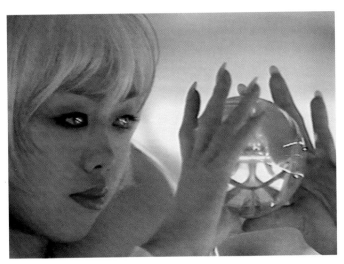

MARIKO MORI, *MIKO NO INORI*, 1996
Digital video still formatted on glass
61 × 76 cm
Courtesy of Gallery Koyanagi, Tokyo and Deitch Projects, New York
Editioned

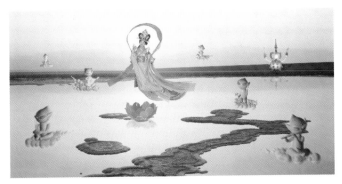

MARIKO MORI, *PURELAND*, 1996–98
Glass with photo interlayer
305 × 610 × 2.1 cm
Five panels, each 1.22 m long
Edition of three
Private collection

in his own nervous, energy-charged works, similarly attempted to give a pictorial record of consciousness in flux. Michaux wrote in 1957, 'I wanted to draw the consciousness of existing and the flow of time... A cinematic drawing.'[11]

Like Michaux (and Beuys) Mori explores connections between art and shamanism, which she associates with technological wizardry: 'The relation [of the work] to technology seems to me to be similar to the shamanistic vision that thinks in terms of transparent materials and gold.... Technology, too, insists on defining what is absent, the unknown centre hidden within us.... Technology is the unending search for both an eternal loss and an eternal present.'[12] For Mori, the light of her glass, light-suffused temple walls and in her video projections signifies, very simply, enlightenment, just as the creatures of her videos are literally made of light: 'Mori visualises the body as a set of radiant energies that sublimate the thing-of-flesh into a spirit made of (celluloid) light', as Norman Bryson observes.[13] Optimistic and idealistic, Mori seems to equate both light and enlightenment with the advanced technologies she harnesses in her work, inspired by them in the way nineteenth-century Symbolists, like Villiers de l'Isle-Adam, were inspired by the inventions of Thomas Edison.

'I don't like at all the idea of putting myself at the centre of a work, even if I've used myself in my work...', says Mori.[14] And it is true that Mariko Mori, the person, is absent from the images she embodies. As distant as any fashion model or pop icon is from her image on a poster, she is 'more distant yet' through her portrayal of supernatural, otherworldly characters, and in her repeated metaphor of a clear, empty shell, pod or coffin. At the centre of the *Dream Temple*, in the

place symbolically occupied by the Bodhisattva Kannon, the place where we might expect to find a resplendently garbed and painted Mariko Mori somehow installed, we find instead an absence. We step into the empty sphere ourselves, as into our own mind, while across its skies pass images suggestive of pure consciousness and rebirth.

NK

(pp. 98–101)
MARIKO MORI, 2000
Photographs by Norbert Schoerner

(pp. 106–107)
MARIKO MORI, *RED LIGHT*, 1994
3 panels: 25.4 × 30.5 × 7.6 cm
Fuji super gloss (duraflex) print, wood, pewter frame
Courtesy Deitch Projects, New York

(pp. 108–109)
MARIKO MORI, *KUMANO*, 1998
Colour photograph on glass
305 × 610 × 2.1 cm
Courtesy Deitch Projects, New York

(pp. 110–111)
MARIKO MORI, *DREAM TEMPLE*, 1999
Installation at Fondazione Prada,
22 May – 15 June 1991
Courtesy Fondazione Prada, Milan

(pp. 112–113)
MARIKO MORI, *4'44"*, 1999
Video stills from the *Dream Temple*
Installation at Fondazione Prada,
22 May – 15 June 1991
Courtesy Fondazione Prada, Milan

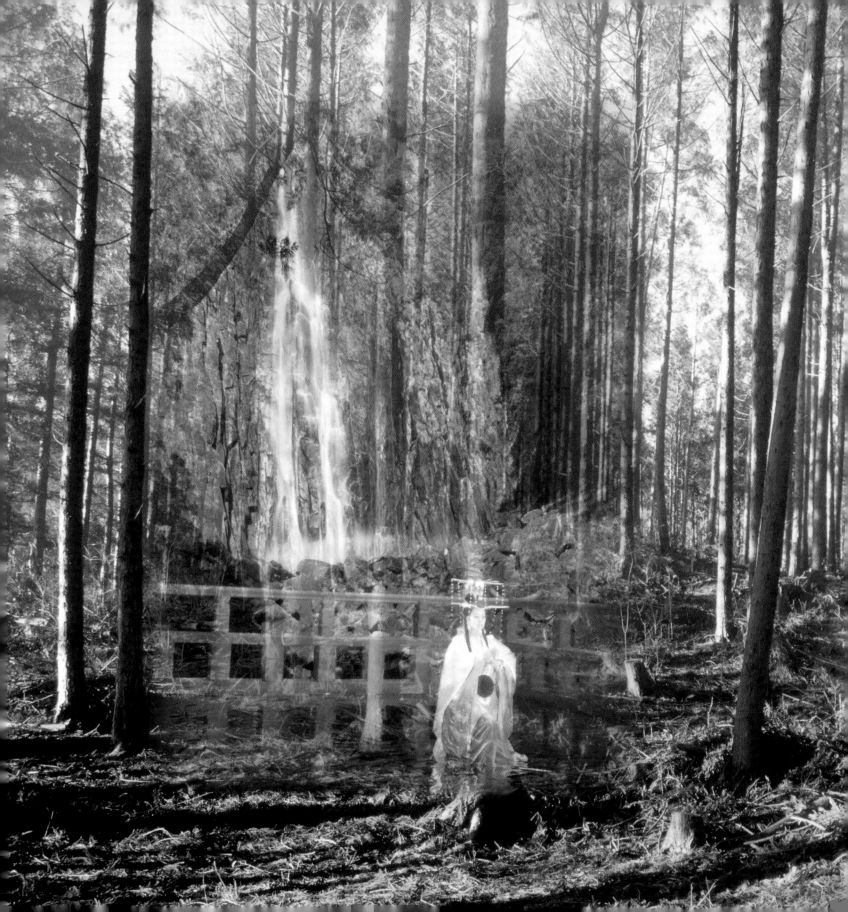

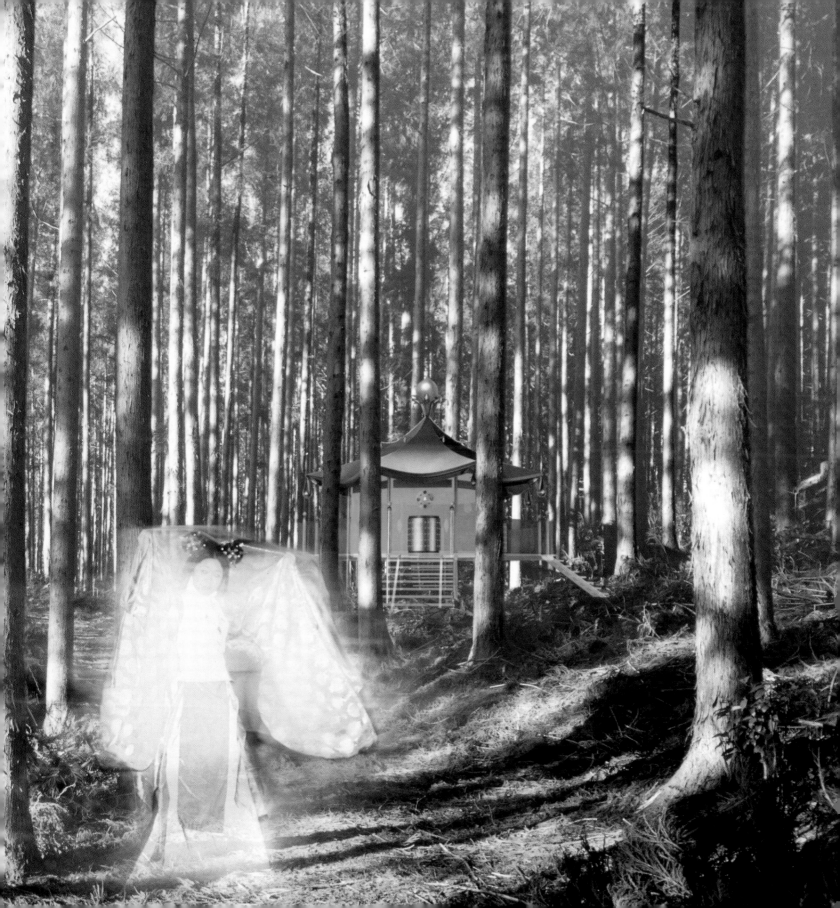

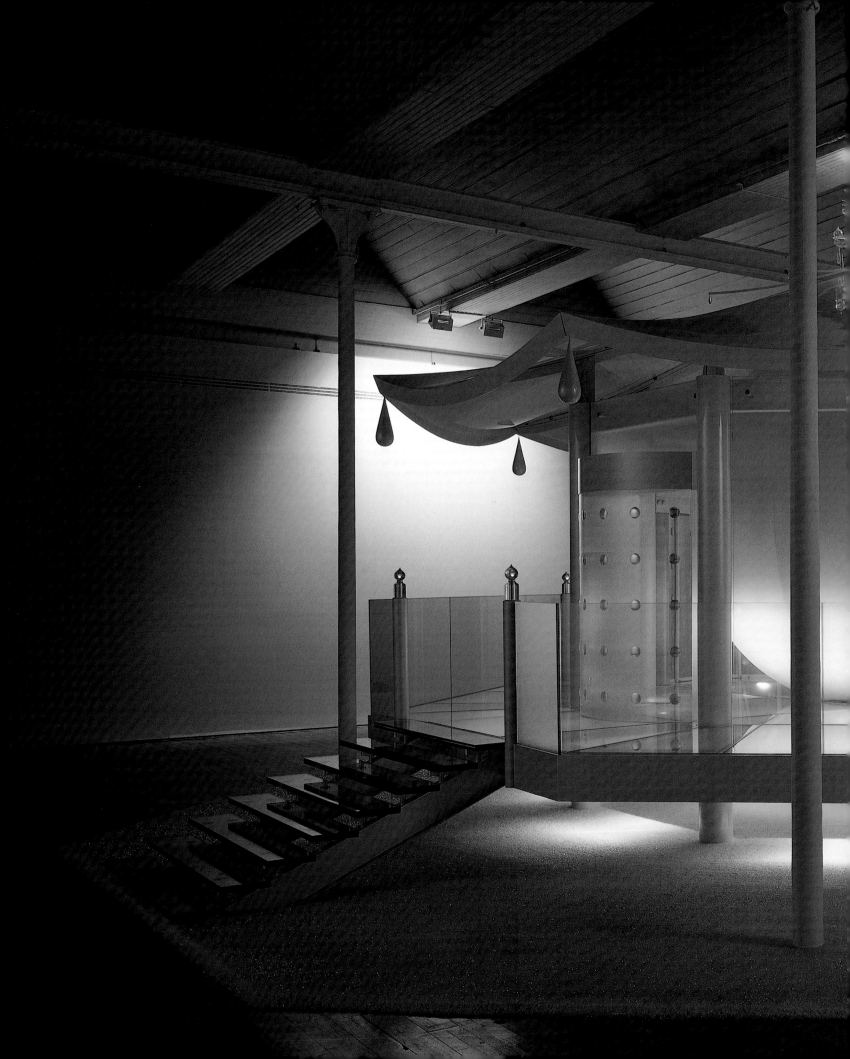

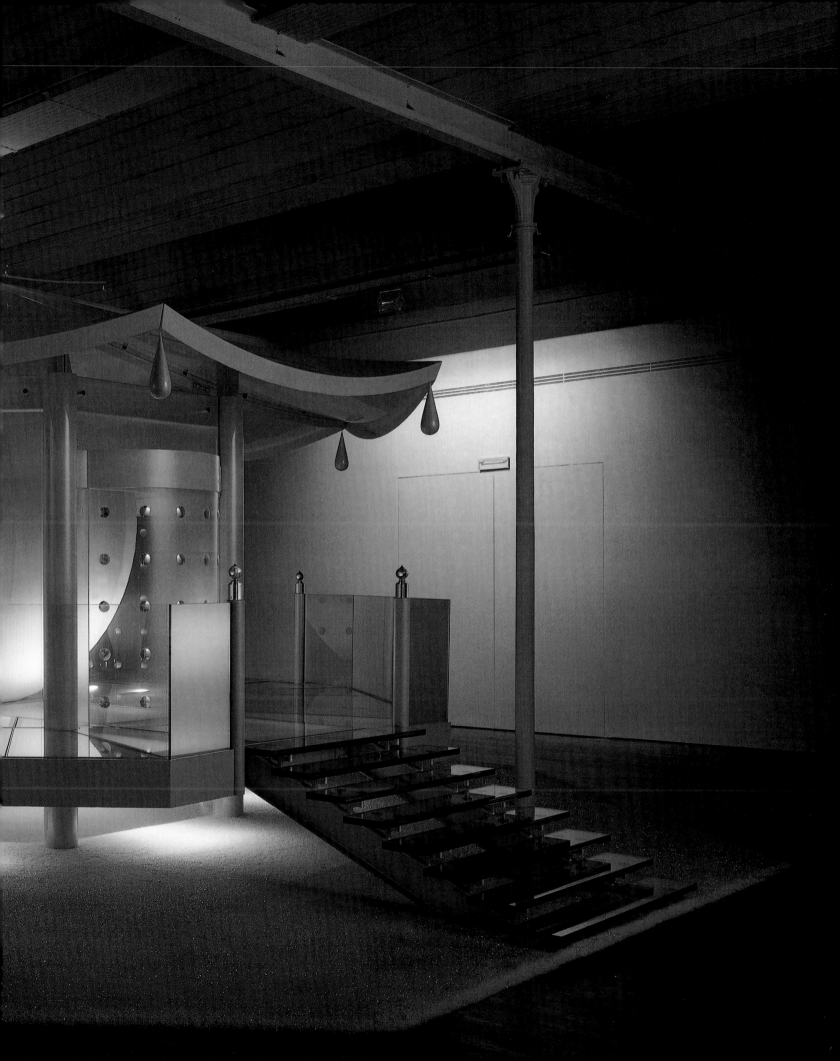

MIKE KELLEY

PLAYGROUNDS FOR ADULTS

At first Mike Kelley's mixed-media installations and performance-based works may appear to be predicated on a negative idealism: instead of the American Dream, the American Nightmare. But there is consolation of sorts in the relentlessly restless nature of his imaginings – a sense that life and many of its victims will move on, like the protagonists of an exuberant road movie, or of a slap-stick comedy.

Mike Kelley was born in Detroit, America's 'motor city', in 1954. His family was working class and Catholic. Until the age of 22 Kelley studied art at the University of Michigan, and he then moved to Los Angeles and took a degree at the California Institute of the Arts, an art school which offered pioneering interdisciplinary and multi-media courses.

One of Kelley's early works, *The Poltergeist*, which was produced in Los Angeles in 1979, was made in collaboration with his former professor David Askevold. It was an evocation of aspects of adolescent consciousness and experience. Ectoplasm – a viscous substance that is supposed to exude from the body of a medium during a spiritualist trance, and which was often faked-up in nineteenth-century 'spiritualist' photographs – appeared to stream out of the orifices of the subject. Kelley was working with the popular perception that adolescence is the period of human development when there is most conflict, and the ectoplasm was meant to evoke these uncontainable energies, both mental and physical.

But he is not in the least bit solemn about all this. He plainly regards such energies as ridiculous, as well as sublime: acne is as central to his idea of being a teenager as rebellion and erections. In the stream-of-consciousness texts that accompany *The Poltergeist* we are told of a teenage girl's embarrassment at outbreaks of acne, as well as her embarrassment at eruptions of ectoplasm from her orifices and pores. We can see these images as a bathetic apotheosis of snotty-nosed kids. Kelley seems to want his works to make us squirm with embarrassment; his intention is to undermine the often po-faced phototexts that were such an important component of 1960s and 1970s conceptual art.

In the 1980s, Kelley launched a scatter-gun assault on a range of Dead White European and American Males. *Plato's Cave, Rothko's Chapel, Lincoln's Profile* (1985) is a sequence of drawings and painted canvases, many of which were hung unstretched. Caves feature in many of the drawings, but they are a long way from Plato's carefully structured sensorium. Instead, they belong to a comic-book dystopia. Spiky stalactites and stalagmites protrude from the rock, and melodramatic texts bark out orders like 'CRAWL WORM!'.

Pay for Your Pleasure (1988), an even more concerted demolition job on Western worthies, featured a long corridor lined with brightly coloured portraits of 43 great male artists, poets and philosophers crudely executed by a sign painter. Each is surmounted by an extract from a text in which the sitters claim that violence and amorality are central to greatness and to the creative process. At the end of the corridor, and functioning like an altarpiece in a nave, Kelley exhibits a painting or a sculpture made by a convicted killer from the city in which the installation is exhibited. At the entrance to the piece, Kelley placed collection boxes for local organisations that campaign for victims' rights.

MIKE KELLEY, *THE POLTERGEIST* **(WITH DAVID ASKEVOLD), 1979**
Seven parts: two photographs, 101.6 × 69.9 cm; text photograph,
101.6 × 83.8 cm; four photographs, each 101.6 × 76.2 cm
Private collection

MIKE KELLEY, *PAY FOR YOUR PLEASURE*, **1988**
Oil on Tyvex, 43 banners, height 243 cm, width variable, donation
box, work of art by a local murderer or violent criminal
Installation, retrospective exhibition, CAPC, Musée d'Art
Contemporain, Bordeaux
Collection Museum of Contemporary Art, Los Angeles

Both these iconoclastic environmental works can be usefully
compared to Kurt Schwitters's *Merzbau*. The *Merzbau* was a sculptural
environment, also known as the 'Cathedral of Erotic Misery', built
in the artist's house in Hanover during the 1920s and 1930s. The
appearance of the structure changed considerably over the years as
Schwitters incorporated new material into his grandiose anti-memorial.
At the centre of it all was a 'column' surmounted by a cast of a child's
head, taken from Schwitters's own son after he died in infancy.
Elsewhere themed 'grottoes', 'caves' and 'shrines' housed memorabilia
and curios, most of which came from friends. These included a bra,
a key, a nail-clipping and hair, a hamster in a cage, and a bottle of
urine. As the viewer moved through, lights flashed on and off. Violent
and seedy tableaux involving plastic figures were set up in the 'Cave
of Murderers', the 'Sex-Crime Cavern' and the 'Big Love Grotto'.
There were also ironic tributes to 'great men' – the 'Goethe Cave',
the 'Luther Cave', the 'Cave of Deprecated Heroes' and the 'Cave
of Hero Worship'.

One of Schwitters's friends thought it was 'a kind of faecal smearing –
a sick and sickening relapse into the social irresponsibility of the
infant who plays with trash and filth'.[1] Kelley's environments from
the 1980s are formally distinguishable from those of Schwitters by
being more exuberant in colour, and large-scale and open-plan in
format. The viewer is simultaneously seduced and repelled, enchanted
and appalled.

At the beginning of the 1980s, Kelley's own engagement with the
memory of childhood became even more explicit when he made
several works featuring soft toys. In 1990 he made a pair of

photographs, *Manipulating Mass-produced Idealised Objects* (black
and white) and *Nostalgic Depiction of the Innocence of Childhood*
(sepia-tinted). Both showed a naked man and woman squatting on
the floor astride soft toys. The man's buttocks were smeared with a
dark chocolatey substance, and he appeared to be rubbing a soft toy
of a rabbit up against himself. On one level, the work suggests that
adults cannot recapture the 'innocence' of childhood – they can only
pervert it. But it also questions whether such innocence ever existed.
The implication is that toys – which are, after all, designed by adults –
are the first of many things designed to be used as fetishes.

In other works, stuffed toys bought second-hand were strung up in
bunches from the ceiling, or, as in *More Love Hours Than Can Ever
Be Repaid* (1987, see p. 118), sewn onto a crocheted afghan hung
on the wall like a big painting. The latter work was exhibited next to
The Wages of Sin (1987), a cluster of brightly coloured half-burned
candles. The stuffed toys and shawls in *More Love Hours Than Can
Ever Be Repaid* were handmade. The title suggests that the labour
and love that went into their making has not been sufficiently
rewarded, either because the person who gave the soft toys as gifts
is not satisfied with the return on the investment; or because the
toys themselves cannot offer love in return. Whatever their precise
meaning, these items were an integral part of Kelley's very own
'cathedral of erotic misery'. He has repeatedly said that his leitmotif
is 'failed eroticism'.

These soft-toy pieces, and the way in which they are sometimes used
and displayed, recall the early Happenings and 'soft' sculptures of
Claes Oldenburg. Yet Oldenburg's work had a much more Utopian

MIKE KELLEY, *MORE LOVE HOURS THAN CAN EVER BE REPAID*, 1987
Handmade craft items and afgans sewn onto canvas
224 × 322.5 × 15 cm
Collection Whitney Museum of American Art, New York
and in the foreground of photograph:

MIKE KELLEY, *THE WAGES OF SIN*, 1987
Wax candles on wood, metal base
132 × 58.5 × 58.5 cm

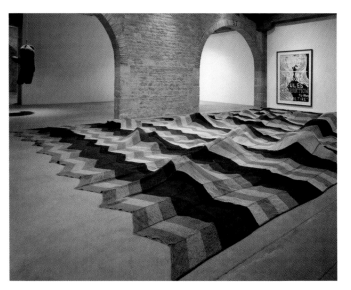

MIKE KELLEY, *LUMPENPROLE*, 1991
Afghan, fabricated by The Fabric Workshop, Philadelphia, and stuffed animals
609.6 × 975.4 cm
Private collection
and on the wall behind:

MIKE KELLEY, *AGEISTPROP*, 1991
Acrylic on paper
213.4 × 152.4 cm

function. As he himself said: 'My personal struggle has been to return painting to the tangible object, which is like returning the personality to touching and feeling the world around it, to offset the tendency to vagueness and abstraction. To remind people of practical activity, to suggest the senses and not escape from the senses, to substitute flesh and blood for paint.'[2]

A celebrated photograph shows Oldenburg's (former) wife Pat embracing one of the soft sculptures, but she is fully clothed and smiling, and there is little sense that the object is going to feature in a violent and/or abusive sexual act. Whereas Oldenburg believed that his handmade objects could have a healing function in modern society, for Kelley they remind us of our continuing trauma.

The idealised and uniform nature of soft toys exercises a form of social control. Such issues are most clearly manifested in Kelley's *Lumpenprole* (1991). This consists of a crocheted afghan of great size, specially fabricated with a striking zig-zag pattern by The Fabric Workshop, Philadelphia. It is laid on the floor like a rug, but does not lie flat because clumps of soft toys have been placed at random intervals underneath it, with the result that it undulates like a hilly landscape. This landscape association is reinforced by the carpet's green and brown colour scheme.

Undercutting the prettiness, however, is a political allegory. 'Lumpenprole' is a shortened form of Lumpenproletariat, the word coined by Karl Marx for the antisocial poor elements within the big cities who had no class loyalty. The lumpy bits under the carpet are, we assume, a concrete manifestation of this underclass. But it is

unclear whether Kelley's notional underclass is pushing its way, like a force of nature, back into the consciousness of those who might own and admire such a carpet, or whether the carpet is smothering them – a literal case of brushing something unpleasant under the carpet. In the last few years, Kelley has made a number of works in which furniture and architecture feature. *Sublevel* (1998) is based on his imperfect recollection of the basement ground plan of the California Institute for the Arts. This part of the building was primarily occupied by darkrooms and video-editing suites. Kelley built a large wooden model of the walls and covered the parts he could not remember with plastic crystals. The minimalist-style structure looked like a series of foundations.

He built a wooden tunnel around the labyrinthine structure which opened into a large aluminium box. This part of the installation was inspired by a story about a primary school teacher who was accused by his pupils of abusing them in a specially built system of tunnels connected to a dungeon in the basement. But the investigation found no trace of a tunnel. In Kelley's version, the audience was invited to crawl through the tunnel, which contained flashing coloured lights, and – inside the aluminium box – a cupboard of phallic-looking objects including a Christmas crib. The whole *mise-en-scène* was an exploration of what has come to be known as false-memory syndrome. Here, even the most innocuous of objects and experiences are mutable, and may well turn into the stuff of nightmares.

Kelley's installation for the Royal Academy continues his exploration of institutions and their place in our consciousness. *Extracurricular Activity Projective Reconstruction #1 (A Domestic Scene)*, the first of

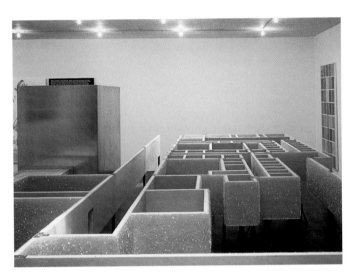

MIKE KELLEY, *SUBLEVEL***, 1998**
Mixed media
215 × 824 × 592 cm
Collection Eric Decelle, Brussels
Courtesy Jablonka Gallery, Köln

an ambitious series of works, is based upon a photograph in a high-school yearbook. Kelley has collected examples of these photographs, which document the extracurricular activities of students, for years. He is especially interested in those which record theatrical performances and dressing-up – what he terms the 'arty and comedic'. Because of their basis in ritual and recourse to stock characters, Kelley treats them as the photographic equivalent of the medieval mystery plays. The photograph that inspired his latest installation shows a scene from a play in which two heavily made-up young men – one well-dressed, the other wearing filthy clothes – are in a slummy apartment, with an open oven mysteriously placed in the centre of the room.

This photographic still will be displayed in the gallery. Kelley has used it as the springboard for a half-hour play which is shown on a TV monitor nearby. Entitled *A Domestic Scene*, it is filmed in the stilted manner of early TV, and played as melodrama. The actors are made up in a style redolent of expressionist theatre and film, so that it is hard to tell their ages with any precision. In Kelley's version, a man wearing filthy white clothes wakes up in a slummy apartment, but has no idea how he got there and does not recognise another man, who is smartly dressed in a neat, buttoned-up white shirt.

The latter explains to him that they are lovers, and have been having a relationship. Eventually, they make a suicide pact, and kill themselves by gassing themselves in the oven that is located in the centre of the room. As they die, they have a vision of Sylvia Plath, who committed suicide in the same way. The third element of the installation is an accurate reconstruction of the apartment in the centre of the gallery. The stage flats, designed to be seen from a distance, are painted in

a rough way. But Kelley's props, unlike ordinary stage props, which are casually knocked together because they are not supposed to be examined at close quarters, are carefully crafted.

Extracurricular Activity Projective Reconstruction #1 (A Domestic Scene) is concerned with the way in which society finds it hard to tolerate or come to terms with unorthodox views and lifestyles. According to Kelley, schools are dystopias masquerading as Utopias. They all tend to be governed by the same set of stultifying rules. In photographs of extracurricular activities, we get a glimpse of a world governed by different rules which Kelley sees as 'carnivalesque'.

But the juxtaposition of three different versions of the same reality – photograph, video, stage-set – casts doubt on the authenticity of the events depicted. It is something that appears very contrived and stage-managed. We can't help but begin to wonder whether there was any spontaneity in this transgression. Indeed, even the method of suicide is inspired by an author, Sylvia Plath, whose poems are set texts in high schools of the Western world. For Kelley, it is imperative that we do not follow someone else's script. JH

(pp. 114–115)
MIKE KELLEY, 2000
Photographs by Norbert Schoerner

(p. 120)
The original black-and-white photograph found in a yearbook, the basis for *Extracurricular Activity Projective Reconstruction #1 (A Domestic Scene)*

(p. 121)
MIKE KELLEY, STILL FROM *EXTRACURRICULAR ACTIVITY PROJECTIVE RECONSTRUCTION #1 (A DOMESTIC SCENE)***, 2000**
Courtesy Mike Kelley Studios

(pp. 122–123)
MIKE KELLEY, SET FOR *EXTRACURRICULAR ACTIVITY PROJECTIVE RECONSTRUCTION #1 (A DOMESTIC SCENE)***, 2000**
Courtesy Mike Kelley Studios

(pp. 124–125)
Filming *Extracurricular Activity Projective Reconstruction #1 (A Domestic Scene)*
Courtesy Mike Kelley Studios

(pp. 126–129)
MIKE KELLEY, STILLS FROM *EXTRACURRICULAR ACTIVITY PROJECTIVE RECONSTRUCTION #1 (A DOMESTIC SCENE)***, 2000**
Courtesy Mike Kelley Studios

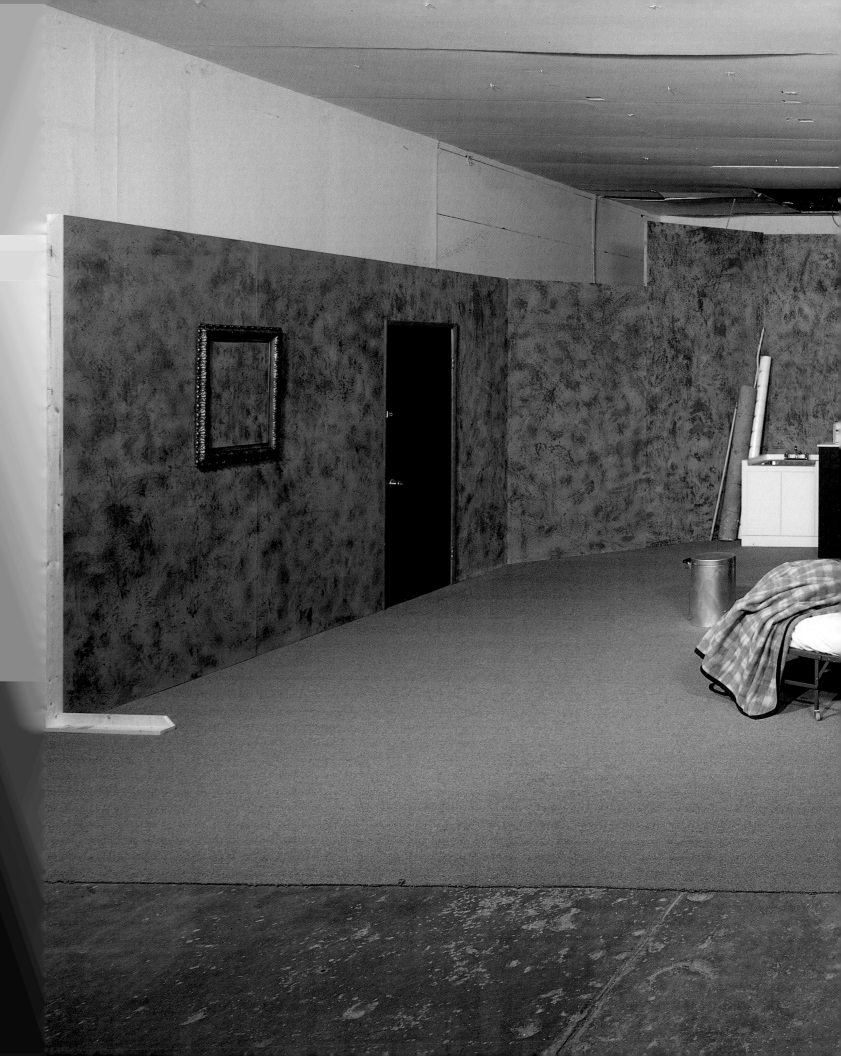

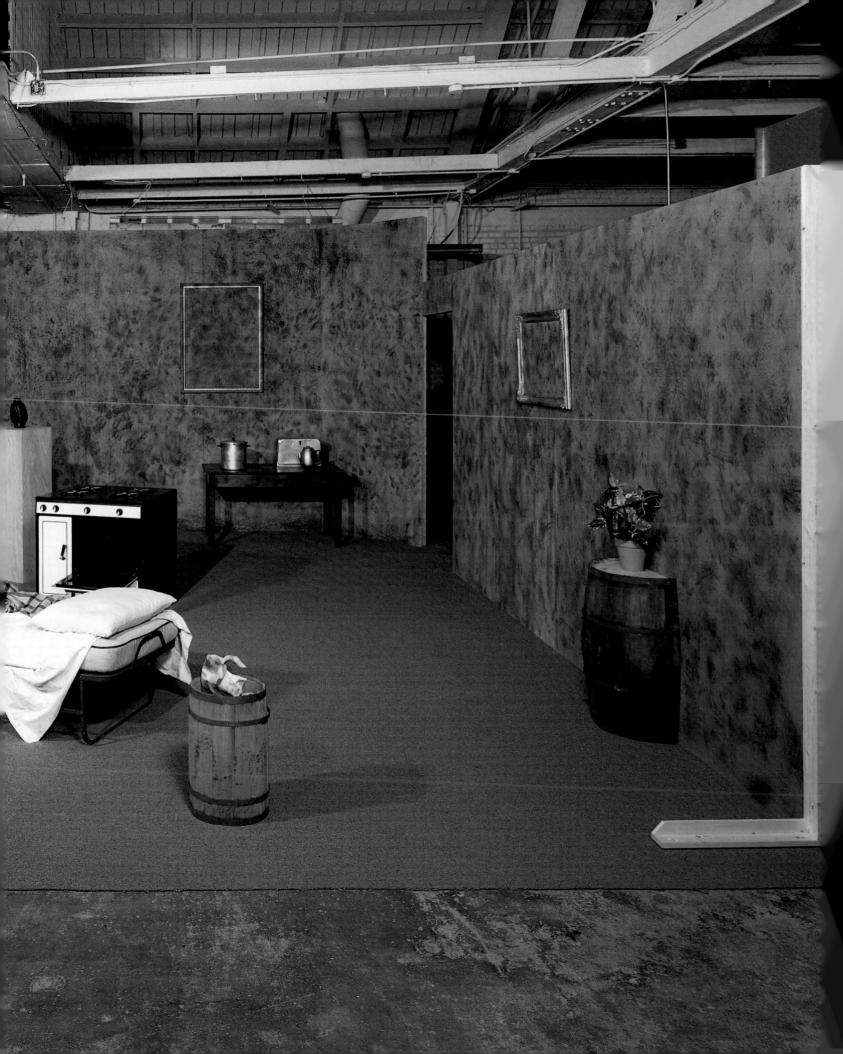

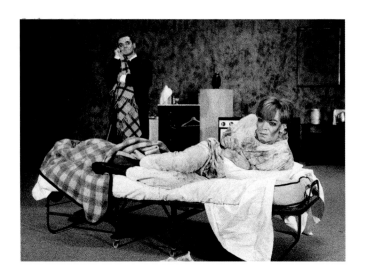

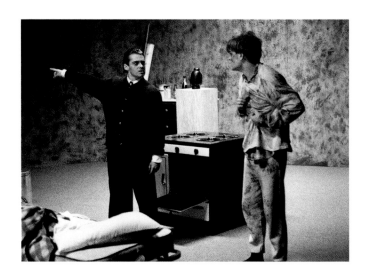

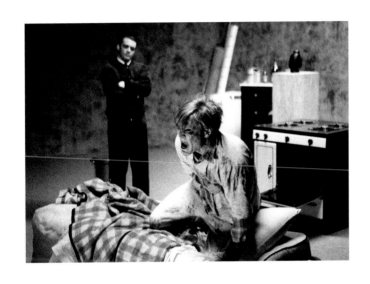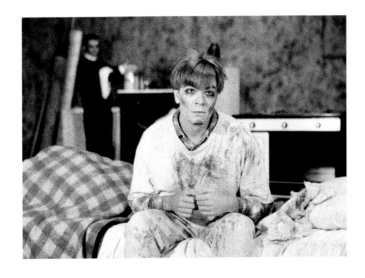

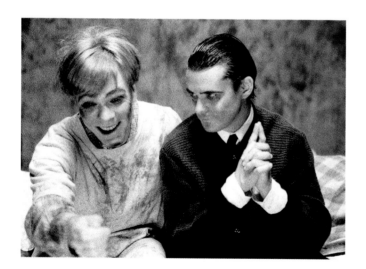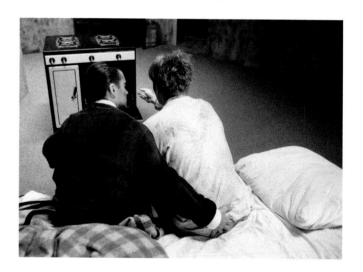

WOLFGANG TILLMANS

MOMENTS OF BEING

We hardly ever see the moon any more
 so no wonder
it's so beautiful when we look up suddenly
and there it is gliding broken-faced over the bridges...

I want some bourbon / you want some oranges / I love the leather
 jacket Norman gave me
 and the corduroy coat David
 gave you, it is more mysterious than spring...
Frank O'Hara, from 'Avenue A'[1]

Wolfgang Tillmans's photographs uncover and illuminate moments of
beauty and desire: skies, stars, moon, eclipses, cityscapes from above,
flowers, tomatoes, oranges, aubergines, peppers, dishes, clothes
(uninhabited, draped), lovers, friends, young men, young women:
dancing, playing, having sex, being high, letting go, improvising,
posing. In gallery and museum installations these images are combined
and recombined in different sizes and print mediums to create giant,
room-sized collages; in the more intimate scale of Tillmans's books
they are intercut with one another to become something like the world-
embracing, onrushing catalogues of poets like Walt Whitman or Frank
O'Hara, or the epiphanies and 'moments of being' of Virginia Woolf.
Tillmans is highly sensitive to the physical status of the photograph as
an artefact on paper, yet his aim is to 'peel away' any sense of artifice
in the image itself in order to 'make the photograph disappear and
leave the viewer alone with what I've been looking at'.

Wolfgang Tillmans was born in 1968 in Remscheid, Germany, a small
town near Düsseldorf. After high school, he moved to Hamburg where
he worked for two years taking care of the elderly in lieu of being
drafted into the army. At night he participated in the city's exciting
club scene. While still in high school, Tillmans had begun making
Xerox art using a black-and-white photocopier, and he continued this
work in Hamburg on a Canon laser copier. Within six months he had
his first exhibition of these prints, in a small gallery café. Feeling the
need for fresh images to work with, Tillmans picked up a camera and
started to take his own. He soon realised that taking pictures was
something he was good at, and that he was more interested in the
photographs themselves than in their 'degradation' as laser prints.
He started taking pictures in clubs of his friends and peers, all in
their early twenties, dancing in seeming self-abandonment to Ecstasy,
loud House music and sheer youthful exuberance, and some of these
images were published in *i-D*, the London fashion magazine which
he had loved since he was fourteen. Although he had already had
some gallery exposure, the 'immediacy and impact of the magazine
page proved more attractive'. Almost overnight, Tillmans found
that he had become a photographer, publishing in local German
magazines as well, and was being considered by some a kind of
visual spokesperson for his generation, a role he viewed with some
misgivings. In fact, as his assignments began to multiply, Tillmans
decided that he was 'too young to be a commercial photographer'
(he was twenty-two), and moved to Bournemouth on the south
coast of England to enrol in a two-year programme at the
Bournemouth and Poole College of Art and Design. Originally
designed as a vocational course, the programme was in practice
a pure, theoretically based fine-art education. The question it forced
him to ask remains with him: 'Why do you want to take another picture
in a photo-saturated world?'

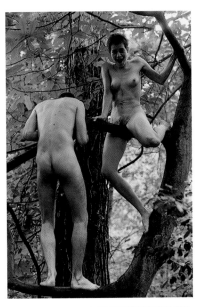

WOLFGANG TILLMANS, *LUTZ AND ALEX CLIMBING TREE*, 1992
Courtesy Maureen Paley/Interim Art, London

WOLFGANG TILLMANS, *STILL-LIFE, YELLOW TOMATOES*, 1995
Courtesy Maureen Paley/Interim Art, London

Moving to London in 1992 (where he has continued to live, with time out for a year in New York [1994–95] and shorter periods in Cologne and Berlin), Tillmans re-established contact with *i-D* magazine. He had recently decided to make no distinction between his commercial or magazine work and the portrait, still-life and landscape photographs he was taking for himself, and only to accept assignments that also interested him as an artist. In fact, fashion and clothes do interest him, or, 'not fashion *per se* but attitudes to fashion and the politics of going out and of do-it-yourself fashion', as opposed to designer fashion. As well as the social implications of clothes, Tillmans is obsessed with the physical matter of clothing: how it identifies and 'becomes' the wearer, like a second skin, and how it looks uninhabited, lying on a floor, hanging up (see p. 142), or draped over a banister or a bicycle.

In photographs of young people in their improvised clothing and accessories, Levis, work clothes, army fatigues, camouflage prints, scarves, sweaters, leather, and the occasional piercing, Tillmans becomes an advocate for an idealistic, pan-sexual, Utopian society. 'I found myself being one of the promoters of that idea of beauty, and that was very exciting: to show my contemporaries as serious beautiful people – not just as crazy people going through a phase, which was never what I saw in myself or in contemporaries I liked.' Most of these pictures, despite their ad-hoc air, are not reportage, but staged in collaboration with the subjects: 'they look real, because the feeling was real', as Tillmans says. In 1992 the 'Sex' issue of *i-D* included an eight-page 'fashion' spread in which Tillmans cast, directed and photographed his friends Lutz and Alex sitting in trees half-naked. Their playful, sexually provocative engagement with each other and

the photographer is clear: artist and models collaborating in images neither would have made alone. These photographs were among those which brought him international gallery attention. Ironically, as soon as he stopped subscribing to the conventional dichotomy between fine and applied art, he found himself at 'the heart of the art world'.

'I don't believe in snapshots,' Wolfgang Tillmans insists. It is tempting to interpret that statement to mean that he doesn't believe they exist, as perhaps they don't – at least not with the absolutely pure unmediated artlessness the word 'snapshot' seems to imply. Tillmans's photographs, in any case, are actually highly formal: 'It's just a new formalism that looks to the untrained eye like snapshots.'[2] Snapshots (if they exist) are often highly formal themselves though, and perhaps what occasionally gives Tillmans's photographs the appearance of snapshots is that shared formal sense, with the subject often loosely centred in the image area. Like that of the snapshot-taker, Tillmans's initial inspiration is a direct response to the beauty of the object or person or moment before him, which he tries to render in the most direct and efficient way. Tillmans's work 'starts in this definition of beauty'[3] and he aims for 'a way of photographing which comes as close as possible to how I saw with my eyes'. At first Tillmans found his photographs were not conveying the subject as he'd seen it, so he experimented with flash until he found a way of lighting pictures so as to give little or no sense of the source of light. His pictures of objects especially, but also people and landscapes, shine as though brand new, washed by even, unemphatic light, a hard-won lack of apparent artfulness that seems to reveal the subject almost as though it were scientific evidence: evidence perhaps of our – the photographer's, the viewer's – existence. 'It's not about creating an image, it's already there.'[4]

WOLFGANG TILLMANS, *MINATO-MIRAI-21*, 1997
Courtesy Maureen Paley/Interim Art, London

WOLFGANG TILLMANS, *CONCORDE I, 444-9*, 1997
Courtesy Maureen Paley/Interim Art, London

Part of the deceptively casual appearance of Tillmans's photographs comes from subject matter that at first can seem off-hand or random: clothing on the floor, dishes in the sink, an aeroplane in the sky. Yet these subjects are exactly not the usual subjects of snapshots, and in Tillmans's work, they are also elements of ongoing thematic explorations, or obsessions. In his pictures the traditional categories of landscape (or cityscape), still-life and figure are very much interwoven. A still-life such as *Faltenwurf (Blue Shorts) II* (1996), for example, which is a close-up of an expanse of shiny, almost iridescent blue cloth, is one of many that can be read topographically, becoming through its imprecisely defined forms and ambiguous scale, a night landscape of moonlit hills and dark hollows 'more mysterious than spring'. (Many of Tillmans's subjects, incidentally, wear camouflage-printed clothing – which, of course, is specifically designed to mimic landscape.) A photograph of uninhabited clothing can also imply a figure and a social attitude, especially when the garment can be read for what it is, like the hanging workmen's jumpsuits in *Faltenwurf (Lutteurs)* (1994). Tillmans's subjects are not armoured in tuxedos or thousand-dollar Armani suits. Rather, the clothes he photographs are relaxed, generic, worn cottons, whose wearers, like the nature of drapery itself, as described in Leonardo da Vinci's *Treatise on Painting*, are 'expansive and free'.[5]

Tillmans's many still-lifes of fruit and vegetables and other foodstuffs are often photographed from above, as are his landscapes. This omniscient and equalising viewpoint avoids the sense of a hierarchy within the objects depicted (the bottle towering over the apple, in front of the cup), or of a deliberately arranged 'composition' which the word still-life unfortunately connotes. Not that forms don't overlap, not that

they aren't composed, but it's 'just a new formalism'. Each element in *Still-life, Yellow Tomatoes* (1995, see p. 133) – tomatoes, figs, squash, plastic spoon, rubber band, empty wrapper, paper napkins and stain – laid out like evidence, has its own separate integrity and identity within the loosely connected but mutually supporting, non-hierarchical 'society' of the composition – a metaphoric social Utopia. When cityscapes are photographed from above, from an aeroplane or a high building – as in *Minato-Mirai-21* (1997) – buildings, bridges, roads, signs and rivers lose both their monumental scale and their land-oriented relationships to one another and become like the objects in a Tillmans still-life. In *Highway Bridges* and *Industrial Landscape* (both 1996) the monochrome urban landscape becomes an organism: a diagram of musculature or an enlargement of blood cells, with connotations of mapping and aerial reconnaisance.

When he is not looking down, Tillmans is often looking up. Between the ages of ten and fourteen he was a 'nerdy science kid' obsessed with astronomy, making careful diagrams of sunspots and taking pictures of the moon. When he was ten years old he already knew that on 11 August 1999, years in the future, Europe would experience a total eclipse of the sun. Some of these very early scientific drawings and photographs are included with recent photographs of an eclipse in 1998 in his book *Totale Sonnenfinsternis* (*Total Solar Eclipse*).[6] Earlier, in 1997, he'd published another artist's book, *Concorde*, containing pictures of the supersonic airliner from the ground, flying far overhead, out of reach, a dream of travel and the future (the plane was introduced the year after Tillmans's birth). In recent years books have taken the place magazines once occupied for Tillmans, as a way for the work to be seen sequenced on the printed page. Books like

WOLFGANG TILLMANS, *FALTENWURF (BLUE SHORTS) II*, 1996
Courtesy Maureen Paley/Interim Art, London

WOLFGANG TILLMANS, *LUTZ, ALEX, SUZANNE AND CHRISTOPH ON BEACH (B&W)*, 1993
Courtesy Maureen Paley/Interim Art, London

Wolfgang Tillmans,[7] *For When I'm Weak I'm Strong*[8] and *Burg*[9] are collections of images, arranged in a near-chronological order going back more or less a decade, which result in a randomness of still-lifes, figures and landscapes interleaved. A number of the same pictures reappear from book to book, as they do in his installations, but are changed by the implications of new contexts. In gallery and museum exhibitions Tillmans mixes sizes, media and physical presentation of images in a giant collage-like hanging that treats each wall, or the exhibition space as a whole, as a larger composition. Unframed C-prints as small as 4 × 6 inches may be pinned up next to reproductions from magazines, or much larger ink-jet prints attached unframed to the wall with small clips. This seemingly jumbled presentation is 'not about casualness'. The installation process can take several days but 'I guess like all the things we really like, it ends up looking as though it just "happened"', Tillmans says. Unlike many, if not most, artists who work in colour photography, Tillmans does his own printing; he is acutely aware of the photograph's status as an artefact: 'The sheet of paper is inseparable from the image it carries.'

It is partly his experience in the darkroom, where improvisation plays a role, and his determination that the work 'not stop at the lens' that have led Tillmans to his new abstract pictures, several of which are exhibited in 'Apocalypse'. 'It began when I started collecting things that went wrong in the darkroom,' he says. 'Throughout my work mistakes have always been important. You could almost say that all progress is derived from mistakes....' In a series of cameraless abstractions, including *Nocturne* (2000, see pp. 136–137), fine thread-like lines, apparently 'drawn' with light, swim over the print surfaces to create delicate patinas of light and shadow, line and mass,

form and formlessness, being and nothingness. Tiny spots are like constellations of pores on universes of living skin. Other new works use abstract elements as interventions upon landscape images. In *Conquistador II* (1995/2000, see p. 145) sunset clouds are interrupted by diagonal bars of coloured light, mimicking the effect of light leaks in the darkroom, and by *trompe l'oeil* cracks and tears. In *I Don't Want to Get Over You* (2000, see p. 140) a blue sky is interrupted by a gestural green abstract squiggle on the right. The title refers to a popular song and a feeling we recognise as one of the late phases of grief, when loss itself seems precious, all we have of a person. For Tillmans, the title may partly refer to the death in 1997 of his lover, Jochen Klein – a painter whose work, as it happens, combined abstract gesture with figural and landscape imagery. There is a bittersweet ambivalence in *I Don't Want to Get Over You*: the blue sky has been violated by the interruption, as when film gets stuck in a cinema projector and the celulloid image curls and burns. Yet the green, plant-like tendril itself is an image of growth despite everything; a rent in the sky revealing the possibility of another dimension. NK

(pp. 130–131)
WOLFGANG TILLMANS, 2000
Photograph by Norbert Schoerner

(pp. 136–137)
WOLFGANG TILLMANS, *NOCTURNE*, 2000
Courtesy Maureen Paley/Interim Art, London

(pp. 138–139)
WOLFGANG TILLMANS, DETAIL OF *use*, 2000
Courtesy Maureen Paley/Interim Art, London

(p. 140)
WOLFGANG TILLMANS, *I DON'T WANT TO GET OVER YOU*, 2000
Courtesy Maureen Paley/Interim Art, London

(p. 141)
WOLFGANG TILLMANS, *STILL-LIFE, TEL AVIV*, 1999
Courtesy Maureen Paley/Interim Art, London

(p. 142)
WOLFGANG TILLMANS, *SUIT*, 1997
Courtesy Maureen Paley/Interim Art, London

(p. 143)
WOLFGANG TILLMANS, *STUDIO*, 1991
Courtesy Maureen Paley/Interim Art, London

(p. 144)
WOLFGANG TILLMANS, *RED ECLIPSE*, 1998/2000
Courtesy Maureen Paley/Interim Art, London

(p. 145)
WOLFGANG TILLMANS, *CONQUISTADOR II*, 1995/2000
Courtesy Maureen Paley/Interim Art, London

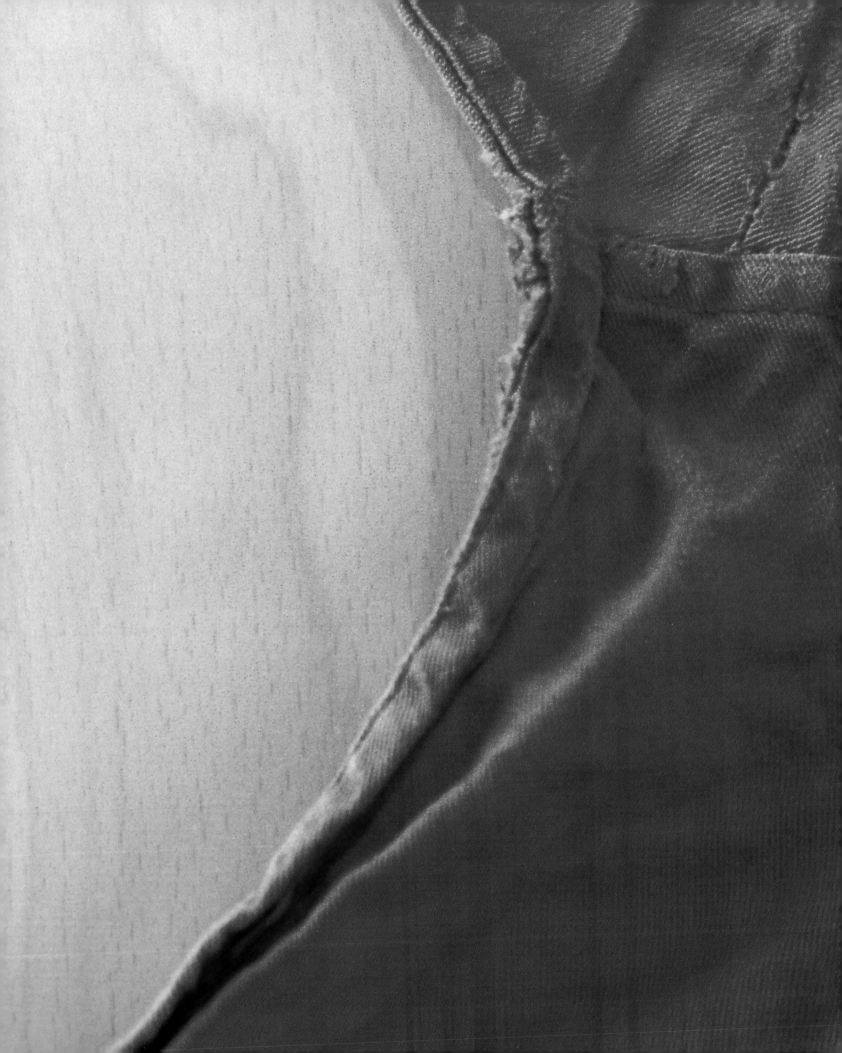

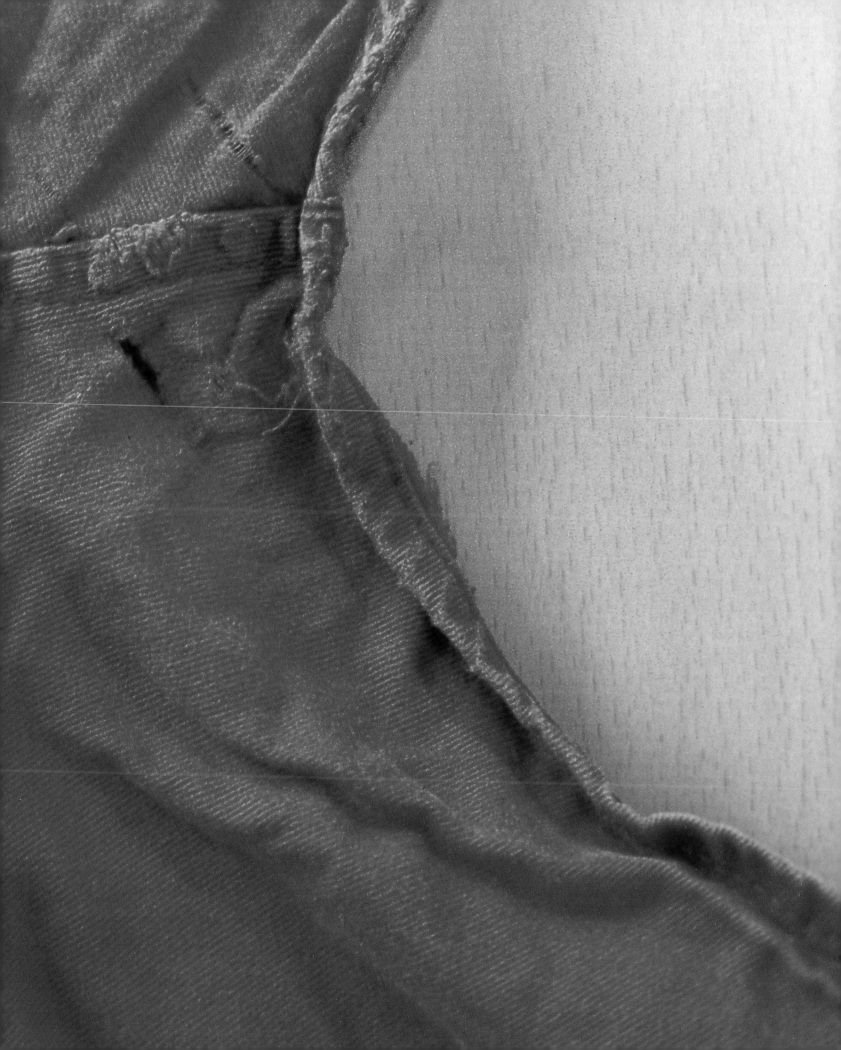

142

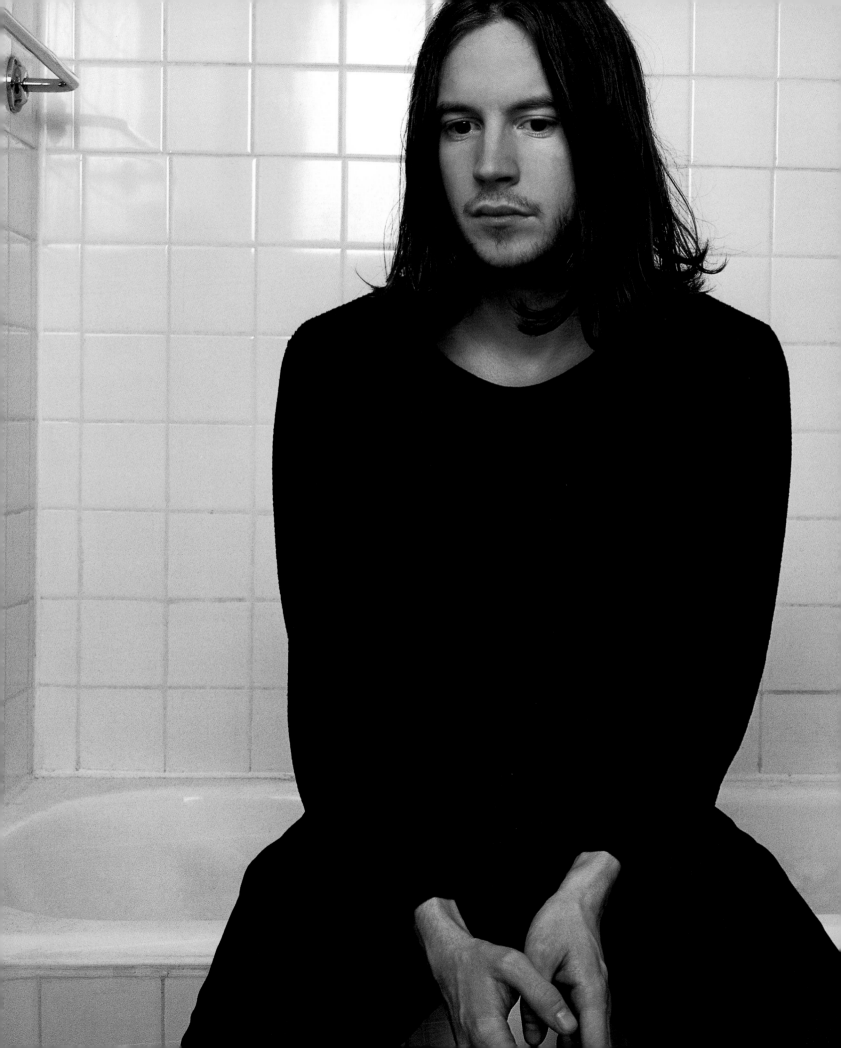

CHRIS CUNNINGHAM

MAN, MACHINE AND MUSIC

Thus at the beginning stage we can say that the shadow is all that is within you which you do not know about.
Marie-Louise von Franz, *Shadow and Evil in Fairy Tales*, 1957

A sleeping white robot is awoken by the touch of two attendant machines. Serviced for love-making in a kind of mechanical ballet, the robot finally meets its lover with a coyness which verges on virginal modesty. A post-industrial folk tale, shot through with sensuality, Chris Cunningham's video for Björk's 'All Is Full of Love' (1999) brings to mind Pascal Bussy's comment about Kraftwerk's song 'Computer Love': 'Could this be the first robot blues?'

As a film-maker, Chris Cunningham creates an atmospheric tension through the highly controlled use of lighting, timing and special effects. He evokes the ambience of environments which seem taut with the expectation of disruption; and it is this device, linked so keenly to his visual interpretation of sound, which makes his film work for musicians such as Aphex Twin, Squarepusher, Portishead (see p. 151) and Leftfield dismantle the clichés of promotional video and reinvent the form, creating postmodern fairy tales rich in contemporary gothicism.

Culturally, this new form of gothicism is also to be found in many of the PlayStation computer games: Cunningham's advert for PlayStation features a 'Celtic cyber-pixie' called Fi Fi as the ambassadress for their slogan, 'Mental Wealth' (see p. 150). The reinvention of gothicism – the compensatory need for 'tales of mystery and imagination' in a world increasingly explained by science – is a constant feature of Cunningham's image-making.

Rather than pursuing the usual course to art college or university, Cunningham managed to talk his way into actual film production by working at the precociously early age of sixteen on the monsters for Clive Barker's *Nightbreed*, and with David Fincher on *Alien3*. The Mozart of movie model-making, Cunningham also sculpted the robot-child for *A.I.* by Stanley Kubrick.

Rejecting the claim that much of his work is 'dark', Cunningham uses the devices of horror, science fiction and the supernatural to suggest stories which seem to articulate the relation of human feelings to the mysteries and myths of our technologically accelerating age. Importantly, he is also a humorist, often using wit and absurdism to frame the devices empowered by his imagery. In his infamous video for Aphex Twin's 'Come to Daddy', for instance, a soul-hungry, demonic-looking figure is released from an abandoned television set when an elderly lady's dog cocks its leg against the screen.

In terms of story-telling, sound and image, Cunningham's interpretation of 'All Is Full of Love' has a tenderness which harmonises with Björk's vocal style, and creates a potent, dreamlike world for the song's sensibility. With their passion conveyed in shades of grey and white, in a clinical-looking environment which animates the stillness of a high-tech service space through the pristine, cold rotations of machine-manufactured components, the robot lovers assume a depth of emotion which reverses the science-fiction cliché of dehumanised machines.

Rather, these robots possess an initial shyness which heightens our sense of their love. In their ultimate coupling, the sexuality of their

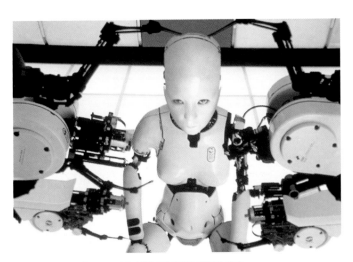

CHRIS CUNNINGHAM/BJÖRK, STILL FROM BJÖRK: 'ALL IS FULL OF LOVE', 1999
Courtesy One Little Indian Records

CHRIS CUNNINGHAM, APHEX TWIN: 'COME TO DADDY', 1997
Album cover
Courtesy Warp Records

love-making is intensified by the flushes of liquid lubricant which speed the fluency of their movements. Finally, as flickers of light play across briar-like, dark swathes of cables, the viewer is left with the sense of having seen machines in love: the tantric ecstasy of robots. In this, Cunningham displays his extraordinary empathy – as an image-maker – with the effects and atmosphere of music. In his own words, Cunningham relates to the entire process of image-making by 'responding firstly to sound'. As a child growing up in Lakenheath, Suffolk – the location of an American airbase – he developed not only a passion for music, but also for interpreting that music through drawing, painting and model-making.

'I spent most of my childhood lying on the floor in my parents' house with my head between the speakers of my father's record player,' Cunningham explained in a television interview. As his parents' taste in music was progressive, running to performers such as Vangelis and the German synthesiser group Tangerine Dream, this immersion in music became entwined in Cunningham's fast-developing creativity. One way to explore the makings of Chris Cunningham's extraordinary career is to consider the phenomenal potency of the imaginary worlds which older children and adolescents develop within their own rooms in the family home. In many ways, these 'bedroom kingdoms' become the laboratory and showroom of maturing feelings, where the worlds on offer from music, films, books and art begin to react with a young person's own response to the world. If that young person happens to have an artistic inclination, as Cunningham did as a child, then the work that is done in the bedroom becomes the crucial founding of atelier skills, as well as a kind of gymnasium for the imagination.

In the case of Chris Cunningham, we know from his interviews that he would draw and make models 'obsessively'. As a young teenager, he became fascinated by books of figurative, representational sculptures and paintings by Michelangelo, for example, and the Victorian painter John William Waterhouse (see p. 151). He was also developing a taste for the electro-pop music of the late 1970s and early 1980s – groups such as The Human League, Dépêche Mode, and, vitally, Kraftwerk. Kraftwerk's influence on his ideas – and even on his approach to artistic discipline – could be taken as profound. Historically, Kraftwerk had emerged in Düsseldorf as a response to the 'head music' scene which had developed in Germany in the 1960s around groups such as Faust, Neu, Amon Düül and Tangerine Dream. In their turn, these groups had rallied to the music of Karlheinz Stockhausen, John Cage and minimalist composers on the fringes of the Fluxus movement such as Tony Conrad and LaMonte Young's Dream Syndicate.

Where Kraftwerk differed from their peers, and the near theology of music which these peers had adopted, was in their gradual stripping down of music itself to an entirely robotic, machine-driven process. Within these robotics – as imagery, philosophy and musical technique – they created a warmth of harmony which has been likened by many critics to the sublimity of American doo-wop singing from the 1950s, and the genius of Brian Wilson's compositions for the Beach Boys. It is tempting to compare this paradoxical discovery of humanising warmth within robotics, as pioneered by Kraftwerk, to Cunningham's interpretation of robot love in Björk's 'All Is Full of Love'. 'I can safely say', Cunningham has remarked, 'that hearing "Numbers", off Kraftwerk's "Computer World" album, was one of the most important influences on my work – ever.'

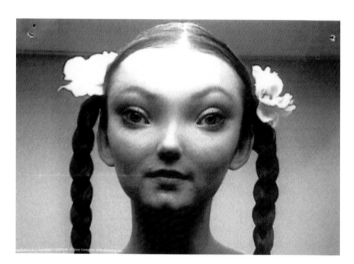

CHRIS CUNNINGHAM, STILL FROM SONY PLAYSTATION: 'MENTAL WEALTH', 1999
Courtesy TWBA GGT Simons Palmer

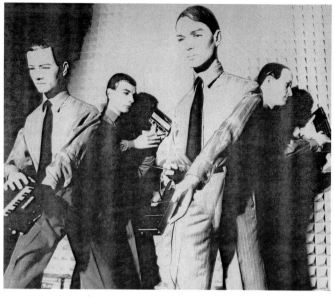

KRAFTWERK: 'COMPUTER WORLD', 1981
Album cover

Released in May 1981, 'Computer World' arrived in a sleeve which depicted Kraftwerk retreating ever deeper into a technological re-creation of themselves. On their previous LP, 'Man Machine', they had posed as constructivist mannequins, and then presented – on their concert tours – actual robots of themselves. Now they seemed to have withdrawn to the other side of a computer screen, achieving a kind of techno-sublimation into the embrace of pure technology. You could imagine the group themselves regarding this conversion as similar to religious ascent: the ecstasy of the saints by way of micro-engineering. One important facet of Kraftwerk's artistic method which Cunningham would share is the group's meticulous planning, honing and control of their composing process. Cunningham is equally obsessive about story-boarding all of his film-work, usually developing and refining new sequences throughout the creative process. The young Chris Cunningham would spend hours drawing the robot mannequins of Kraftwerk, as well as illustrations for The Human League's first two LPs, 'Reproduction' and 'Travelogue'. Considered now, these records represent a heightened sense of classical Western romanticism: they celebrate the mysteries of landscape and the consequences of solitude; and they champion the discipline of artistic craft to enhance the articulation of deep emotions. They are also steeped in a leavening wit, towards their own assumption of new, romantic identities, and towards the world which they interpret. This sense of wit is also fundamental to the vision of Chris Cunningham.

With his grounding in the world of problem-solving design, Cunningham's brilliance as a technician has been matched by his imaginative vision. He has explained in interviews that he has 'always been fascinated by the machinery behind the special effect' – been

more concerned with the actual mechanics which control a viewer's suspension of disbelief than with the conceptual underpinning of narrative.

Cunningham rejects the whole ethos of MTV-style 'video partying', in which the promos become little more than an index of pop cultural clichés, tightly controlled by corporate fears of confusing the consumer. Importantly, in 'Windowlicker', with Aphex Twin, Cunningham dismantles the deeply held sexism which rules over a particular genre of promotional video, disrupting the tired erotica of bikini-wearing young women through the witty and anarchic device of giving them all Richard D. James's features. In this much, his vision takes on a political aspect, daring to expose the insidious stereotyping of race and gender which is advanced in the world of the pop promo.

In his career as an internationally acclaimed director and creator of music videos, Cunningham has developed a visual style and an artistic approach to his subjects which brings the drama of contemporary cinema to the poetics of ambient, 'electronica' music. If his greatest inspirations have come from electronic music and *musique concrète*, then it can be argued that Cunningham's own work is deeply musical in its own right – advancing the architecture of electronic sound into a visual and dramatic medium.

It is these concerns which are now leading Cunningham to pursue further the abstract fringes of electronic music, and how that music can relate to moving images and story-telling. Having worked with artists – notably Aphex Twin, Squarepusher and Boards of Canada – on the ground-breaking Warp label, Cunningham's own work identifies

JOHN WILLIAM WATERHOUSE, *HYLAS AND THE NYMPHS*, 1896
Oil on canvas
98.2 × 163.3 cm
Manchester City Art Galleries

CHRIS CUNNINGHAM, STILL FROM PORTISHEAD: 'ONLY YOU', 1997
Courtesy Go! Beat, London

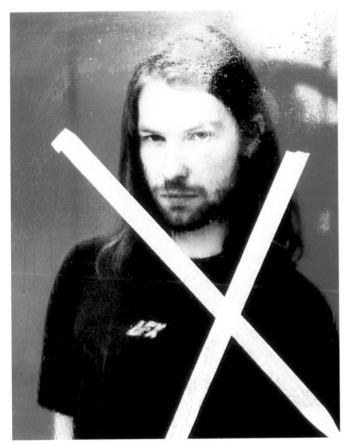

WOLFGANG TILLMANS, *APHEX TWIN*, 1993
Courtesy of the artist and Maureen Paley/Interim Art/London

with the radical ways in which many of Warp's artists are pushing back the boundaries of what can be done with recorded music.

Usually, these Warp releases – from Autechre, for instance – reveal a staggering ability to turn the recording process into a meticulous layering of music, in which the seeming simplicity and purity of the finished piece turns out to be a whole geometry of sound, perfectly set in place. This process mirrors Cunningham's own concerns. In *flex*, his work for 'Apocalypse', created once again with Aphex Twin, he has made a piece which tracks a physical relationship through sound and image, inviting the viewer to engage with a sensory experience which explores, like fairy tales and abstract music, our deeper relation to our inner feelings – the shadow which may give way to light. MB

(pp. 147–148)
CHRIS CUNNINGHAM, 2000
Photograph by Norbert Schoerner

(pp. 152–161)
CHRIS CUNNINGHAM, STILLS FROM *flex*, 2000
Courtesy Anthony d'Offay Gallery, London

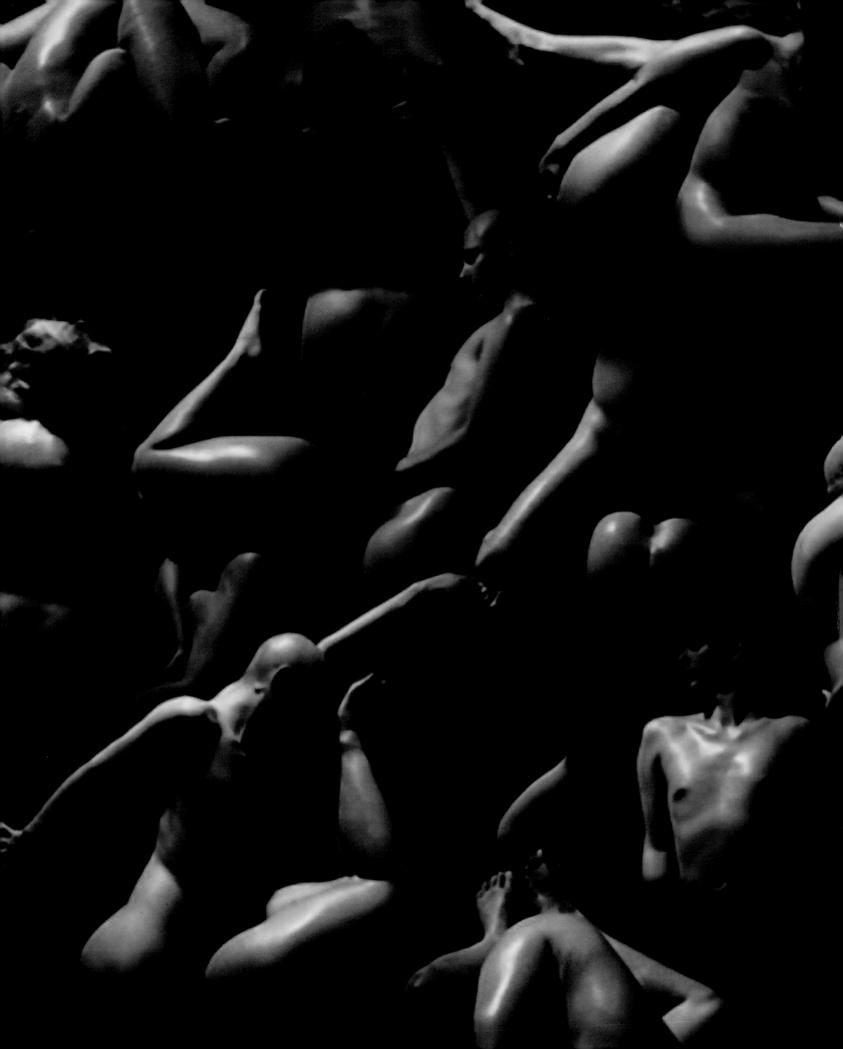

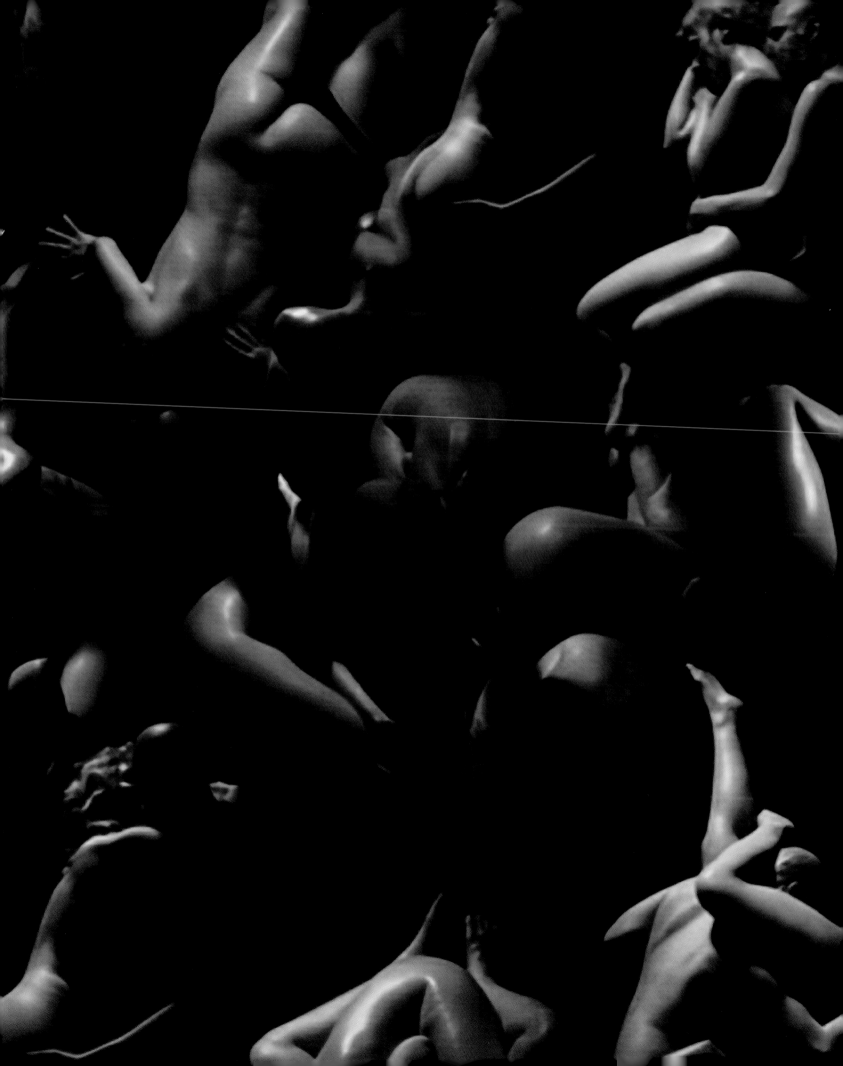

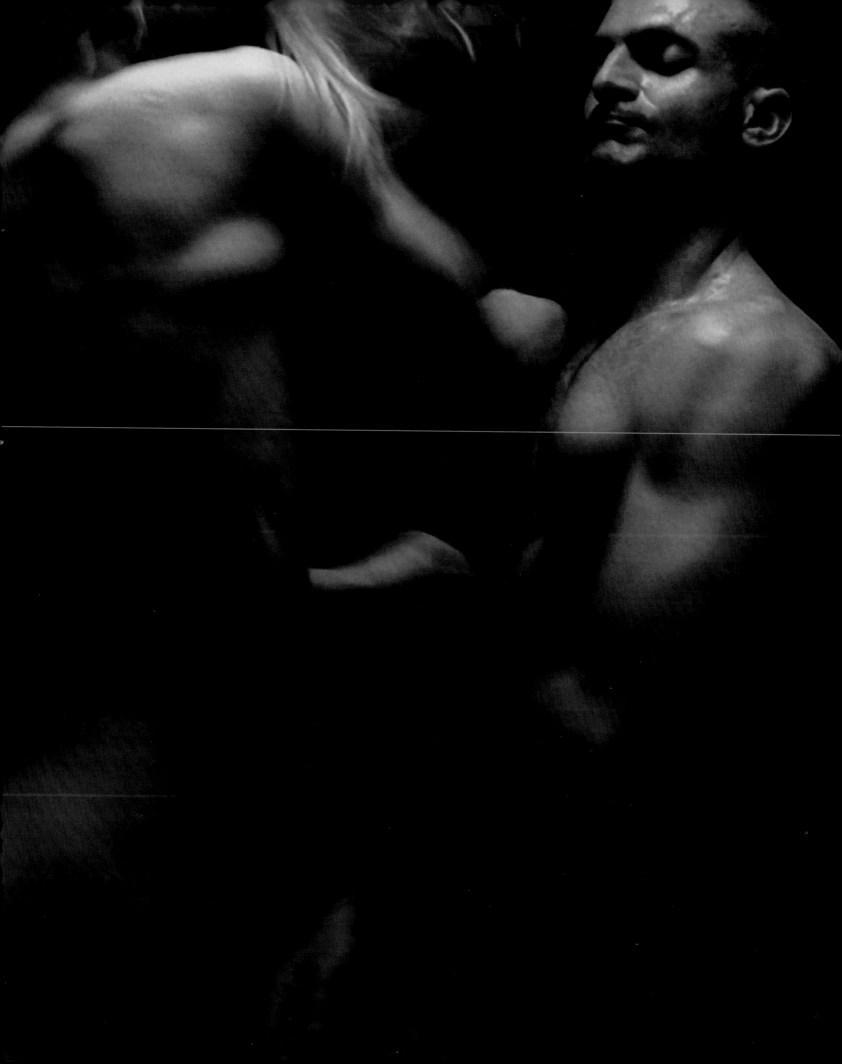

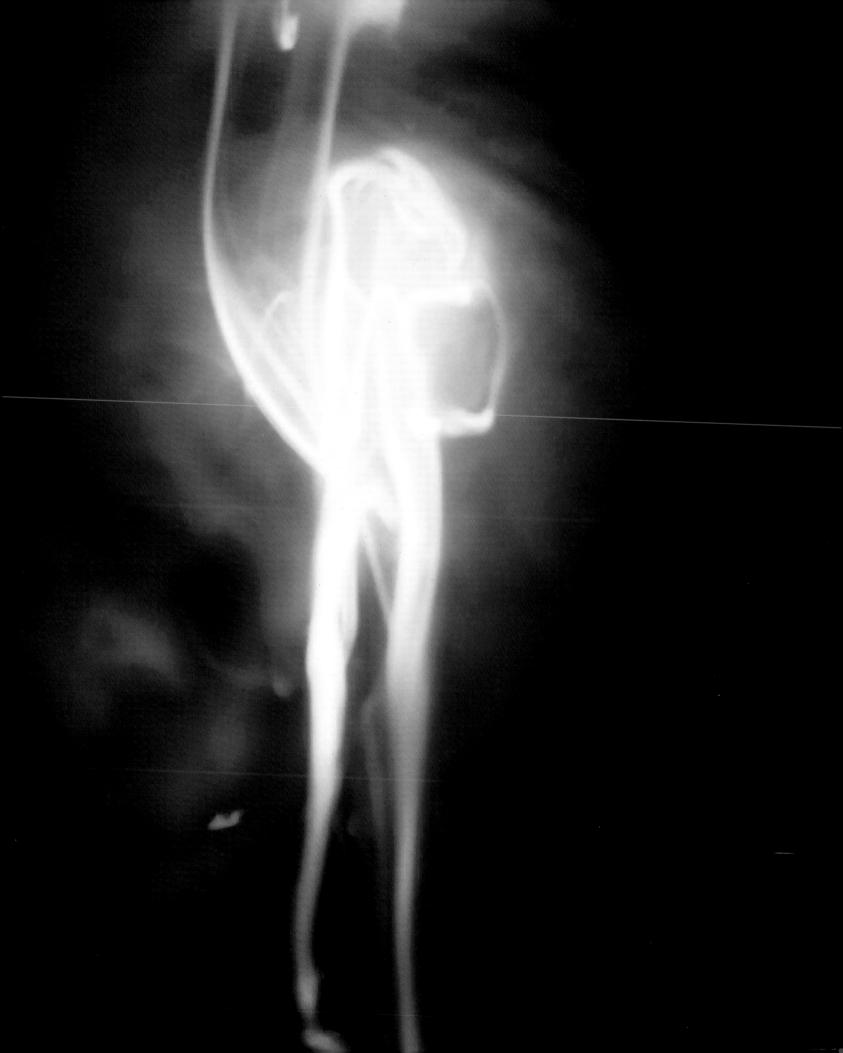

TIM NOBLE AND SUE WEBSTER

SHADOWPLAY

Take a pinch of Schemeland
And turn it into Dreamland...
'Death Trip', Steve Harley and Cockney Rebel, 1974

Visceral yet lumpen, lurid yet delicate, the art of Tim Noble and
Sue Webster is filled with contradictions. Encountering their work
for the first time, a viewer will be struck by its mixture of vivacity and
savagery. Mixed messages of love and death, of ambition and nihilism,
are carried on a style which alternates between cartoon delinquency
and a kind of modern baroque.

Sue Webster was born in Leicester in 1967, and Tim Noble in Stroud
in 1966. The couple first met in 1986 at Nottingham Polytechnic,
where they were both studying fine art. Their personal relationship,
from this initial meeting, has become a major informant of their
creative partnership as artists. The couple do not claim to be two
people working as one artist; rather, the direction of their work is
dictated and considered by the conflation of their separate ideas,
enthusiasms and acquired skills. As Tim Noble remarks, 'We are
consistently inconsistent; that's one of our greatest strengths.'

Over the course of their career, Tim Noble and Sue Webster have
worked in many different artistic media: they make paintings,
sculptures and assemblages of lights and neon. The couple
have also turned their hands to fly-posting montaged pictures of
themselves, and once set up their own street tattoo-parlour during
the 'Livestock Market' art fair held in Rivington Street in East
London in 1997. Above all, however, Tim Noble and Sue Webster
have worked with the idea of themselves as artists who are making

works within the somewhat febrile climate of contemporary British
culture. Their intentions are maybe explained by a work which they
made in 1998, *Dirty White Trash (with Gulls)*. In this piece, 'six
months worth of artists' rubbish' has been meticulously assembled
and crafted – itself a contradictory act – in such a way that when
light is projected upon the seemingly chaotic heap, it casts the
shadow of the artists in perfect profile. Caught with the accuracy
of a silhouette, this shadow piece shows the couple relaxing back
to back, one sipping a glass of wine, the other enjoying a cigarette.
Meanwhile, two stuffed seagulls pick at a few discarded chips on
the edge of the dumped rubbish. What could this tell the viewer
about Tim Noble and Sue Webster as a couple? They live together
as well as work together, and they have an uncanny physical
similarity which makes them look like brother and sister. And
as artists?

One answer might be that they regard themselves as determinedly
careerist, within a line of work – the art world – that they regard
as a complex game, and one in which cheats, short cuts or open
ridicule of the prevailing mainstream can all be taken as valid moves.
Following hard on the heels of this assessment of the pair, however,
is the fact that their work can be divided into that which is extremely
simple to make – little more than the cut-and-paste techniques of
ersatz punk montage – and that which is painstakingly crafted. Taken
all together, the different strands of their art entwine to make a coded,
polemical commentary on cycles of life and decay – the mortality of
species and the deliquescence of cultural movements or individual
careers. In this sense, Noble and Webster could be described,
with accuracy, as 'decadent' artists.

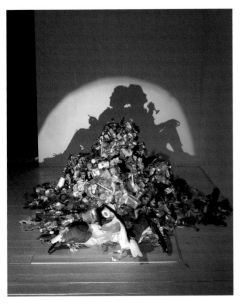

TIM NOBLE AND SUE WEBSTER, *DIRTY WHITE TRASH (WITH GULLS)*, 1998
Seagulls, light projector, six months of artists' rubbish
Dimensions variable
The Collection of Dakis Joannou, Athens

TIM NOBLE AND SUE WEBSTER, *BIG EGO*, 1993
Billboard poster
Courtesy Modern Art, London

On leaving Nottingham, the couple took up a residency, in 1989, in the sculpture studios at Dean Clough, in Halifax. It might be taken as eloquent of their artistic temperament – or of the recurring motifs within their later work, suggesting a desire to keep themselves at arm's length from their peers – that Noble and Webster headed north just as the movement which would become mediated as 'Young British Art' was beginning to gather momentum in London.

As Damien Hirst had curated his influential 'Freeze' show at the Port of London Authority building in London's Docklands the previous year, so within two years the mere idea of Young British Art would have become a usefully malleable phenomenon. Taken up by the media, as much as by patrons, galleries and collectors, this new direction in British art – as it merged with other pop cultural strands – would be taken to represent the temper of the *Zeitgeist*.

In 1992, Tim Noble came to London to study on the sculpture MA course at the Royal College of Art. By this time, the whole phenomenon of Young British Art was following, point for point, the route between a fledgling metropolitan bohemia (those former urban badlands, colonised by artists) and 'uptown patronage' which the American cultural commentator Tom Wolfe had defined in his book *The Painted Word* nearly two decades earlier.

Cutting-edge contemporary art – 'warm and wet from the loft', as Wolfe describes it – can enjoy a relationship with its patrons which benefits both parties. The ensuing social and cultural milieu created by this relationship – and as seen, in Britain, to have been achieved through the mediated phenomenon of Young British Art – becomes a new kind of orthodoxy, influential in taste-making, and provoking an inevitable response.

The translation of Young British Art into a social phenomenon, with its own cast of characters and social types, and its particular topography around Hoxton and Shoreditch in East London, seems central to an understanding of the earlier work of Noble and Webster. As the couple moved to Hoxton in 1995, holding their first solo exhibition, 'British Rubbish', at the Independent Art Space, they arrived on the Young British Art scene as the partying of that movement was already approaching its second wind. For Noble and Webster, the appropriation of Young British Art's own idea of itself – as an oven-ready phenomenon, as it were – became their point of intervention.

In terms of their style, Noble and Webster have been claimed by some critics to revive the aesthetics – and tactics – which were set in place by the first wave of British punk rock between 1976 and 1978. Too young to have participated in this movement as anything other than youthful observers, Noble and Webster can be seen to have taken a received idea of punk – the strategies, the baggage and the healthy bloody-mindedness – and applied it to their own generation's attempts to re-route popular culture through the media of contemporary art.

Prior to 'British Rubbish', Noble and Webster had already made works which centred around the sloganeering, fly-posting and do-it-yourself ethos of punk pamphleteering. Tim Noble had usurped a billboard poster competition run by *Time Out* magazine in 1993, with his work *Big Ego*. The competition was open to people who had been resident in London for 25 years (Noble had not) and in this much Noble's

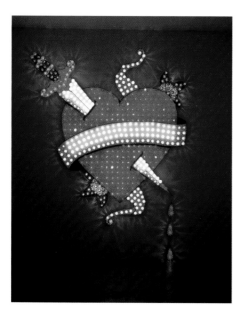

TIM NOBLE AND SUE WEBSTER, *TOXIC SCHIZOPHRENIA*, 1997
516 Lamps, holders and UFO coloured caps, 6 mm foamex, vinyl,
aerosol, electronic, 51-channel, multi-functional sequencer
260 × 200 cm
Collection of Saatchi Gallery, London

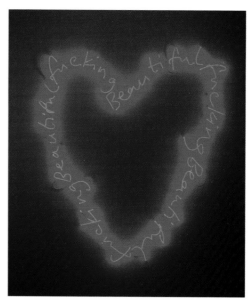

TIM NOBLE AND SUE WEBSTER, *FUCKING BEAUTIFUL*, 2000
Hot pink neon
168 × 148 × 6.5 cm
Edition 5 + 1AP
Private collection

design – a crudely assembled poster (which was in fact designed by
Sue Webster), featuring his face and the statement, 'Tim Noble Born
London 1968' – was revelling in its own falsehood. Noble, after all,
was born in Stroud in 1966.

Similarly, in 1994, Noble and Webster doctored an image of the
legendary artists Gilbert & George, by simply sticking their own faces
over those of the original. They called this work *The Simple Solution*,
and it followed the same thinking – in terms of making a creative
virtue out of hijacking an existing graphical device – as Noble's
disruption of the *Time Out* poster competition.

If one of the distinguishing characteristics of the Young British
Artists – as a mediated, social type – was to own or affect an image
of 'dumbed-down' rebelliousness (the 'Boho Dance' in Tom Wolfe's
definition of the type), then Noble and Webster were amplifying this
tactic to the point of caricature.

More than one critic has remarked how their street tattoo-parlour,
with its amateurish, felt-tip pen 'tattoos', exposed the way in which
a previously working-class, light-industrial area of London had become
colonised in the name of art from the power-base of a bourgeois
economy and lifestyle. This was Wolfe's 'Boho Dance' made visible.
As David Barrett was to write of the event: 'Young artists finally
had the hard-core tattoo they'd always wanted, and they strutted
up and down Charlotte Road like a bad actor doing the LA Bloods.'

By the middle of the 1990s, however, Noble and Webster were
beginning to plan intensely crafted pieces. Inspired by a trip to

Las Vegas – although they say that watching videos of films about
Las Vegas inspired them more – the couple began to work with light.
Exuberant, vivacious and redolent of the perverse glamour of British
travelling funfairs, these light pieces took the 'trash aesthetic' of
rockabilly gothicism and turned it into free-floating emblems of desire
and sensory overload (see above and pp. 172–173).

The visual joyousness of these pieces – simplistic promises of glamour,
carnival and success – were matched by two further developments
in the work of Noble and Webster. In many ways, their do-it-yourself
aesthetic had become the signature of their vision: that despite
themselves, almost, they were honing a view of contemporary
culture which was based on the imminent implosion of cultural
materialism itself.

What was emerging in their work, through their monolithic model
of themselves as a quasi-Neanderthal couple – *The New Barbarians*
(1997, see pp. 169, 170) – and their gruesome projections of
themselves from the contours of garbage, was a targeted celebration
of aimless nihilism. This was not the proactive nihilism preached
by Nietszche as a phase of spiritual empowerment. Rather, in the
imagery of decay, violent death and destruction, sharpened with wit
and tempered with sentimentality, this was the imagery of romantic
nihilism: tribal, insular and dancing on the imagined grave of a society
which might one day choke to death on the sheer waste of its own
consumer products. The triumph of terminally dumbed-down culture.

In one of their most recent works, *British Wildlife* (2000, see pp.
174–175), Noble and Webster have consolidated the themes and

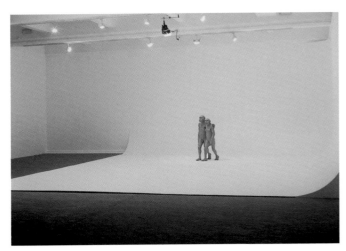

TIM NOBLE AND SUE WEBSTER, *THE NEW BARBARIANS*, 1997/99
Glass-reinforced plastic, translucent resin, plyboard, fibreglass
Installation view, Chisenhale Gallery, London, 1999
Dimensions variable
Private collection, New York

TIM NOBLE AND SUE WEBSTER, *FROM F**K TO TRASH*, 2000
Acrylic on MDF
30.5 × 30.5 cm
Collection of the Flash Art Museum, Milan

techniques of their 'Shadow' pieces. As with their obsessive involve-ment in crafting the 'trash' of their 'White Trash' pieces, the couple have assembled a quantity of inherited stuffed animals – themselves reminiscent of a forlorn, morbid notion of Britishness – which cast a monumental shadow of their combined profiles.

Through working with the legacy of taxidermy, in which they can describe the nuances and cruelties of the natural world, Noble and Webster present the viewer with a compelling tableau of morbidity and ghoulishness. If *Dirty White Trash (with Gulls)* put forward the idea that Noble and Webster saw themselves as trash, trashing in turn a rubbished society, then *British Wildlife*, with its poetically archaic assemblage of stuffed animals, seems to amplify the themes of mortality. In all of this, however, they celebrate their relationship with one another, reversing the sentiments of the classical 'Et in arcadia ego' to suggest that in the midst of death there is life.

For 'Apocalypse', Noble and Webster have expanded their aesthetic to encompass an epic notion of the sublime – re-routed through the now-established signature of their own vivid style. *The Undesirables* (itself reminiscent of the title of a pulp exploitation novella from the late 1950s) takes the form of a mountain of garbage-filled bin liners with a scattering of litter on its peak (see pp. 176–177). The projected shadow of this crowning litter shows Noble and Webster no longer in profile but now with their backs to the viewer, and to scale, as observers on the summit.

Inspired in part by their drive to Glastonbury's music festival, and their wait on a hillside, as the sun was setting, to hear a performance

by David Bowie, the couple also cite the cover of Gary Numan's 'Warriors' LP as an influence on this work. 'We've ascended above the trash,' says Sue Webster of *The Undesirables*, thus completing (in the tradition of nihilism) a classic circuit of Western romanticism. MB

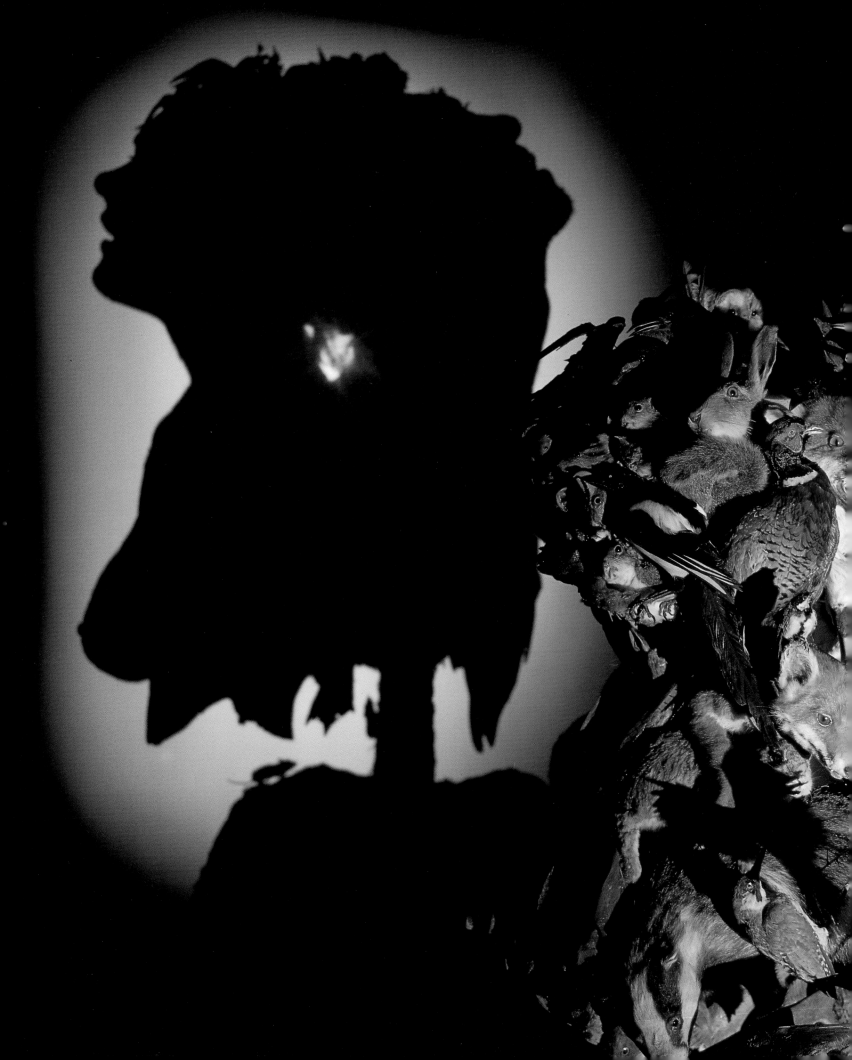

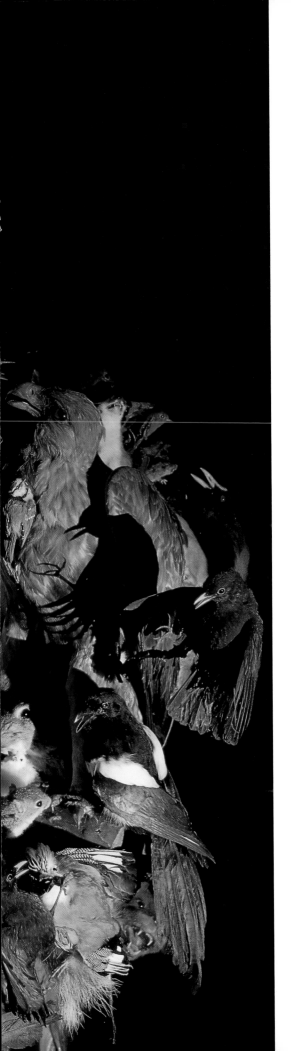

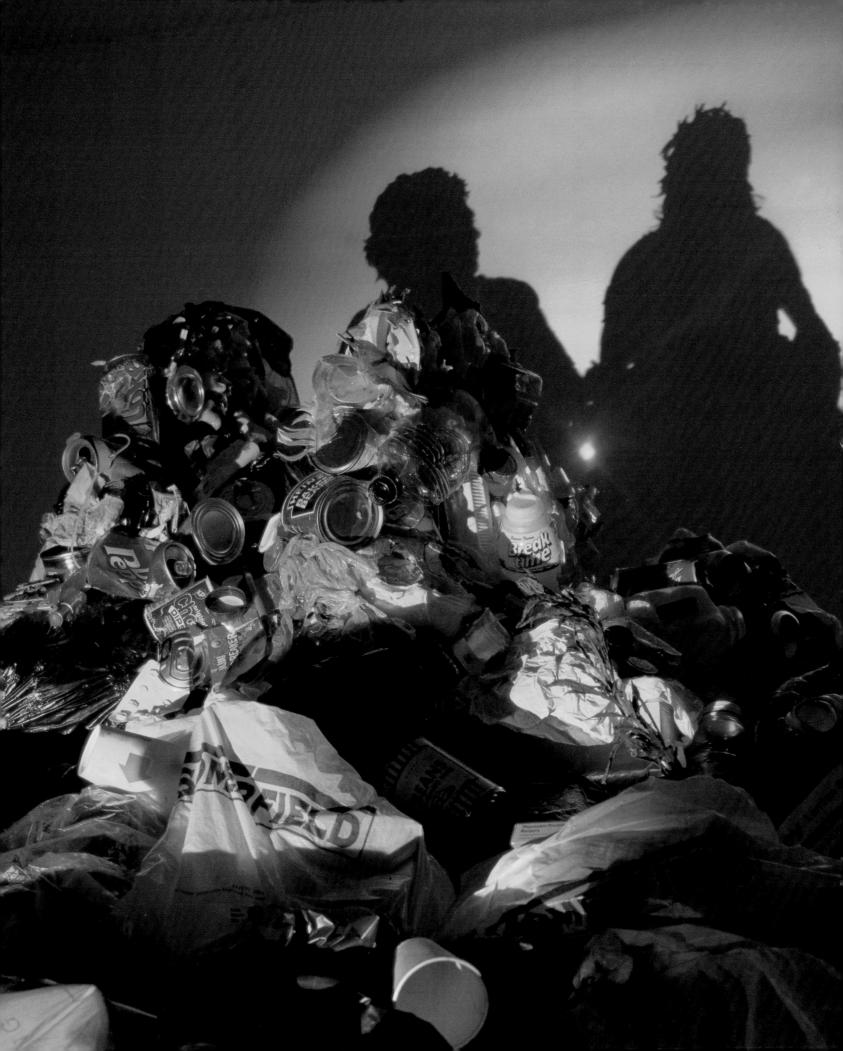

DARREN ALMOND

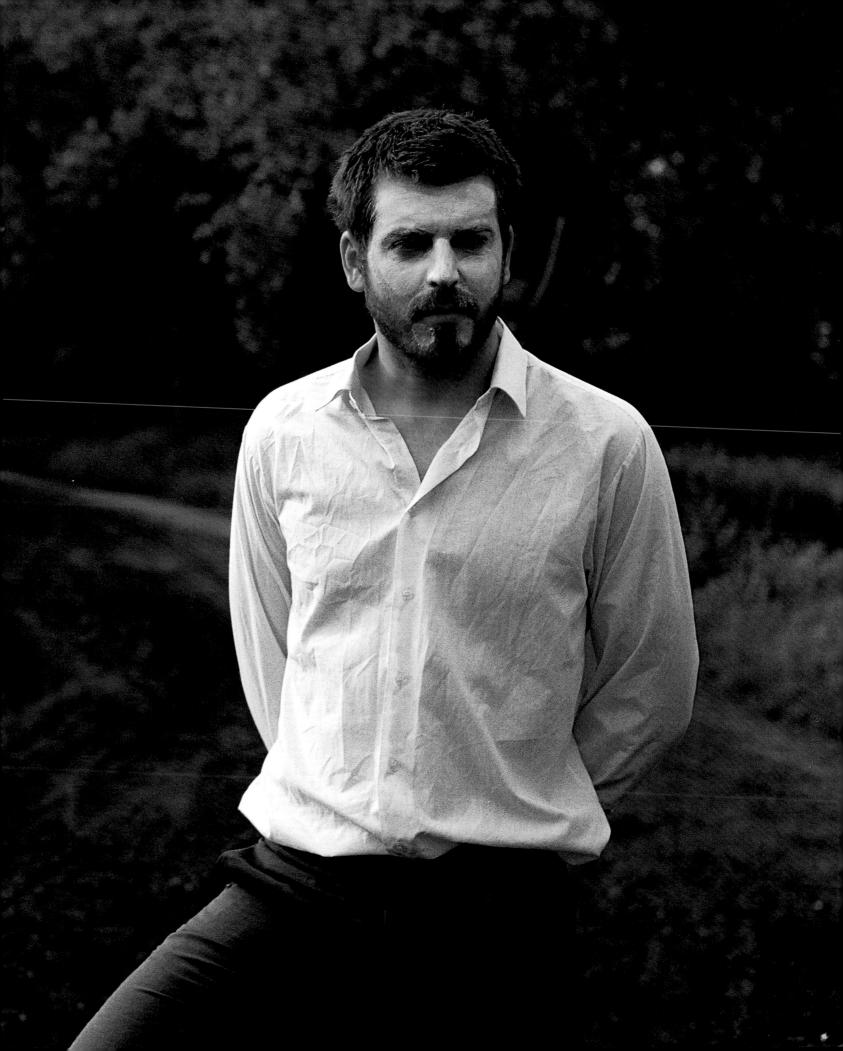

THE TICKING OF THE CLOCK

At first sight it seems that everything is plain and clear and laid out before us in Darren Almond's *Traction* (1999). Almond's father, seen in close-up on one of three large screens, recounts how he came about the various injuries he has suffered over the years. The narrative unfolds through a series of responses to questions posed by Almond himself, who is heard, but who remains off-screen. Beginning with an early memory of his own blood flowing from a badly cut toe, Almond's father slowly moves up his body, charting the various flesh wounds and broken bones that have come as a consequence of a life spent working in construction and labouring jobs and relaxing on the sports field. According to the account, it has been a hard life with more than its fair share of accidents and mishaps. In spite of this, however, there is no hint of anger being directed either at something as unspecific as fate, or at more tangible targets such as mendacious employers or unsympathetic medical staff. Instead, the tone is matter-of-fact and gently humorous. This recording of the unscripted conversation between Almond and his father was later played back to the artist's mother, and on an adjacent screen we see her listening to it. She says nothing, reacting to the narrative with smiles and expressions of shock or surprise, and finally begins to weep.

Throughout this journey from one end of Almond senior's body to the other, a black-and-white image of a digger scraping at a road surface and clearing the resultant rubble plays on the third screen. Slowed down and silent, it comes up just after the beginning of the work and fades away shortly before the end. The conversation thus frames this otherwise constant reminder of the economic and physical realities of the world of hard manual work within which Almond's father has lived and made his living. Because the digger is contained in this way, it is impossible to take the unrelenting harshness of working conditions to which it alludes as anything so straightforward as a reason, an excuse or an explanation for the very personal events and their consequences which we are being told about. Social conditions and the broader play of history are undoubtedly significant as the context within which a life – this particular life – is led, but it is the viewer, too, working across and between the different screens, who necessarily becomes engaged in the construction of narrative. Notwithstanding the richness of the visual material and the information given on the soundtrack, it is soon apparent to the spectator that whatever it is to which we are being given access, it is nothing so simple as a knowledge of the incidents being recounted by Almond's father. For all that we come to know them, they remain essentially inaccessible to us, a fact that is brought home by the mother's final breakdown into tears following Almond's last question, 'And Mum's seen all this happen?' The effect of the father's slow tracking from split toe to leg wound to sliced thumb to cracked ribs to fractured skull is to constitute a body for, and within, the film; a body which refers to, but which is not identical with, the flesh and blood of which it speaks. It is, in Martin Herbert's words, 'a topography of the figure, one which has not been displayed but which...has been convincingly figured forth in its pure absence'.[1]

Presence and absence tug against one another elsewhere in Almond's work, especially in his use of broadcasting technology. *A Real Time Piece* (1996) employed it to transmit a picture of his studio by satellite to a shop in another part of London. Standing in one location, viewers could watch what went on in another, distant space. To all appearances what actually went on was not very much; although as a studio it was ostensibly the site of the production of art, the artist was absent.

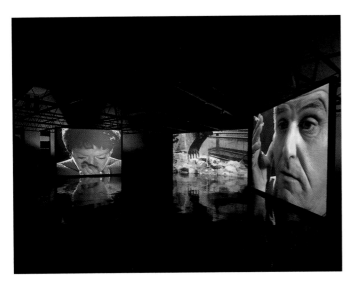

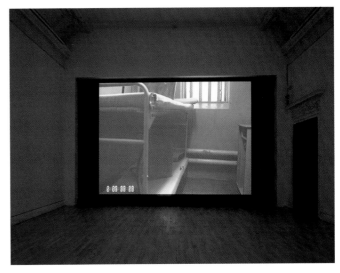

DARREN ALMOND, *TRACTION*, 1999
Three-part video installation
Duration: 28 minutes
The Renaissance Society

DARREN ALMOND, *H.M.P. PENTONVILLE*, 1997
Video footage of live link between Pentonville Prison and ICA London (7 May 1997) with sound
Edition of 3 + 1 AP (U-matic tape and CD)
Duration: 1 hour
Courtesy Jay Jopling/White Cube, London

All that could be seen was the room itself in which the only discernible incident was the slow change in light conditions and the flipping over of a clock from minute to minute. For a subsequent piece, *H.M.P. Pentonville* (1997), Almond set up a live broadcast from a cell in Pentonville prison to the ICA. The cell remained empty, but for the sounds – of the building's occupants, and of doors opening and closing, being locked and unlocked – that spilled into it from elsewhere. Here the viewer was forced to face the truth of a language that refers to the serving of a prison sentence as 'doing time', and to acknowledge the flow of time as the medium of the body's existence. In a related way, Almond talks of vulnerability in respect of *Traction*: 'the vulnerability of your body, the vulnerability of your mind, the vulnerability of love, the vulnerability of tenderness, the vulnerability of loss and the vulnerability of yourself against time'.[2] *Traction* is as much a portrait of the artist himself (even though he is never seen), as it is of his parents.

In his essay 'Entropy and the New Monuments', Robert Smithson wrote that instead of asking what the time is, we should pose the question, 'Where is the time?'[3] This would better acknowledge our awareness of the interconnectedness of the spatial and the temporal aspects of our personal and collective histories. Reference is frequently made to the fact that Almond was a train-spotter in his youth. The activity enabled him to travel widely outside Wigan, where he was born in 1971, and to develop a sense of the wider space of the country through an understanding of its rail network and the timetables that structure movement across it. Recalling his past spent standing at the end of platforms, Almond cast a series of metal nameplates in the style of those seen on InterCity 125s.

Eric Blair (1997), the real name of George Orwell, a man famously associated with Wigan, is there. Another, playfully suggesting that perhaps the town has more than one famous son, commemorates *Darren James Almond* (1997). Somewhat as Simon Patterson's *Great Bear* (1992) substitutes comedians, footballers, philosophers, newsreaders, kings and others for the names of London underground stations on the tube map, Almond's nameplates weave personal biography, private passion, culture, history and politics through the world at large (see pp. 186–187). Other works – *Schwebebahn* (1995) and *Geisterbahn* (2000, see p. 185) – have taken trains as their subject matter. The Schwebebahn is Wuppertal's monorail, constructed early in the twentieth century. Now more of a curiosity than anything else, at the time it was built it represented both a vision of the future, and a belief in the technological capabilities that could lead to that vision being realised. Almond's film was shot from one of the suspended cars, and the footage was then flipped and reversed so that time, gravity and the body's relation to both became disconcertingly unbalanced. *Geisterbahn*, shot from the eye socket of the skull on the front of a ghost-train car, shows the view as it circuits the ride in Vienna. The slowed-down film is black and white – mostly black – with occasional sparks of light that intimate form and presence, but which rarely resolve themselves into recognisable images or objects. This suspension of visual resolution is heightened by the soundtrack of spare electronic music, which also implies the possibility of structure, harmony, melody, without ever quite delivering them.

For social theorist Michel de Certeau, travelling by train acts to disrupt spatial experience, breaking the three dimensions of real space into separate elements of one and two dimensions – namely, the line of the

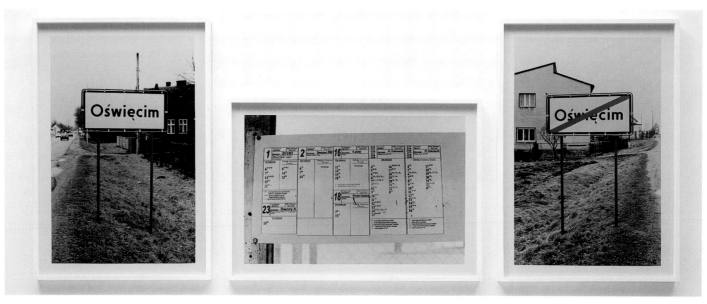

DARREN ALMOND, *JOURNEY*, 1999
C-type colour prints, triptych
Three panels: each 53 × 76 cm (framed)
Courtesy Jay Jopling/White Cube, London

track and the plane of the window onto which the landscape through which one passes is projected. It is only when we step down onto the platform again at the end of the journey, says De Certeau, that history can begin once more.[4] Someone once said that the best way to catch a train is to miss the one before it. The appeal of this piece of advice is that it characterises the day not as a series of isolated events separated by irrelevant periods of inactivity, but as a continuous flow within which time spent in expectation, anticipation, contemplation or just plain idleness has its own significance. Time understood in this way becomes something more than a blank duration waiting to be filled up with meaningful occurrences. It is, rather, something through which one lives and in so doing finds oneself altered. It is the difference between the German words *Erlebnis*, which conveys something that one has, as it were, lived to see, and *Erfahrung*, which suggests a happening that, in its thorough assimilation, leaves one a different person. The sense of time in Almond's work is of this latter sort. The way in which we experience time itself, rather than events that happen to require time for their unfolding, is one of his central concerns. It features in one way or another in much of his work, and is not infrequently physically present – as with *A Real Time Piece* – in the form of a clock. In the same way, *Tuesday (1440 Minutes)* (1996) shows the artist's studio, comprising as it does 24 panels of 60 photographs taken at minute intervals throughout a day. Just as Jan Dibbets's sequence of photographs taken in his studio in 1969 – *The shadows in my studio as they were at 27/7/69 from 8.40–14.10 photographed every 10 minutes* – primarily plots the movement of shadows as the sun moves overhead outside, Almond's photographs show the day's cycle from darkness to light and back to darkness as itself an event.

Over a period of years, Almond has made several works in and about Auschwitz (now the Polish town of Oswiecim). He is conscious that his generation is entirely removed from any direct experience of World War II, and while the culture continually impresses upon him and his peers the importance of this event, the war remains 'a completely abstract notion'. Access to it can only be gained through the constructed accounts of those somewhat older than himself who were there. This state of affairs presents Almond, as it does the rest of us, with a choice. Either we take the time and trouble to investigate this history, or we let it slip away and instead concentrate on trying to satisfy our own immediate desires: 'I'm outside, waiting at a bus stop. I can choose to go in and get involved with the histories and look at the relics and try to come to terms with that moment in history, or I can get on that bus and carry on.'[5] *Oswiecim, March 1997* (1997, see pp. 188–189) consists of two black-and-white films projected side by side to the accompaniment of music by Arvo Pärt. Each shows one of the bus stops outside the former concentration camp. People who have perhaps visited the camp and are about to make the return journey stand at one, while at the other a small number of passengers wait for a bus to take them further. One thinks of Joseph Beuys's sculpture *Tram Stop* (*Strassenbahnhaltestelle*) (1961–76, see p. 17), which, while it employs a similar metaphor in referring to the same historical reality, comes from an artist whose work grows from that very experience of the war that Almond does not have.[6]

Last year, Almond was granted permission to remove the bus shelters featured in the films. Transplanted to Berlin, they were positioned in the Max Hetzler Gallery to form Almond's exhibition there. In the gallery environment the shelters connect with sculptural history:

DARREN ALMOND, *TUESDAY (1440 MINUTES),* **1996**
Photographs
Each frame: 64.5 × 54 cm
Edition of five
Courtesy Jay Jopling/White Cube, London

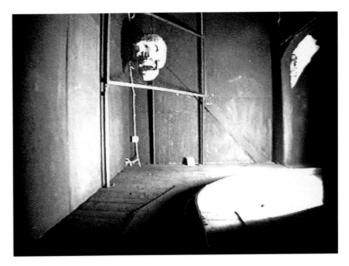

DARREN ALMOND, *GEISTERBAHN,* **1999**
Single screen black-and-white video loop
Duration: 9 minute loop
Courtesy Jay Jopling/White Cube, London

the Duchampian ready-made, the found object (cigarette butts remain in the waste bins), the engineered look of minimal sculpture, and so on. Yet they are, in other ways, precarious structures since they have been uprooted and now simply rest on the floor. The reconnection with Oswiecim and its history is now being made in a further stage of the project. Permission to remove the original bus shelters was granted only on condition that Almond design and provide replacements. Following this exhibition the new shelters on show here will be reinstalled outside the former concentration camp. MA

(pp. 178–181)
DARREN ALMOND, 2000
Photographs by Norbert Schoerner

(pp. 186–187)
DARREN ALMOND, *ALFRED,* **1999**
114.5 × 22.3 × 1.2 cm
Cast aluminium and paint
Courtesy Jay Jopling/White Cube, London

(pp. 188–189)
DARREN ALMOND, *OSWIECIM, MARCH 1997,* **1997**
Two 8 mm parallel films with sound
Dimensions variable
Courtesy Jay Jopling/White Cube, London

(pp. 190–191)
DARREN ALMOND, *BUS STOP (2 BUS SHELTERS),*
1999
Aluminium and glass
Each 603 × 303 × 270 cm
Installation at Galerie Max Hetzler, Berlin

(pp. 192–193)
DARREN ALMOND, CAD DRAWINGS FOR *BUS STOP*
(2 BUS SHELTERS), **1999**
Drawings by Cory Burr, M. J. Smith Design

Stranglers

on a Train

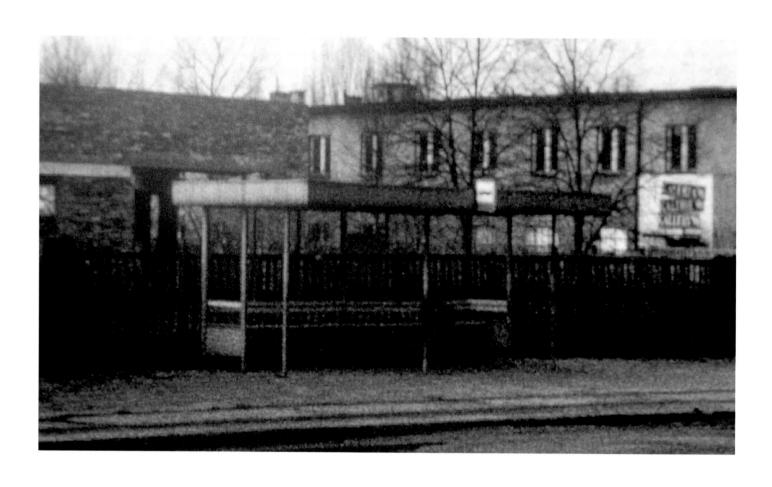

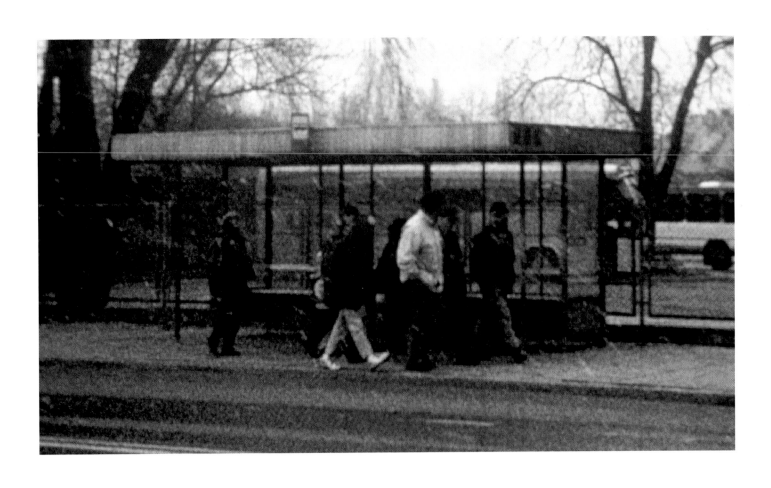

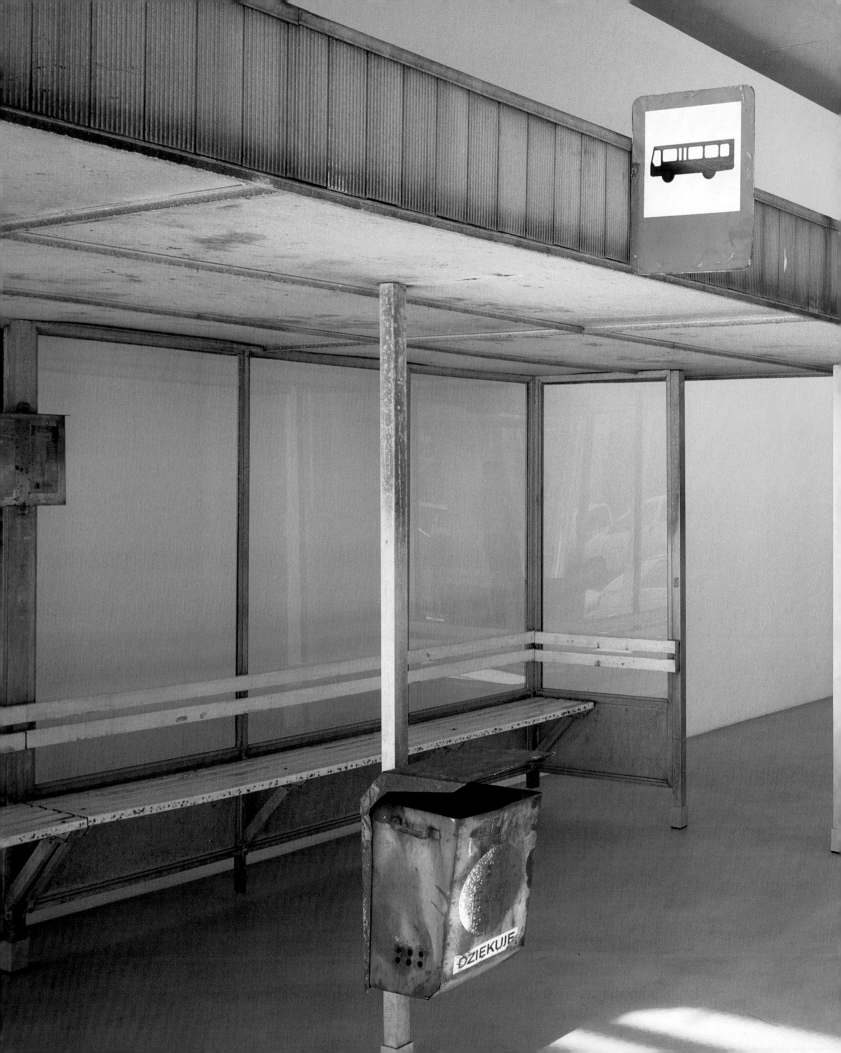

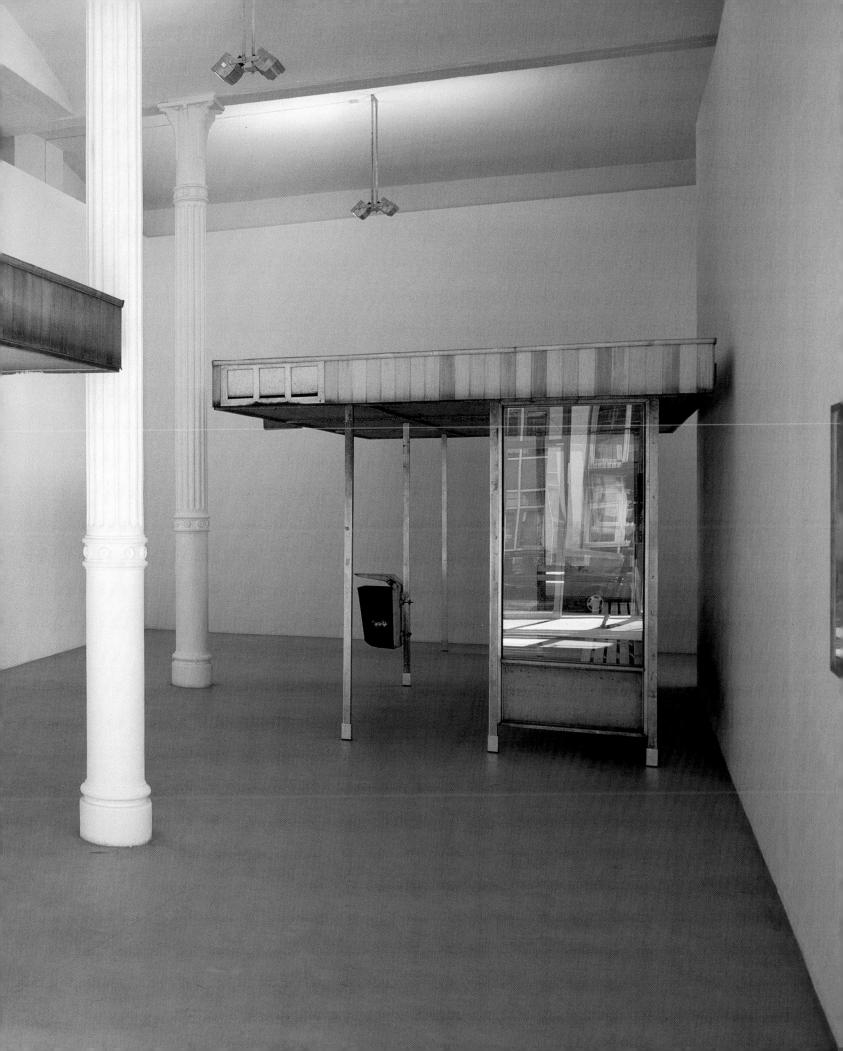

Do not overthrow! Nicht stürzen!
Keep dry! Vor Nässe schützen!
Fragile! Zerbrechlich!

ANGUS FAIRHURST

THEATRE OF THE ABSURD

Right from his earliest work, Angus Fairhurst has been interested in the mechanics of consumption and the manufacturing of desire. Born in Kent in 1966, he was one of the generation at Goldsmiths who went on to become so influential in British art during the 1990s. While still at Goldsmiths in the 1980s he was struck by a message he came across on an item of clothing. It made explicit the fact that the capitalist system characterises any piece of merchandise as something which has been conceived specifically for each individual consumer. The prospective purchaser, identified as 'you', is addressed: 'Hello, let me introduce myself. I was made with you in mind. I was made for living in. I'm fun, I'm fearless and I'm the best, so wise up and try me.'[1] That such an overblown invitation was attached to nothing more than a cheap pullover seemed both ridiculous and yet somehow appropriate. Shortly after that, a series of postcards, blown up to huge proportions and punctured with a host of plastic price tags, began Fairhurst's exploration of this territory, setting images of perfection, fantasy and the ideal in the context of that network of purchase and consumption which gives them purpose and meaning. Since then, using a variety of media, he has set up systems of communication and of the transmission of information, and pushed them to their limits in testing the possibilities through them of empathy, feeling and physical and emotional connection.

Fairhurst's work confounds us. It is not simply that he employs a wide range of forms and techniques – drawing, painting, photography, sound, computer printout, performance, animation, sculpture – it is more that disappointment, in the sense that things anticipated are inevitably frustrated, sits at the heart of all his work, and to an extent fuels it. The word to describe his art might well be 'abject', were it not

for the fact that the term fits too neatly into current art-critical and theoretical debates about the shifting relationship between subject and object. His work is too acceptable to be acceptable. The way Fairhurst puts it, much more directly, is that he 'sticks his oar in' and tries 'to trip up what might otherwise be'.[2] In the sound work *Fainter and Fainter* (1998), a bank employee answers a phone, discovers that there is no-one on the line and hangs up. When the phone rings again, the person who picks it up hears a replay of the first person's answer. The third time both earlier calls are heard. This continues until there is a tinny cacophony of voices feeding back into the bank's attempts to meet its customers' needs. Each effort to function properly and adequately meets a mutant version of itself coming back the other way. Due to its multiplication, this perverse kind of reflection makes it increasingly difficult to hang on to anything like the original. An earlier telephone work by Fairhurst involved connecting pairs of London galleries in such a way that both picked up the receiver in response to a call. After repeatedly discovering a 'rival' on the other end of the line who was, by all appearances, playing a joke on them, several galleries started to think that they were being deliberately targeted. It was a small kind of unrest to foment, but Fairhurst has never been one to get ideas above his station. Even the titles of his works tell us as much. How excited should we be at the prospect of seeing a series of paintings called *Low/er/est Expectations* (1997), or some animated film loops entitled *Things That Don't Work Properly/ Things That Never Stop* (1998)? Pairs of disembodied legs move up and down, sometimes connecting but more usually moving counter to one another. Male and female genitals overlap, redouble themselves and become messily overcomplicated before resolving into isolated simplicity again. What interests Fairhurst in all of this is the process

ANGUS FAIRHURST, *GOLDEN SWIRL ATTACHMENT*, 1990
Photograph, garment attachments, gold spray
122 × 173 × 6.5 cm
Private collection

ANGUS FAIRHURST, *PIETÀ*, 1996
C–type print
Edition of six plus A/P
248 × 183 cm
Courtesy Sadie Coles HQ, London

of change. Something that is set up generates from within itself a kind of mutation or decay, or an increasing complexity, such that, in its final falling apart, the possibility either of a return to the original simplicity, or of establishing something altogether new, is realised. In the animated loop *Broken/Unbroken* (1999), two pairs of legs, joined at the waist, cavort in a manner that is part acrobatic, part sexual. The shimmering and shifting background against which this takes place comes about as a direct consequence of Fairhurst's technique of drawing on computer. The background colour for each frame is provided with a single click of the mouse, which means that if the outline of the legs is not continuous, they will be flooded with the same colour.

A gorilla appears in several guises in photographs, on video, in drawings and animations. Sometimes the pathetic inadequacy of the attempt to convince is advertised, as in the title *A Cheap and Ill-fitting Gorilla Suit*; but as often as not we are left to hover between perceptions of this figure as being either not quite human or all too human. Is it male or female? Either, neither or both is open to question. In *Pietà* (1996), lying naked across the lap of one such creature – a human dressed up to look like an unclothed animal – Fairhurst's deliberate resemblance to, or aping of, the dead Christ in the arms of a loving and tender gorilla/Mary, as in Michelangelo's *Pietà*, is both ridiculous and moving. A persistent image in recent years, closely related to the presence of the gorilla in Fairhurst's work, has been a fake banana skin lying in a mirrored box. In *It's Up There for Thinkin', Down There for Dancin'* (2000, see p. 200), there is another kind of distorted reflection: one of the oldest jokes in the book replicated to infinity, the slight twinge of guilt that comes with feelings of *schadenfreude*, magnified to

monstrous proportions. While the reflective space itself is neat and clean, however, it is contained within a cardboard box. The illusion may work, but it rests upon shaky foundations and could well fall apart at any minute. More importantly, perhaps, it will inevitably fall apart at some time in the future. There is the same lack of sophistication in the fabrication of Fairhurst's light boxes. Pristine, illuminated surfaces bearing texts such as *Stand Still And Rot* (1997) and *Standing Stock Still* (1998) are supported on a simply made, taped-cardboard structure.

The band that Fairhurst leads, 'Low Expectations', makes the right moves and strikes the correct poses. That is, it looks more or less like a band. True, several figures come on stage with little more than a small sequencer and a stopwatch, but then Fairhurst himself walks up to the microphone, looking very much as if he is about to start singing. A girl starts dancing around, and someone else sits at a drum-kit. But these first impressions are as close as we ever come to the usual experience of live music. The sequencers are each programmed with several samples from various pop songs, and to begin with they are played more or less sequentially. In the group's early days Fairhurst sampled music he liked, but more recently he has used whatever happens to be in the top ten at the time of performance. The snatches of tune are instantly recognisable, and the repetition of one almost manages to establish a rhythm before it is cut off to be replaced by another. Soon the samples start to cut across one another, and then more come in again until discernment of a rhythmic or melodic structure becomes impossible in the dense matting of sound. The movements of the girl seem increasingly to be guided by some inner impulse rather than by the sounds around her, and by the time the drummer starts to play, the point has already long passed at which

ANGUS FAIRHURST, *IT'S UP THERE FOR THINKIN', DOWN THERE FOR DANCIN'*, 2000
Cardboard, acrylic mirror, rubber, wire
108 × 48 cm
Courtesy Sadie Coles HQ, London

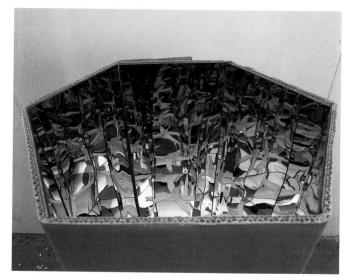

ANGUS FAIRHURST, DETAIL FROM *IT'S UP THERE FOR THINKIN', DOWN THERE FOR DANCIN'*, 2000
Courtesy Sadie Coles HQ, London

a beat would help to clarify matters. Comparisons might be drawn with the 1970s group, 'Nice Style – The World's First Pose Band', formed by Bruce McLean and Paul Richards. Both bands adopt all the postures and paraphernalia of pop-music performance and yet refuse ultimately to provide the audience with direct satisfaction. As their name suggested, though, the important factor for 'Nice Style' was the look: the right hair, the right clothes, the right attitude. For Fairhurst, in contrast, the impetus is provided by the characteristics of current music production: the mix of homage and theft in the culture of sampling, the replacement of composition by construction in the making of new music, and so on. It is hard to listen to 'Low Expectations' if all one is looking for is unthinking confirmation of what one already understands. Earlier performances were, in Fairhurst's view, easier on the ear, and this progressive thickening of the soundscape from gig to gig is itself an instance of the degeneration through increasing complexity that is so much a feature of his work generally. We might expect a return to simplicity in the near future, or at least a dialogue between this current complexity and a renewed danceability.

Along with the internal development of the band's sound, the activities of 'Low Expectations' have also spawned other projects. Three CDs, entitled *Low*, *Lower* and *Lowest Expectations*, have been released. Rather than naming each of the tracks, Fairhurst denoted them on the sleeve by means of different simple repetitive patterns drawn using a computer. These, in their turn, have been rendered in enamel paint on aluminium panels by sign painters (see p. 204). In all of this a number of shifts back and forth take place between reality and representation.

While not strictly speaking representations of the tracks, Fairhurst's computer drawings were nonetheless done 'in the spirit' of those sounds: 'Some people have said they worked out which one was which. I wonder if I did in fact know what I was doing, but I doubt it.'[3] In the case of the drawings themselves, the real space of their existence is the computer screen on which the patterns are generated. Perversely, then, their being rendered physically palpable through printout has the effect of flattening, and to a certain extent, deadening them; an effect that is reversed through the reanimating act of copying them in paint. Like the band's sound, each series of paintings starts with a single set of patterns. As the sequence progresses, there are more and more overlays until the image becomes a dense and unreadable surface. The first series, *Low Expectations*, is monochrome, and the eventual outcome of Fairhurst's generative process – a completely black surface – is signalled long before it actually happens.

During a couple of recent performances, Fairhurst spent much of his time on stage in front of the band constructing a large framework from which he hung a makeshift screen, cobbled together from lengths of cloth and sheets of paper and card. The more hidden the band became, the easier it was to see the video that was being projected onto its members throughout the performance. When they eventually stopped playing, now entirely obscured, it seemed that perhaps the event had been transformed from a concert into a screening. Such ambiguity meant that the audience remained unsure as to when things could be said to have finished. When, for example, should the applause come? As soon as the band stopped playing? Ten minutes later when the DJ started up again? Or ten minutes after that when the video was switched off?

ANGUS FAIRHURST, *OCCASIONALLY COMPATIBLE,* 1999
Animation stills
Courtesy Sadie Coles HQ, London

An ad hoc screen of this same sort cuts across Fairhurst's space in
'Apocalypse', providing a disjointed surface upon which a revolving
constellation of film loops endlessly plays itself out. A swivel chair
with two pairs of disembodied legs appears, an idea also seen in
Occasionally Compatible (1999), a similar, previous work in which
swivel chairs are propelled in opposing directions by two sets of legs.
A tube – hairy on the outside, smooth-muscled inside – continuously
inverts and everts itself. Two intertwined and looped colons move
around and through each other. These and others turn full circle
around the screen, eventually coming back to what might be the
same place or what could just as easily be a different place at the
same moment. This and/or situation is repeated on the other side
of the gallery where a walk-in octagonal hall of mirrors copies us
beyond ourselves to infinity. MA

(pp. 194–197)
ANGUS FAIRHURST, 2000
Photographs by Norbert Schoerner

(pp. 202–203)
ANGUS FAIRHURST, LOW EXPECTATIONS
Performance Cologne, 26 April 1999
Courtesy Sadie Coles HQ, London

(p. 204)
ANGUS FAIRHURST, *6TH LOWEST EXPECTATIONS,*
1996
Enamel paint on aluminium
180 × 180 cm
Courtesy Sadie Coles HQ, London

(p. 205, clockwise from top left)
ANGUS FAIRHURST, *THREE (ADMITS TWO),*
RAINBOW'S END, IN/OUT PIPE, AN INCREDIBLE
FORCE OF NATURE, **2000**
Drawings
All 21 × 28 cm

(p. 206)
ANGUS FAIRHURST, INSTALLATION VIEW OF
NORMAL/DISTORTED/SUPERIMPOSED, 2000
Animation
IMAGINE YOU ARE TOP BANANA, 2000
Mirror, wood
NORMAL/DISTORTED/SUPERIMPOSED, 2000
Light, switching mechanism, cardboard,
perspex

(pp. 207–209)
ANGUS FAIRHURST, ANIMATION STILLS FROM
NORMAL/DISTORTED/SUPERIMPOSED, 2000

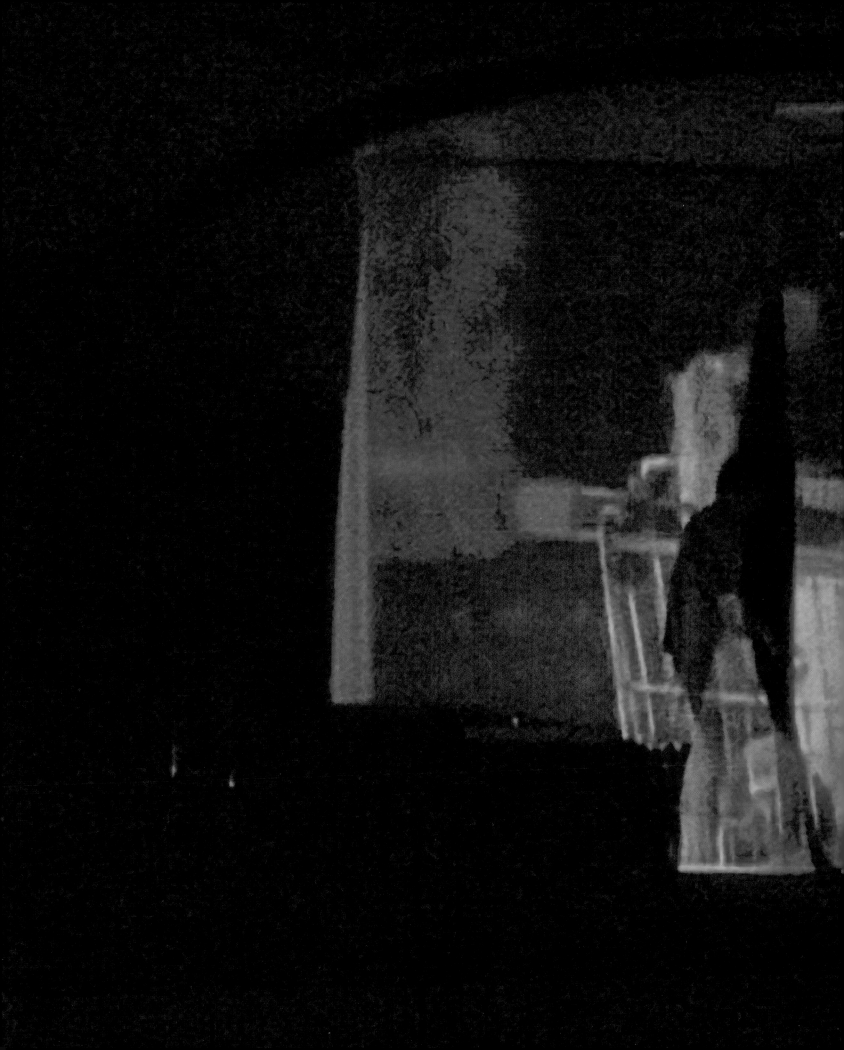

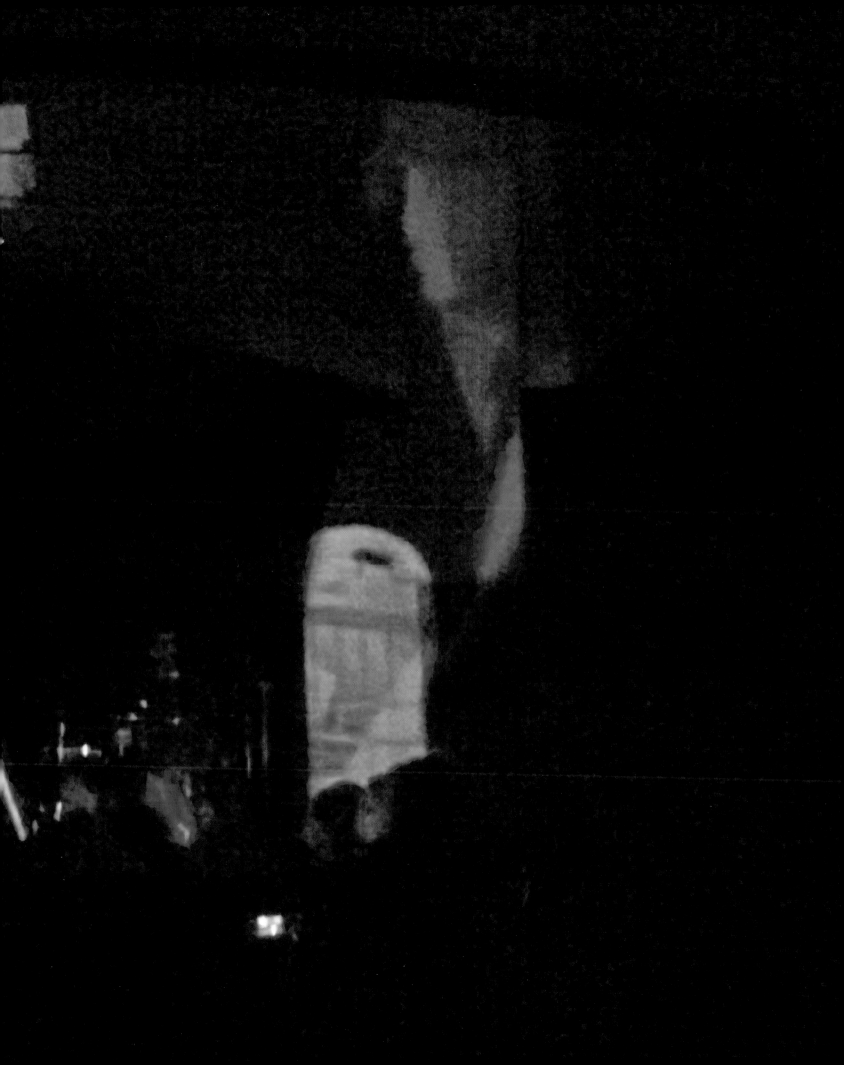

projector

Wood
+ paper
screen

octagonal
hall of
mirrors

mirrored floor
and ceiling

Sign
'Normal, distorted,
Superimposed'

JAKE AND DINOS CHAPMAN

COLLABORATING WITH CATASTROPHE

Many modern figurative sculptors have been at pains to give their works a heightened expressivity. They have tried to create sculptures on which the eye and mind cannot easily come to rest. They have wanted to drive viewers round and across every figure, and so prevent them from simply focusing on the face, or looking at a figure from a fixed viewpoint.

The key catalyst is the French sculptor Auguste Rodin (1840–1917). The Austrian poet Rainer Maria Rilke, in his great essays on Rodin, identified what was really new about his work.[1] 'No part of the body was insignificant or negligible…each part was a mouth uttering it in its own manner.' When Rodin read about the weeping feet of Pope Nicholas III in Dante's *Divine Comedy*, he found that he 'already knew there could be weeping feet, that there is a weeping of the whole body, of the whole person, and that every pore can bring forth tears'. Rilke believed that in Rodin's work the most expressive features – such as mouths and eyes – had multiplied and migrated to all parts of the human body, energising it. There was no longer a clear distinction between surface and orifice, and between organs.

Jake (b. 1962) and Dinos Chapman (b. 1966) are some of the most significant contemporary heirs of Rodin. They seek to heighten the level of involvement between viewers and sculpted bodies by reconfiguring those bodies. They want as much of the human body as possible to be in play and in flux – the inside as well as the outside. Their genetically re-engineered mannequins may not always suggest that there is (*pace* Rilke) a *weeping* of the whole body, but they do insist – with deadpan humour – that there is a bleeding, an excreting, a urinating, a copulation and a deforming of the whole body.

The Chapman brothers began collaborating in the early 1990s, having studied at the Royal College of Art in London and worked for the photo-artists and 'living sculptures' Gilbert & George. Their first sculpture to attract attention was a three-dimensional re-creation of Goya's series of etchings, *Disasters of War*. They made painstaking reconstructions of individual scenes using plastic figurines that had been melted, then reshaped and repainted.

Each tableau, showing a harrowing scene of violent death and torture, was mounted on a base covered in fake grass. These were then carefully arranged in a circular formation. The Chapmans' insistence on a neat pastoral setting for these atrocities (the original scenes take place in barren wastelands) gives them a decidedly suburban feel. They are manicured, 'bonsai' versions of Goya, almost like greens on a Lilliputian golf course.

By gathering the atrocities together so picturesquely and playfully, and presenting them like a tray of human canapés, the brothers suggest that any form of violence can be naturalised and commodified. But equally, they alert us to the violence and perverted logic inherent in the smallest and most basic of things: children's toys. Their work is predicated on the belief that aggression – sexual as well as physical – is as integral to the child's world as to the adult's. They are great admirers of William Blake, and like him they believe there is no neat distinction between innocence and experience.

In 1994, the Chapmans made a life-size fibreglass reconstruction of Goya's etching *Great Deeds Against the Dead*, in which mutilated and dismembered remains of three men hang from a tree. These were

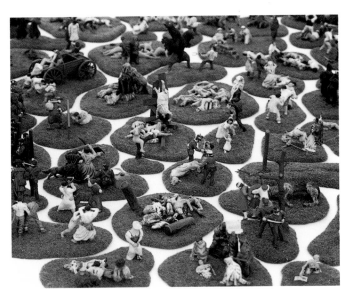

JAKE AND DINOS CHAPMAN, DETAIL OF *DISASTERS OF WAR*, 1993
Mixed media
Dimensions variable
Courtesy Victoria Miro Gallery, London

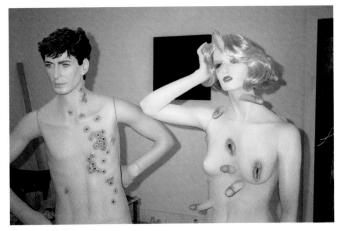

JAKE AND DINOS CHAPMAN, DETAIL OF *MUMMY CHAPMAN* AND *DADDY CHAPMAN*, 1994
Life-size fibreglass figures
Courtesy Victoria Miro Gallery, London

made from shop-window mannequins, carefully painted and provided with wigs. They also made a pair of sculptures entitled *Mummy Chapman* and *Daddy Chapman*. These show their burgeoning interest in creatively mutilated figures. *Mummy Chapman* was a life-sized female mannequin who has sprouted vaginas and penises. She was formally similar to a martyred St Sebastian, though instead of being shot through with arrows, she was armed with male and female sexual organs. *Daddy Chapman* was a male mannequin covered in anuses, though they subsequently chopped his head off and put a penis in place of his nose, turning him into a priapic Pinocchio. We can't be sure whether these absurd eruptions are supposed to be empowering or emasculating: is *Mummy Chapman* a menacing fertility goddess, or one of the walking wounded, crippled by some uncontrollable sex drive? Whatever the answer, the way in which the brothers respond imaginatively to their parents has a Jacobean monstrousness.

These family portraits also recall psychoanalytic accounts of schizophrenia. In a 1979 essay by Gilles Deleuze on the scrambled language of Lewis Carroll and Antonin Artaud, we are told: 'The first evidence of schizophrenia is that the surface is punctured. Bodies no longer have a surface. The schizophrenic body appears as a kind of body-sieve. Freud emphasised this schizophrenic aptitude for perceiving the surface and the skin as if each were pierced by an infinite number of little holes. As a result, the entire body is nothing but depth; it snatches and carries off all things in this gaping depth, which represents a fundamental involution. Everything is a mixture of bodies and within the body, telescoping, nesting in and penetrating each other.'[2] The Chapman brothers are fascinated and horrified by the porosity of the human body and of human nature – no man, for them,

is ever an island. The fact that they collaborate is symptomatic of this. They are equally fascinated by the porosity of language. Their jointly written texts, such as the one that prefaced the catalogue to their 1996 ICA exhibition, 'Chapmanworld', are staccato streams of consciousness.

In 1995, the Chapmans produced one of their most haunting works, *Zygotic acceleration, biogenetic de-sublimated libidinal model (enlarged × 100)*. The pseudo-scientific title suggests that this pristine confection is the result of some state-of-the-art genetic experiment. It consists of a ring of naked shop-window mannequins of children, all seamlessly joined like Siamese twins (see p. 214). These creatures of undetermined gender are repellent and seductive in equal measure. Most of them stand up, looking out towards the viewer, but some are inverted, or erupt from another's groin or stomach. Instead of a conventional mouth and nose, several have anuses surmounted by penises; only a few have arms. All wear brand-new trainers, and all have shiny, taut skin. On the face of it, this is the result of an experiment to clone children, and to create a conformist, self-sufficient community. But it seems to have failed hopelessly: these creatures, you suspect, could be and do anything.

The faces are painstakingly painted and articulated (the artists' attention to detail is equally evident in their prints and drawings, see pp. 216–217), and the children's expressions have subtle nuances. Some of the protagonists look happy, others mournful; some benign, others aggressive. What could be more poignant and pregnant than the gesture of the half-raised arm of the child who is joined at the belly? Rilke's description of Rodin's *Gates of Hell*

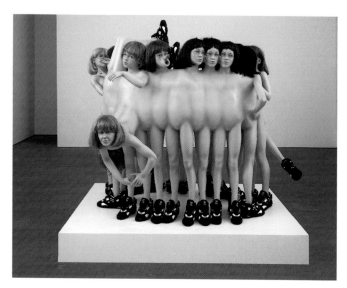

JAKE AND DINOS CHAPMAN, *ZYGOTIC ACCELERATION, BIOGENETIC DE-SUBLIMATED LIBIDINAL MODEL
(ENLARGED × 100)*, 1995
Fibreglass models, resin, paint, trainers
150 × 180 × 140 cm; plinth 180 × 20 × 150 cm
Courtesy Victoria Miro Gallery, London

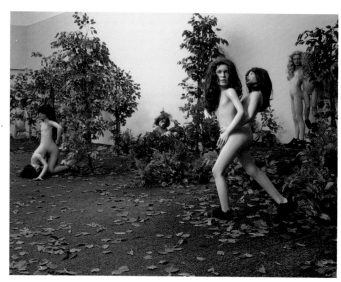

JAKE AND DINOS CHAPMAN, DETAIL OF *TRAGIC ANATOMIES* GARDEN INSTALLATION, 1996
12 fibreglass figures, resin, paint, trees and foliage
Dimensions variable
The Saatchi Gallery, London

comes to mind. Here there were bodies 'touching at all points and clinging together like animals at deadly grip with one another…bodies which were like listening human faces and like arms about to strike; chains of bodies, garlands and tendrils, and figures like heavy bunches of grapes, into which the sweetness of sin rose from the roots of pain'; some bodies even came together like 'closely related chemicals'.

An equally great emotional range was present in *Tragic Anatomies*, a walk-in tableau completed in 1996. Here, 13 groups of variously conjoined and sexualised children were arranged in a paradise garden made from Astroturf and plastic plants. The iconography is ultimately derived from a subject that was a staple of Renaissance art – the children's bacchanal. Renaissance artists were fascinated by the capacity of children to be demonic and anarchic, as well as cuddly and sweet. The naked putti in Donatello's *Amoratys*, Mantegna's *Putti Playing with Masks*, and, above all, Michelangelo's *Children's Bacchanal*, have a sinister precociousness that never fails to disturb viewers used to 'meek and mild' representations of children. They are not quite animal, not quite human. The grandiose way in which the Chapmans' tableau was set up, and some of the mutants' gestures and expressions, were also redolent of Poussin's bacchanals and tragic landscapes, exhibited at the Royal Academy the previous year.

The question of what it might mean to be human was further explored in *Ubermensch* (1995), a painted fibreglass monument to Professor Stephen Hawking, the invalid scientist who devised an explanation for the origins of the universe. Hawking is only able to communicate his findings through the auspices of computer technology. His wheelchair has been mounted precariously on top of a beetling crag. Although the

monument represents the apotheosis of a famous scientist, his wizened body is the polar opposite of conventional ideas of the all-conquering hero – the Ubermensch.

The sculpture is often compared to Landseer's *Monarch of the Glen*, but a more precise analogy is to be found with the kind of equestrian monument in which an 'enlightened' ruler sits astride a rearing horse that stands on an outcrop of rock. The greatest of all is Etienne-Maurice Falconet's monument to Peter the Great in St Petersburg. Peter the Great tried to westernise Russia, and founded an Academy of Sciences.[3] Falconet's monument showed him conquering nature, as he explained: '[My Tsar] is surmounting the rock, which serves him as a base, and which is the emblem of the difficulties he has overcome.'[4]

In surmounting this rocky outcrop in a wheelchair, the scientist Stephen Hawking seems to have overcome even greater difficulties than Peter the Great. However, Hawking's victory may well be pyrrhic. The wheelchair is stranded at the top of the crag and could topple off at any moment. He looks as though he may have been left to face the elements, like those Spartan babies who were exposed on mountain tops. His moment of greatest triumph is also his moment of greatest danger. Our own feelings about heroism in general, and about the disabled in particular, are put to the test. Many viewers will feel embarrassed by the set-up; are we really comfortable with the idea that a disabled man and a scientist can ride so high?

Hell, which has taken over two years to complete, is a summation of the Chapmans' work to date (see pp. 218–225). It contains over 5,000 figures, all painstakingly made and painted by hand, as well

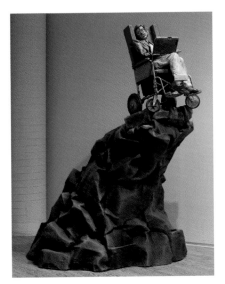

JAKE AND DINOS CHAPMAN, *UBERMENSCH*, 1995
Fibreglass, resin, paint
366 × 183 × 183 cm
Private collection, London

JAKE AND DINOS CHAPMAN, *DISASTERS OF WAR #22*, 1999
Etching with watercolour
Paper size: 24.5 × 34.5 cm
Courtesy Jay Jopling/White Cube, London

as nine different landscapes containing a range of buildings and vehicles. The rectangular landscapes are mounted on rickety wooden trestles arranged in the shape of a swastika. Spaces have been left between all of the sections so that the viewer can walk around them. In the centre a volcano spews out Nazis. The landscapes are killing fields where tortures and punishments of Bosch-like ingenuity are meted out to Nazis by naked mutant figures. Body parts, skeletons and skulls are strewn everywhere.

In one section, the Nazis' bodies are thrown into a huge pit, where they take on the vermicular qualities of cold pasta. In an open-air theatre next to a pit of bodies, mutants act as puppeteers, with strings passing through the limbs of Nazis. One thinks of those lines from *King Lear*: 'as flies to wanton boys so are we to the Gods'. Elsewhere, Nazis are exterminated in one of their own camps. In the seas, mutant fish continue the assault. A particularly grisly punishment is meted out by a female mutant with four heads who stands on a military vehicle. She holds a steering wheel whose elongated shaft passes through the neck and head of a Nazi. Some Nazis are driven, perhaps by hunger, to cannibalise their comrades.

On first inspection, it appears as though the Nazis are simply getting a taste of their own medicine, as in an extremely brutal war film. But this is no straightforward revenge narrative. It is not clear whether the mutants are supposed to be the kind of people whom the Nazis, with their belief in eugenics, sought to wipe out (a Stephen Hawking figure appears to sit in a caterpillar tractor on a hill overlooking some of the atrocities); or whether they are the ultimate manifestation of the Nazi ideal – invincible killing-machines produced by genetic experiment.

Indeed, the work has the rudiments of a nightmare that is playing on an endless loop. The Chapmans say that it represents an 'eternal return'. In a section containing a burnt-out church, skeletal Nazis emerge from tombs in the graveyard; and in another we find what appears to be a reanimation plant. A ruined Neoclassical temple, draped with the fragments of Nazi banners, has a frieze on the pediment which shows more skeletons coming to life. In this culture, violence feeds on itself, and we, too – if we admire the skill with which it is all done, or feel compelled to wander through it – are implicated.

Rodin was accused by the writer Anatole France of 'collaborating too much with catastrophe'.[5] By this, he meant that the fragmented and distorted figures and the broken body parts were the consequence of a morbid and sadistic sensationalism, rather than the product of a search for undiluted and energised essences. The same kind of complaint has regularly been made about the mutilated and mutated figures created by the Chapmans. Yet after 2,000 years of Christianity, in which the crucifixion is the central episode, it is scarcely possible to separate out these two strands of feeling. Christianity teaches believers simultaneously to love and hate the most horrifying wounds. What the Chapmans are doing, with mordant wit, is to underscore how tangled are the webs of human desire and disgust. JH

(pp. 210–211)
JAKE AND DINOS CHAPMAN, 2000
Photograph by Norbert Schoerner

(p. 216)
JAKE AND DINOS CHAPMAN, *RAT HEAD*, 2000
Etching and watercolour
Paper size: 47 × 38.1 cm
Courtesy Jay Jopling, White Cube, London

(p. 217)
JAKE AND DINOS CHAPMAN, *URINATING*, 2000
Etching and watercolour
Paper size: 47 × 38.1 cm
Courtesy Jay Jopling, White Cube, London

(pp. 218–225)
JAKE AND DINOS CHAPMAN, DETAILS OF *HELL*, 1999–2000
Photographs by Norbert Schoerner

216

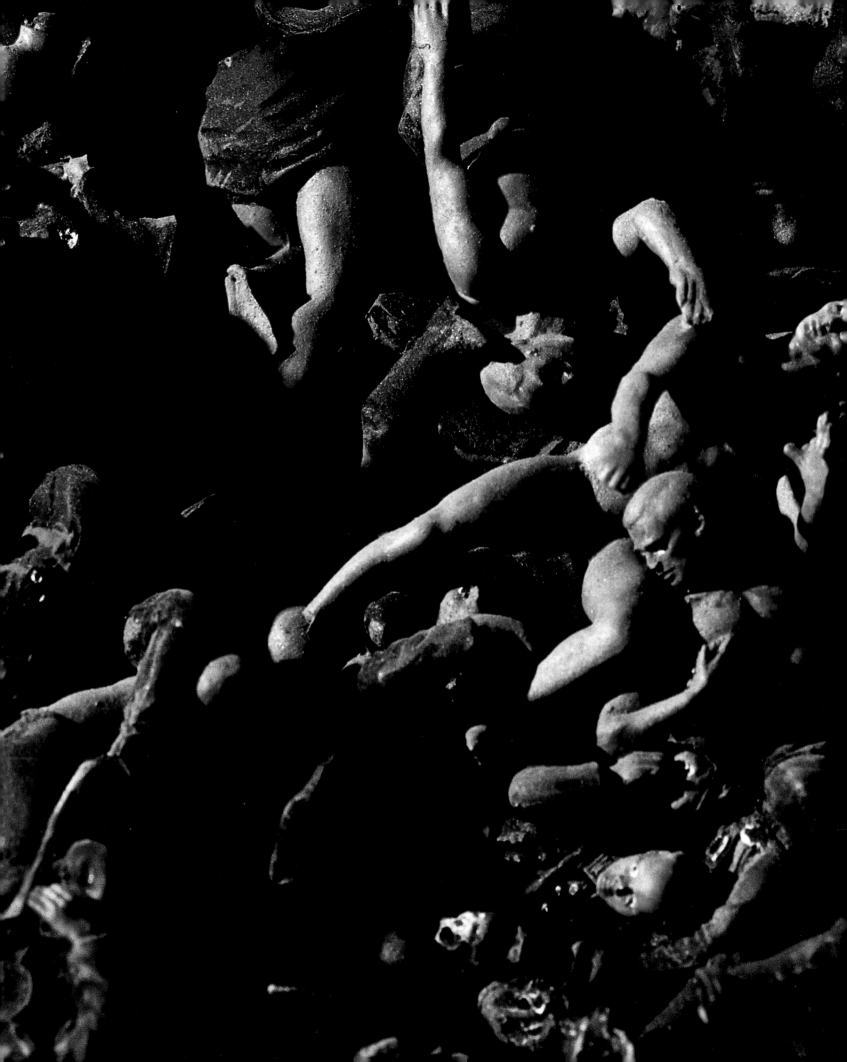

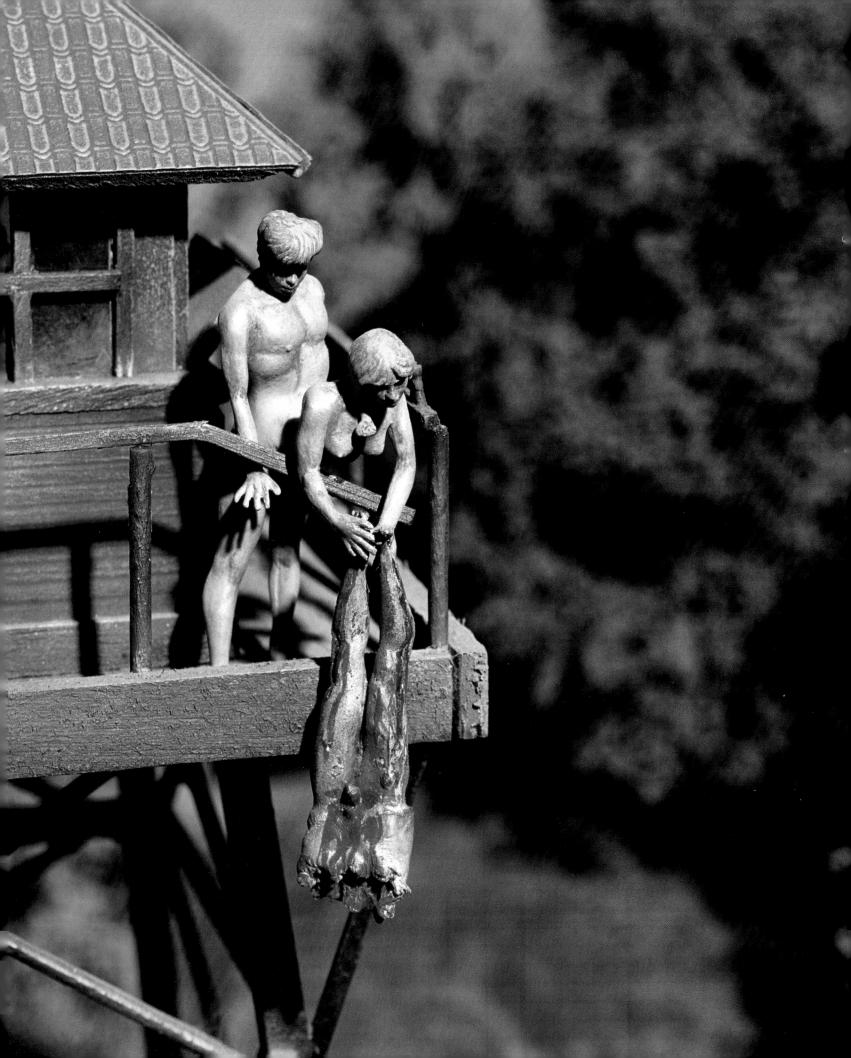

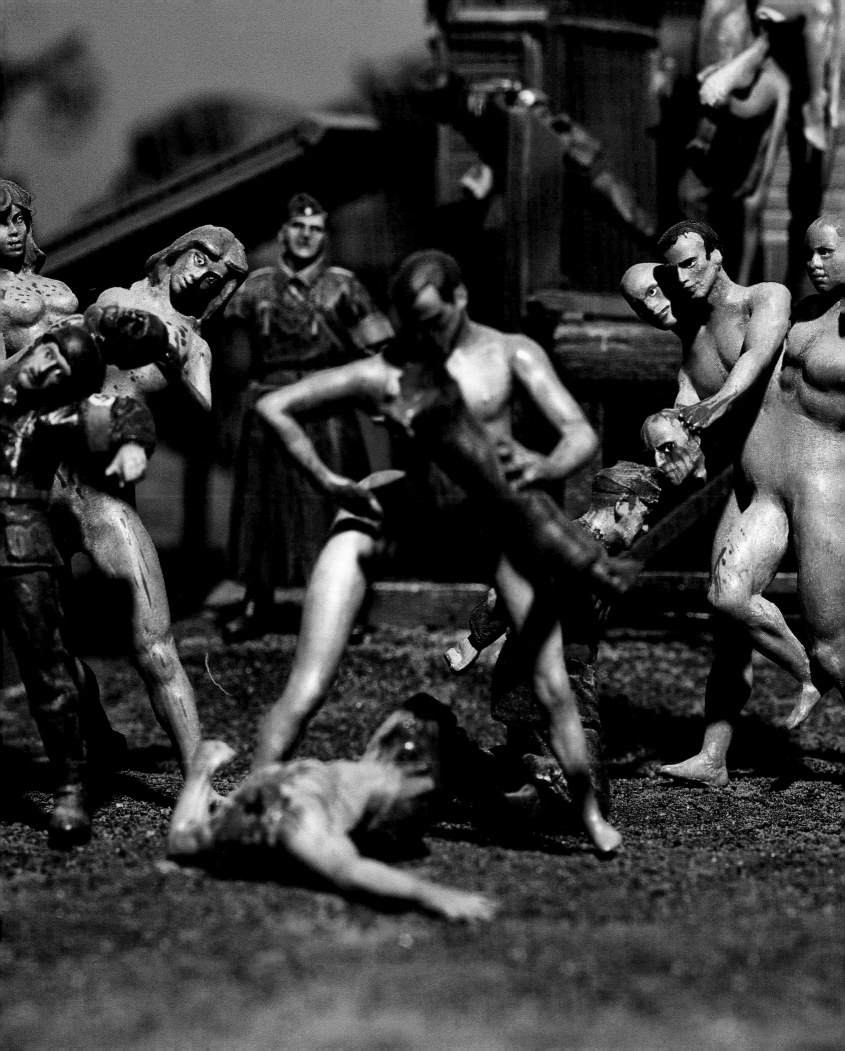

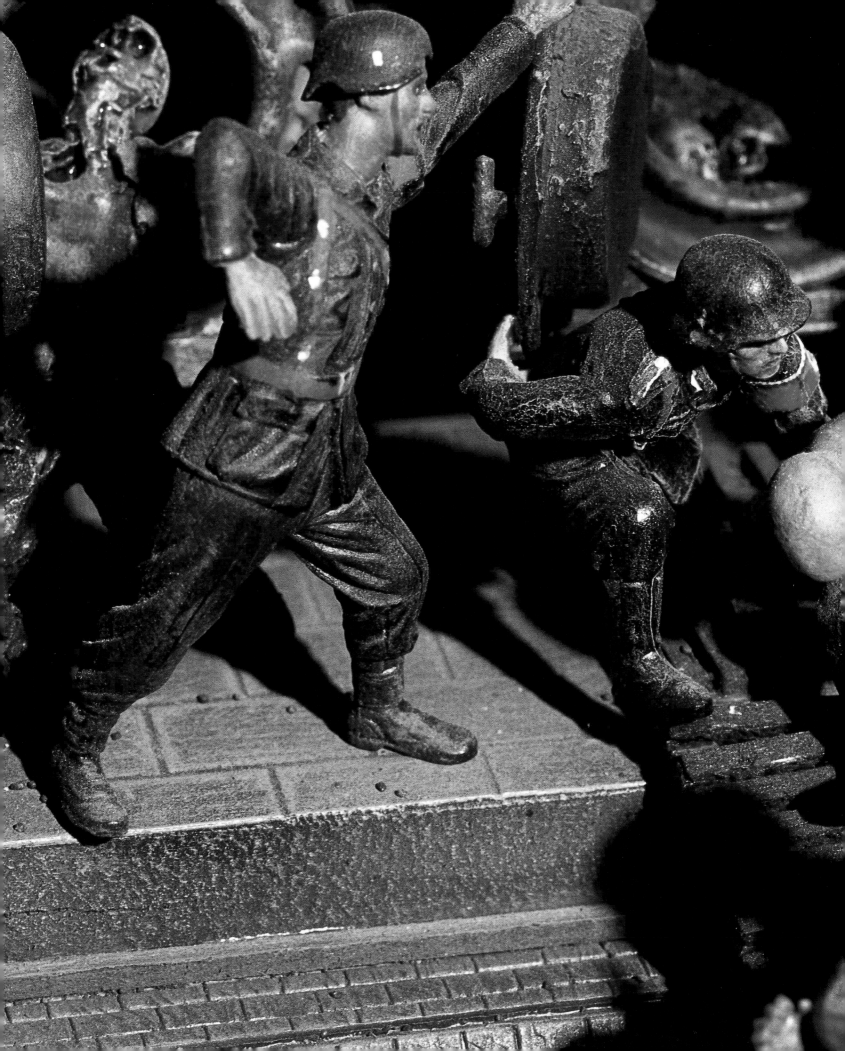

JEFF KOONS

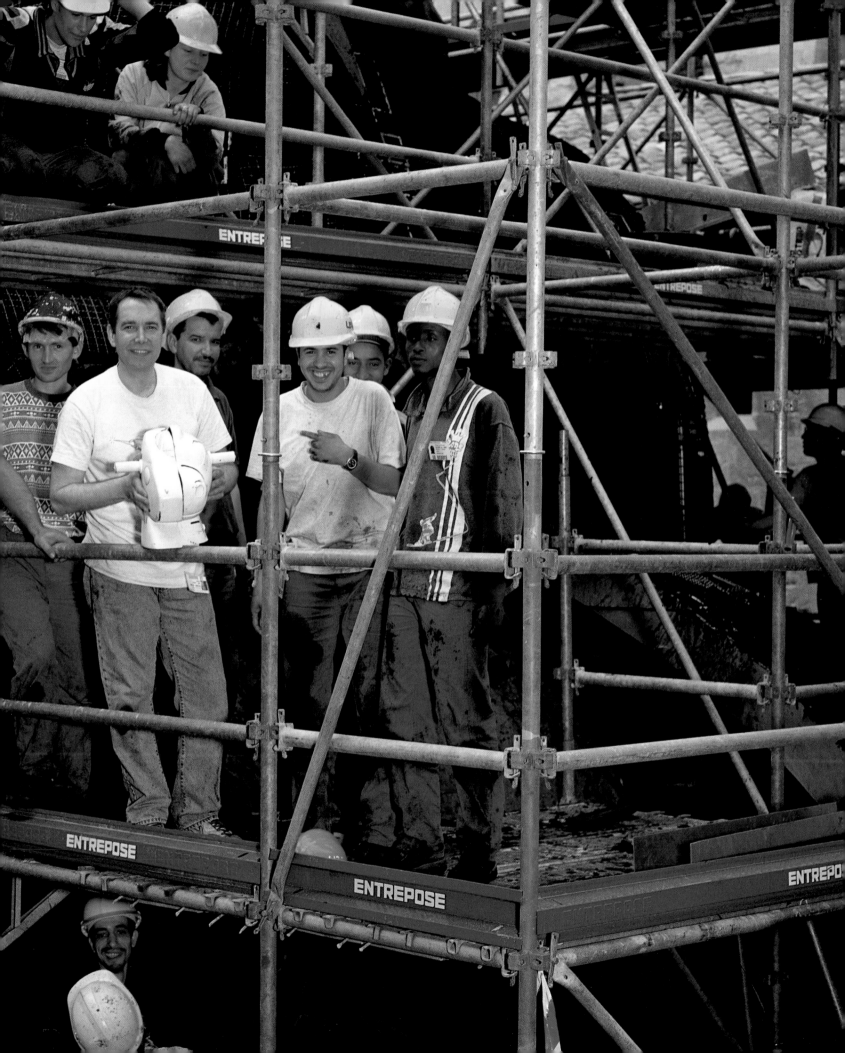

COLOURED BY REFLECTION

The slightest word that we have said, the most insignificant action that we have performed at any one epoch of our life was surrounded by, and coloured by the reflection of, things which logically had no connexion with it and which later have been separated from it by our intellect which could make nothing of them for its own rational purposes, things, however, in the midst of which...the simplest act or gesture remains immured as within a thousand sealed vessels.... If, owing to the work of oblivion, the returning memory can throw no bridge, form no connecting link between itself and the present minute...for this very reason it causes us suddenly to breathe a new air, an air which is new precisely because we have breathed it in the past...since the true paradises are the paradises that we have lost.
Marcel Proust, *Time Regained*[1]

Brilliant, reflective, contradictory, Jeff Koons's work is, at one of many levels, an attempt to recapture the lost Edenic 'newness' of childhood. While many Koons works are literally sealed vessels, others, are 'sealed vessels' in the Proustian sense that their meanings lie not in the forms themselves but in the associations they hold immured within them. 'Embrace your past,' Koons exhorts, and in photographs included in monographs on his work, the artist is often shown as a child. Though Koons was brought up a Lutheran, his work is steeped in Roman Catholic imagery and sensibility, and he has said, 'I enjoy the way the Catholic Church used art as propaganda.'[2] Like the pronouncements of the Church, Koons's statements do not always seem to match the evidence of the works, yet they often have a way of coming true. Koons is a *provocateur* whose art opens the interrelated Pandora's boxes of taste and class, as he remakes objects of low-brow popular culture in luxurious media and inflated size for the comparatively rarified audience of contemporary art galleries, with the statement, 'The public is my ready-made.'[3] Taking the actual, Duchampian ready-made to delirious levels, Koons simultaneously extends Warhol's transformation of the commercial dissemination of art and the mechanics of fame.

Jeff Koons was born in York, Pennsylvania, in 1955. His father owned a furniture and interior-decorating store. As a child Koons enjoyed visiting what he later described as its 'articulated environment'[4] of made-up living rooms, bedrooms, halls and kitchens. His parents encouraged young Koons's artistic (and marketing) talent by displaying his childhood paintings – copies of old masters – in the store windows and selling them for hundreds of dollars. Koons attended Maryland Institute College of Art in Baltimore, where he studied Byzantine art and folk art, before transferring to the School of the Art Institute of Chicago. There he became friends with the painter Ed Paschke and took note of the Chicago School of 'funk' artists, before moving to New York in 1976, where he got a 'day job' selling memberships at the Museum of Modern Art. His own art from this period consisted of sculptures incorporating found inflated plastic toys and flowers placed on 12-inch-square mirrors.

Koons began working as a commodities broker in 1979 in order to finance his next artworks. These sculptures, later termed the 'Pre-New', were, like the inflated toys, variations on the Duchampian ready-made: household electrical appliances glued onto vertical plastic tubes containing fluorescent lights. Isolated on the illuminated tubing, the appliances appear to levitate. Koons's concern with defying gravity was carried over into his next works, 'The New', which consisted of new

JEFF KOONS, *NEW HOOVER CONVERTIBLES, GREEN, RED, BROWN, NEW SHELTON WET/DRY DISPLACED DOUBLEDECKER*, 1981–87
Four vacuum cleaners, Plexiglass, fluorescent lights
251.5 × 137 × 71 cm
Private collection

JEFF KOONS, *ONE BALL TOTAL EQUILIBRIUM TANK*, 1985
Glass, steel, sodium chloride reagent, distilled water, basketball
154.5 × 78 × 35 cm
Private collection

vacuum cleaners encased in clear plastic boxes with rows of fluorescent lights arranged below them in separate, narrower boxes. Koons says he chose vacuum cleaners because of their 'anthropomorphic qualities': their ability to 'breathe' and the hermaphroditic connotations of their hoses, nozzles and apertures. In the clear boxes, either upright or reclining, they do look disturbingly human, or post-human, like effigies or relics in museum cases; those which are lying down are particularly poignant. The works' titles incorporate the brand names of the machines, such as *New Hoover Convertibles, Green, Red, Brown, New Shelton Wet/Dry Displaced Doubledecker*. Koons found the term 'Wet/Dry' a particularly suggestive oxymoron, 'similar to either-or, being and nothingness'.[5] The series and its name, 'The New', also suggested to Koons the idea of new life, or childhood. 'You could think of the state of being "new" as the individual. That's what I really want you to think about, how you can't be new. To have your own integrity you have to live and you're not immortal. But here the machine can just have integrity forever by not participating.'[6]

In his first two solo shows, not held until 1985 and 1986, Koons continued to explore physical and metaphysical dichotomies of weight and weightlessness, being and nothingness, gravity and intoxication, the animate and the inanimate. The first exhibition included bronze casts of an inflated rubber boat, a snorkel, and a diver's oxygen tank with life-jacket, and, most memorably, his utterly surprising *Equilibrium Tanks*. These rectangular glass tanks of water with one or more basketballs floating magically in the middle have become quintessential images of late twentieth-century art. As Koons pointed out, they suggest a biological organism, a foetus floating in amniotic fluid, an egg, a cell. They are 'states of being', he said, '...to exist in

equilibrium which cannot be sustained',[7] a state perhaps rather like the half-waking, half-sleeping state of free association and 'newness' with which Proust begins *A la recherche du temps perdu*. The floating ball also suggests a globe – the earth suspended in a finite universe.

Koons's 1986 show, 'Luxury and Degradation', included *Jim Beam: J. B. Turner Train* (1986), a model train cast in highly polished stainless steel from 'collectible' train-shaped ceramic bottles of Jim Beam bourbon. Like the originals, each car of Koons's version was filled with liquor and sealed by the distillery. Koons associates the reflective surface of stainless steel with 'luxury' and the recurrent images of intoxication with a loss of control; both are forms of 'degradation'. 'The more luxurious something becomes, the more reflective generally it becomes – the grille of a Mercedes, the distortion of light through crystal. These are all very intoxicating experiences. One gets lost. I wanted to show that, and to have the viewer be able to be in this intoxicated state and start to understand that luxury is a negative thing.'[8] Conceptually, Koons is as involved with the unseen contents of the work as with its surface. 'The seal to me is the interface with the soul of that work.... If somebody who has one of these works of art ever breaks the seal they've ruined the piece. They can get very intoxicated. They may learn a lot about distortion of thought patterns and maybe what the creative process is by drinking the liquor. But the piece is dead.'[9]

The shiny mirror finish of the train model and other sculptures serves to dematerialise the objects. This is particularly true for Koons's famous *Rabbit*, one of a group of 'Statuary' figures cast in stainless steel from 'ready-made' originals by Koons in 1986. Undoubtedly the

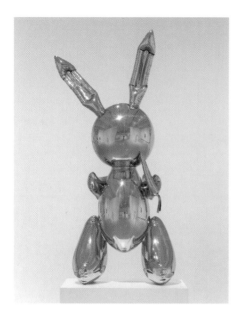

JEFF KOONS, *RABBIT*, 1986
Stainless steel
104 × 48.5 × 30.5 cm
Private collection

JEFF KOONS, *MICHAEL JACKSON AND BUBBLES*, 1988
Ceramic
106.5 × 179 × 82.5 cm
Private collection

most successful of the group, *Rabbit* looks so strange and otherworldly that one doesn't recognise the underlying form of the child's generic inflated toy at first. The nearly spherical mirrored head and belly reflect, contain and absorb the room and the viewers, as though the sculpture existed everywhere except the space it actually occupies – almost a kind of 'black hole' – or a metaphor for Koons's *oeuvre* as a whole. ('I want to make my work erase itself,' he said.[10])

Koons's ambivalent vision of bad taste is dated by, and rooted to, his 1950s and 1960s childhood. With the next series, 'Banality', Koons embraced this past in an extravagant body of work created to his designs by German wood-carvers and Italian porcelain artists. The sculptures are not always simply enlarged ready-mades, but have in many cases been created from two-dimensional models. In many a human being is paired with an animal, which may or may not be a toy, and it is unclear who is toying with whom. The colours and forms of the manufactured animals are perfect, impersonal, affectless, and oddly similar to polychrome wood effigies in Catholic churches. In a gallery setting, the objects inspire *frissons* of horror and snobbery, yet when we re-encounter their originals in the everyday world, we react with almost fond recognition: they are 'Koonses' now for us, the way young women in the street became 'Renoirs' for Proust's narrator once he knew Renoir's paintings.[11]

In 1989 Koons began work on the series 'Made in Heaven'. He posed with the Italian porn star and Member of Parliament, Ilona Staller (known as Cicciolina), whom he married in 1991, in sexually explicit situations, presented as large colour photographs and as sculptures crafted in Venetian glass and in carved, painted wood. Most shocking

were the photographs: not artful nude couplings but blunt vignettes in flat, saturated colour, complete with close-ups of penetration and 'cum shots'. In 'Made in Heaven' Koons again exposed an aspect of the culture at large that is usually kept from sacrosanct gallery walls. The versions in three dimensions, however, were no more shocking than reproductions of Rodin's *The Kiss*. Koons has called himself and Cicciolina in these works a new Adam and Eve. Adam and Eve were the parents of mankind, but possibly the parents Koons more directly portrays in these works are those of the 'Jeff Koons' child persona. The giant flowers and pet animals which surround him and Cicciolina belong to that persona, so that, in a sense, these works represent Koons himself, a spectator at his own conception.

Koons's marvellous, 40-foot-high *Puppy* was another surprise, a monumental animal made of some 20,000 flowering plants. First exhibited in front of the Baroque castle of Arolsen in Germany in 1992, *Puppy* upstaged, in some minds, the nearby 'Documenta 9'. Since then it was exhibited in a slightly different incarnation in Sydney, has been acquired by the Guggenheim Museum in Bilbao, and, at the time of writing, is on view in New York's Rockefeller Center. *Puppy* is perhaps unique among contemporary avant-garde artworks in providing pleasure to viewers of all degrees of art knowledge. Koons's earlier statement, 'I have always tried to create work which does not alienate any part of my audience'[12] became true when he made *Puppy*. The meaning of Koons's work is entwined with the history of our reaction to it.

Over the last five years Koons has been working on his 'Celebration' series, a group of extremely large sculptures and paintings. Again,

JEFF KOONS, *BOURGEOIS BUST: JEFF AND ILONA*, 1990
Marble
113 × 71 × 53.5 cm
Private collection

JEFF KOONS, *PUPPY*, 1992
Live flowers, earth, steel
1200 × 500 × 650 cm
Private collection

animals, toys and reflection are prominent in the work. Many paintings in the series, such as *Party Hat* (1995–97) and *Tulips* (1995–97, see pp. 234–235), with their reflective, light-shattering backgrounds of silvered-plastic Mylar and child's party imagery, bear disarming similarities to paintings from the 1970s or 1980s by realist painters like Janet Fish or Audrey Flack – artists one wouldn't necessarily expect to find Koons looking at.

Koons is exhibiting *Tulips* and three other works from the 'Celebration' series in 'Apocalypse'. The huge painting *Shelter* (1995–97, see pp. 236–237) was executed in oils on canvas from a photograph by Koons, and depicts a still-life set-up of plastic toys and a Lincoln Log cabin, the foreground strewn with drifts of popcorn. The faces of the toys address the viewer like performers from a stage, as if frozen into a tableau from one of the free-associating, improvisational narratives of child's play. As Thyrza Nichols Goodeve has said of the 'Celebration' series, 'The viewer becomes the mutable form while the objects of the Koonsian aesthetic determine reality, looking out at you as much as you look at them. They behold us, forcing us to play a vertiginous game.'[13]

Balloon Dog (1994–2000, see p. 240), the three-metre-high, highly polished, red-tinted stainless-steel sculpture that will stand in the Wohl Central Hall at the top of the Burlington House staircase, is in a sense like a Hollywood remake of the 1986 *Rabbit*: much larger and in colour, and no less wonderful for that. For Koons, the enormous size of the works in the 'Celebration' series is a way of expressing generosity. He said, 'I'm not making things big to make them big... these images and these objects are defining themselves that this is

the size they want to be. They're archetypes. And archetypes are bigger than any one individual. An archetype is something which helps everybody survive.'[14] The giant *Moon* (1994–2000, see pp. 238–239), made in highly reflective stainless steel, represents a Mylar party balloon (recalling, in a much grander scale and material, Warhol's helium-filled Mylar balloon pillows of 1966). Koons's interest in inflated and reflective objects has persisted from his very early mirror and rubber-toy pieces, to *Rabbit*, and now these giant new works. An inflated object has reached a kind of optimum state, an equilibrium: if it were under-inflated it would appear shapeless, not itself, bunny indistinguishable from dinghy; if over-inflated it would self-destruct. An inflated object is all surface, no substance; or rather its 'substance' is the most common (yet precious) element on earth – the air we all breathe. The membrane separating inside from outside defines the form of the object, but being mirrored in this case, gives us back ourselves and our world as its true content, inside out. In reflections, memories, and associations, the work of art before us disappears. It is us. As usual, Jeff Koons has the last word: 'The public is my ready-made.' NK

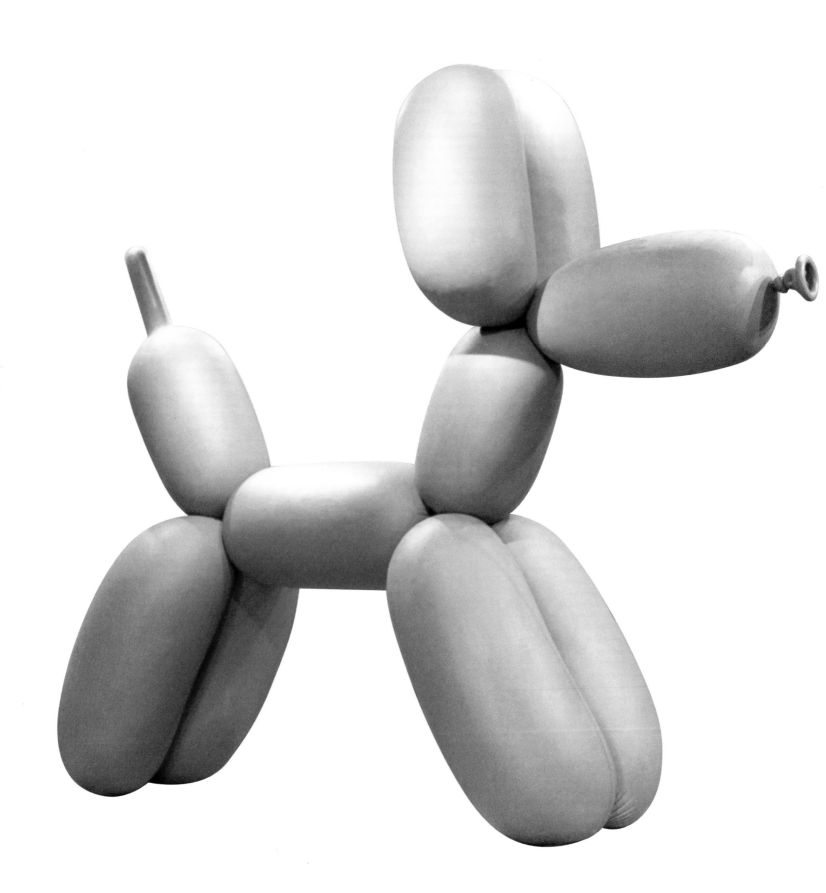

LIST OF WORKS

DARREN ALMOND
Bus Stop (2 Bus Shelters), 1999
Aluminium and glass
Each 603 × 303 × 270 cm
Jay Jopling (London)

MAURIZIO CATTELAN
La Nona Ora (*The Ninth Hour*), 1999
Carpet, glass, wax, paint
Life size figure
Private collection
Courtesy Anthony d'Offay Gallery, London

JAKE AND DINOS CHAPMAN
Hell, 1999–2000
Glass fibre, plastic and mixed media (nine parts)
Eight parts 182.9 × 121.9 × 121.9 cm
One part 121.9 × 121.9 × 121.9 cm
The Saatchi Gallery, London

CHRIS CUNNINGHAM
flex, 2000
Film
Courtesy Anthony d'Offay Gallery, London

ANGUS FAIRHURST
Normal/Distorted/Superimposed, 2000
Animation
Imagine You Are Top Banana, 2000
Mirror, wood
Normal/Distorted/Superimposed, 2000
Light, switching mechanism, cardboard, perspex
Courtesy Sadie Coles HQ, London

MIKE KELLEY
*Extracurricular Activity Projective Reconstruction #1
(A Domestic Scene)*, 2000
Mixed media
304.8 × 874.8 × 731.5 cm
Courtesy the artist and Galleria Emi Fontana, Milan

JEFF KOONS
Balloon Dog, 1994–2000
High chromium stainless steel with transparent colour
coating
320 × 378.5 × 119.5 cm
The Dakis Joannou Collection

Moon, 1994–2000
High chromium stainless steel
310.5 × 310.5 × 98.5 cm
The Dakis Joannou Collection

Shelter, 1996–97
Oil on canvas
300 × 376 cm
Collection of Rachel and Jean-Pierre Lehmann

Tulips, 1995–98
Oil on canvas
282.7 × 332 cm
The Dakis Joannou Collection

MARIKO MORI
Dream Temple, 1999
Audio, metal, glass, plastic fibre optics, VisionDome
(3-D hemispherical display)
5 × 10.67 m
Courtesy Fondazione Prada, Milan

TIM NOBLE AND SUE WEBSTER
The Muthafucka, 2000
528 coloured turbo caps, fittings and bulbs,
8 mm Foamex, electronic sequencer
D. 243.8 cm
Courtesy Modern Art, London

The Undesirables, 2000
Wood, garbage, bin liners, light projector,
electric fans, electric heater
Dimensions variable
Courtesy Modern Art, London

RICHARD PRINCE
Crazy, 1999–2000
Acrylic and silkscreen on canvas
175.3 × 452.1 cm
Courtesy Sadie Coles HQ, London,
and Barbara Gladstone Gallery, New York

Jokes, 1999–2000
Acrylic and silkscreen on canvas
175.3 × 452.1 cm
Courtesy Sadie Coles HQ, London,
and Barbara Gladstone Gallery, New York

Untitled, 2000
Acrylic on foam core
137 × 122 cm
Courtesy Sadie Coles HQ, London,
and Barbara Gladstone Gallery, New York

Untitled, 2000
Acrylic on foam core
147 × 132 cm
Courtesy Sadie Coles HQ, London,
and Barbara Gladstone Gallery, New York

GREGOR SCHNEIDER
Cellar, 1985–99
Wood, concrete, stone, plaster, paint, glass
Courtesy Sadie Coles HQ, London

WOLFGANG TILLMANS
Aufsicht, Yellow, 1999
Inkjet print
Courtesy Maureen Paley/Interim Art, London

Conquistador I, 1995/2000
Inkjet print
Courtesy Maureen Paley/Interim Art, London

Conquistador II, 1995/2000
Inkjet print
Courtesy Maureen Paley/Interim Art, London

Conquistador III, 1995/2000
Inkjet print
Courtesy Maureen Paley/Interim Art, London

*Lutz, Alex, Suzanne and Christoph on Beach,
(B&W)*, 1993
Inkjet print
Courtesy Maureen Paley/Interim Art, London

Rose, 1999
Inkjet print
Courtesy Maureen Paley/Interim Art, London

69 Love Songs, 1995/2000
Inkjet print
Courtesy Maureen Paley/Interim Art, London

Still-life, Tel Aviv, 1999
Framed C-type print
Courtesy Maureen Paley/Interim Art, London

use, 2000
Framed C-type print
Courtesy Maureen Paley/Interim Art, London

LUC TUYMANS
Cosmetics, 2000
85 × 60 cm
Oil on canvas
Private collection, Belgium
Courtesy Zeno X Gallery, Antwerp

Embroidery, 1999
Oil on canvas
143.5 × 183.5 cm
Private collection, Los Angeles
Courtesy Zeno X Gallery, Antwerp,
and David Zwirner Gallery, New York

Maypole, 2000
234 × 118 cm
Oil on canvas
Courtesy Zeno X Gallery, Antwerp

Pillows, 1994
54.5 × 67 cm
Oil on canvas
Carnegie Museum of Art, Pittsburgh. A. W. Mellon
Acquisition Endowment Fund, 1998

Portrait, 2000
56.5 × 30 cm
Oil on canvas
Private collection, Holland
Courtesy Zeno X Gallery, Antwerp

Portrait 'Old Lady', 2000
67 × 39 cm
Oil on canvas
Private collection, Chicago
Courtesy Zeno X Gallery, Antwerp

Reuntgen, 2000
111 × 81 cm
Oil on canvas
Courtesy Zeno X Gallery, Antwerp

SELECT BIBLIOGRAPHY

DARREN ALMOND
Daniel Birnbaum, 'Openings: Darren Almond', *Artforum*, January 2000

Francesco Bonami, *Common People. Arte Inglese Tra Fenomeno e Realta*, exh. cat., Fondazione Sandretta Re Rebaudengo per l'Arte, Turin, 1999

Francesco Bonami, *Delta*, exh. cat., Musée d'Art Moderne de la Ville de Paris, Paris, 1997

Louisa Buck, 'Interview with Darren Almond', *The Art Newspaper*, 101, March 2000

Kate Bush, 'Doing Time', *Frieze*, 42, September–October 1998

Amy Cappellazzo and Peter Wollen, *Making Time. Considering Time as a Material in Contemporary Video & Film*, Palm Beach Institute of Contemporary Art, Florida, 2000

Martin Glaser and René Block, *Chronos & Kairos*, exh. cat., Museum Fridericianum Kassel, 1999

Martin Herbert, 'Darren Almond', *Camera Austria International*, 67, 1999

Sensation: Young British Artists from the Saatchi Collection, exh. cat., Royal Academy of Arts, London, 1997

Michael Tarantino, *So Faraway So Close*, exh. cat., Espace Méridien, Brussels, 1999

'This Is Modern Art', film presented by Matthew Collings, Oxford Television Company Production for Channel Four, June–July 1999

Gilda Williams, 'Darren Almond at the ICA', *Art in America*, December 1997

MAURIZIO CATTELAN
Abracadabra: International Contemporary Art, exh. cat., Tate Gallery, London, 1999

Francesco Bonami, 'Maurizio Cattelan' in *Cream: Contemporary Art in Culture*, London, 1998

Francesco Bonami, 'Maurizio Cattelan', *Flash Art Italia*, 178, 1994

Francesco Bonami, *Unfinished History*, exh. cat., Walker Art Center, Minneapolis, 1998

Francesco Bonami, Nancy Spector and Barbara Vanderlinden, *Maurizio Cattelan*, London, 2000

Barbara Casevecchia, 'I Want to be Famous: Strategies for Successful Living', *Flash Art Italia*, April–May 1999

Maurizio Cattelan, exh. cat., Castello di Rivoli, Museo d'Arte Contemporanea, Turin, 1997

Maurizio Cattelan, exh. cat., Kunsthalle, Basel, 1999

Maurizio Cattelan, exh. cat., Weiner Secession, Vienna, 1997

Vittoria Coen, 'Maurizio Cattelan', *Flash Art Italia*, 151, 1989

Fatto in Italia, exh. cat., Centre d'Art Contemporain de Genève, Geneva, and Institute of Contemporary Arts, London, 1997

Future Present Past: XLVII Venice Biennale, exh. cat., Milan, 1997

Simon Grant, 'Maurizio Cattelan', *Art Monthly*, 174, March 1994

Clarisse Hahn, 'Maurizio Cattelan', *Art Press*, 201, April 1995

Elizabeth Janus, 'Maurizio Cattelan', *Frieze*, 34, May 1997

Marco Meneguzzo, 'Maurizio Cattelan', *Artforum*, February 1998

Giacinto Di Pietrantonio and Maurizio Cattelan, 'Face to Face: Interview', *Flash Art Italia*, 143, April–May 1988

Projects 65: Maurizio Cattelan, exh. cat., The Museum of Modern Art, New York, 1998

Sculpture Projects in Münster, exh. cat., Ostfildern-Ruit, 1997

Olivier Zahm, 'Openings: Maurizio Cattelan', *Artforum*, 10, Summer 1995

JAKE AND DINOS CHAPMAN
Brilliant! New Art from London, exh. cat., Walker Art Center, Minneapolis, and Contemporary Art Museum, Houston, 1995

Jake & Dinos Chapman: Unholy Libel: Six Feet Under (with an interview by Robert Rosenblum), Gagosian Gallery, New York, 1997

Chapmanworld, exh. cat., Institute of Contemporary Arts, London, Grazer Kunstverein, Graz, and Kunst-werke, Berlin, 1996

Dinos and Jake Chapman, Georgina Starr, Wolfgang Tillmans, exh. cat., Andrea Rosen Gallery, New York

Sarah Kent, 'Interview: Gender Blenders', *Time Out London*, 1–8 May 1996

Stuart Morgan, 'Rude Awakening', *Frieze*, 19, November/December 1994

Mark Sanders, 'The Art World Deserves Them', *Dazed & Confused*, 14, October 1995

Sensation: Young British Artists from the Saatchi Collection, exh. cat., Royal Academy of Arts, London, 1997

CHRIS CUNNINGHAM
Ahead, February 1999

'Caution', *Dazed & Confused*, 55, June 1999

Flux, issue 14

Phil Jackson, 'Chris Cunningham', *Sleaze Nation*, 2, 10 November 1998

Alex Needham, 'Q&A: Chris Cunningham', *The Face*, April 2000

John O'Reilly, 'Face the Music', *Guardian*, 5 March 1999

Charlotte Raven, 'Erotica? I'd Rather Have a Robot Lesbian', *Guardian*, 3 August 1999

ANGUS FAIRHURST
Michael Archer, *Etats specifiques*, exh. cat., Musée des Beaux-Arts, Le Havre, 1992

Brilliant! New Art from London, exh. cat., Walker Art Center, Minneapolis, and Contemporary Art Museum, Houston, 1995

Yilmaz Dziewior, Angus Cook, Jörg Heiser and Dorothea Strauss, *Angus Fairhurst: The Foundation*, exh. cat., Ursula Blickle Stiftung, Kraichtal, and Kunsthalle St Gallen, 1999

'Gallery Connections', artist's project, *Frieze*, pilot issue, 1991

Liam Gillick and Andrew Renton, eds, *Technique Anglaise: Current Trends in British Art*, London, 1991

'It's a Maggot Farm', *Artscribe*, November/December 1990
Ian Jeffrey, *Freeze*, exh. cat., PLA Building, London, 1988

Maximum Diversity, exh. cat., Galerie Krizinger in der Benger Fabrik, Bregenz, and Academy of Arts, Vienna, 1998

Gregor Muir, 'Angus Fairhurst', *Frieze*, June/July/August 1994

Richard Shone, *Made in London*, exh. cat., Simmons & Simmons, London, 1996

Richard Shone, *Some Went Mad, Some Ran Away*, exh. cat., Serpentine Gallery, London, 1994

Richard Wentworth, *Thinking Aloud*, exh. cat., SBC National Touring Exhibitions, London, 1998

MIKE KELLEY
Hal Foster, 'Obscene, Abject, Traumatic', *October*, 78, Autumn 1996

Mike Kelley and Julie Sylvester, 'Talking Failure', *Parkett*, 31, 1992

Mike Kelley, exh. cat., Kunsthalle, Basel, Portikus, Frankfurt am Main, and Institute of Contemporary Arts, London, 1992

Mike Kelley: Catholic Tastes, exh. cat., Whitney Museum of American Art, New York, 1993

Mike Kelley, exh. cat., Kunstverein Braunschweig, Braunschweig, 1999

Mike Kelley, exh. cat., Museu d'Art Contemporani de Barcelona, 1997

Mike Kelley 1985–1986: Anti-Aesthetik of Excess and Supremacy of Alienation, exh. cat., Wako Works of Art, Tokyo, 1996

Rosalind Krauss, 'Informe Without Conclusion', *October*, 78, Autumn 1996

L'Informe: Le Modernisme à rebours, exh. cat., Centre Georges Pompidou, Paris, 1996

Missing Time: Works on Paper 1974–1976, Hanover, 1995

Robert Storr, 'An Interview with Mike Kelley', *Art in America*, June 1994

Paul Taylor, 'Interview with Mike Kelley', *Flash Art*, October 1990

Three Projects: Half a Man, From My Institution to Yours, Pay for Your Pleasure, exh. cat., Renaissance Society, University of Chicago, 1988

The Uncanny, exh. cat., Gementeemuseum, Arnhem, 1993

Brian Wallis, 'Mike Kelley's The Uncanny', *Art in America*, June 1994

John C. Welchman, Isabelle Graw and Anthony Vidler, *Mike Kelley*, London, 1999

JEFF KOONS
John Caldwell et al., *Jeff Koons*, exh. cat., San Francisco Museum of Modern Art, 1992

Matthew Collings, 'Jeff Koons', *Pop Art*, exh. cat., Royal Academy of Arts, London, 1992

Michael Danoff, *Jeff Koons*, exh. cat., Art Institute of Chicago, 1988

Thyrza Nichols Goodeve, 'Euphoric Enthusiasm', *Parkett*, 50–51, 1997

Helena Kontova and Giancarlo Politi, 'Jeff Koons Ten Years Later', *Flash Art*, Summer 1997

Jeff Koons, A Millennium Celebration: Works from the Dakis Joannou Collection 1979–1999, exh. cat., Deste Foundation, Athens, 1999

Jeff Koons, *The Jeff Koons Handbook*, London, 1992

Jeff Koons and Martin Kippenberger, 'Collaborations', *Parkett*, 19, 1989

Veit Loers, *Made for Arolsen*, Schloss Arolsen, 12 June 1992

Metropolis, exh. cat., Martin-Gropius-Bau, Berlin, 20 April 1991

Angelika Muthesius, ed., *Jeff Koons*, Cologne, 1992

Jeanne Siegel, 'Jeff Koons: Unachievable States of Being', *Arts*, October 1986

MARIKO MORI
Norman Bryson, 'Cute Futures: Mariko Mori's Techno-Enlightenment', *Parkett*, 54, 1998–99

Michael Cohen, 'Mariko Mori: Plastic Dreams in the Reality Bubble', *Flash Art*, 194, May–June 1997

Concentrations 30: Mariko Mori, Play with Me, exh. cat., Dallas Museum of Art, Dallas, 1997

Ein Stück von Hümmel: Some Kind of Heaven, exh. cat., Kunsthalle Nürnberg, Nuremberg, 1997

Esoteric Cosmos, exh. cat., Kunstmuseum Wolfsburg, Stuttgart, 1999

Thyrza Nichols Goodeve, 'Mariko Mori's Cyborg Surrealism', *Parkett*, 54, 1998–99

Lust und Leere: Japanische Photographie der Gegenwart (The Desire and the Void: Art and Photography in Japan), exh. cat., Kunsthalle Wien, Vienna, 1997

Made in Japan, exh. cat., Shiseido Gallery, Tokyo, 1995

Mariko Mori: Dream Temple, exh. cat., Fondazione Prada, Milan, 1999

Dominic Molon, 'Mariko Mori: Between Buddhism and Techno Pop', *Flash Art*, October–November 1998

Dominic Molon, Lisa Corrin, Carol S. Eliel, Margery King and Mariko Mori, *Mariko Mori*, exh. cat., Museum of Contemporary Art, Chicago, and Serpentine Gallery, London, 1998

Mariko Mori, Le magasin, exh. cat., Centre National d'Art Contemporain, Grenoble, 1996

Shin'ichi Nakazawa, 'No Angels Here, Yet She Lives', *Parkett*, 54, 1998–99

Olivier Reneau, 'Between Cyberspace and Manga World', *Atelier*, October 1996

TIM NOBLE AND SUE WEBSTER
Dalya Alberge, 'Artist Floats a Gut Reaction to His Critics', *Independent*, 11 May 1993

David Barrett, Tim Noble and Sue Webster, and Stuart Shave, *The New Barbarians*, exh. cat., Chisenhale Gallery, London, and Spacex Gallery, Exeter, 1999

Neal Brown, 'British Rubbish @ IAS', *Frieze*, September/October 1996

Louisa Buck, *Moving Targets: A User's Guide to British Art Now*, London, 2000

Gordon Burn, 'I Want It All and I Want It Now', *Guardian*, 7 December 1998

Jake Chapman, '20 Rivington Street', *Frieze*, March/April 1998

Jeremy Cooper, *No FuN without U: The Art of Factual Nonsense*, London, 2000

Ian Geraghty, 'WOW: Modern Art', *Untitled*, Spring 1999

Mark Harris, '20 Rivington Street', *Art in America*, July 1998

Waldemar Januszczak, 'Cheeky Monkeys', *The Sunday Times*, 21 February 1999

Mike Lewis, 'Meet the Boozing Brothers with a Flare for Trouble', *Mirror* (Wales), 25 April 2000

Cedar Lewisohn, 'Modern Life Is Rubbish', *Flash Art International*, May–June 2000

Charles Saatchi, *Young British Art: The Saatchi Decade*, London, 1999

Ingrid Sischy, 'Tim Noble and Sue Webster', *Interview Magazine*, September 2000

Christian Viveros-Faune, 'Diamonds in the Rubbish', *New York Press*, 15–21 March 2000

Gilda Williams, 'WOW: Modern Art', *Art/Text*, May/July 1999

RICHARD PRINCE
Kathy Acker, 'Red Wings: Concerning Richard Prince's "Spiritual America"', *Parkett*, 34, 1992

Lisa Phillips et al., *Richard Prince*, exh. cat., Whitney Museum of American Art, New York, 1992

Richard Prince: Adult Comedy Action Drama, New York, 1995

Richard Prince, *4 × 4*, New York, 1997

Richard Prince Girlfriends, exh. cat., Museum Boymans Van Beuningen, Rotterdam, 1993

Richard Prince, *The Girl Next Door*, Los Angeles and Vienna, 2000

Richard Prince: Photographs 1977–1993, Hanover, 1994

Richard Prince, *Why I Go to the Movies Alone*, New York, 1983

David Robbins, 'Richard Prince: An Interview by David Robbins', *Aperture*, 100, 1985

Daniela Salvioni, 'Richard Prince, Realist', *Parkett*, 34, 1992

Spiritual America, exh. cat., IVAM Centre del Carme, Valencia, 1989

Susan Tallman, 'To Know, Know, Know Him', *Parkett*, 34, 1992

Roger Taylor, 'Prince', *World Art Magazine*, 1993

Neville Wakefield, 'Richard Prince', *Elle Decor*, 46, 1996

Edmund White, 'Bad Jokes', *Parkett*, 34, 1992

GREGOR SCHNEIDER
Daniel Birnbaum, 'Interiority Complex: Gregor Schneider's Dead House ur, 1985–', *Artforum*, 38, 10, Summer 2000

53rd Carnegie International, exh. cat., Carnegie Museum of Art, Pittsburgh, 1999

Ulrich Loock, 'Junggesellenmaschine Haus ur' ('Bachelor Machine Haus ur'), *Kunstforum*, 142, October/December 1998

Gregor Schneider, exh. cat., Kunsthalle Bern, Berne, 1996

Gregor Schneider, Arbeiten 1985–1994, exh. cat., Museum Haus Lange, Krefeld, 1994

Gregor Schneider, Dead House ur 1985–1997, exh. cat., Städtisches Museum Abteiberg, Mönchengladbach, Galerie Foksal, Warsaw, Portikus, Frankfurt am Main, and Musée d'Art Moderne de la Ville de Paris, Paris, 1998

WOLFGANG TILLMANS
Jen Budney, 'Come On Baby', *Parkett*, 53, 1998

Dinos and Jake Chapman, Georgina Starr, Wolfgang Tillmans, exh. cat., Andrea Rosen Gallery, New York

Echoes, exh. cat., Kunsthalle New York, New York, 1995
L'Hiver de l'amour, Musée d'Art Moderne de la Ville de Paris, Paris, 1994

Carlo McCormick, 'Talking Pictures', *artnet.com*, http://www.artnet.com, 25 November 1998

Midori Matsui, 'Tillmans's Memory Machine', *Parkett*, 53, 1998

Judith Nesbitt, 'Only Connect', *Parkett*, 53, 1998

Burkhard Riemschneider, ed., *Wolfgang Tillmans*, Cologne, 1995

Soggetto Soggetto, exh. cat., Castello di Rivoli, Turin, 1994

Wolfgang Tillmans, *Burg*, Cologne, 1998

Wolfgang Tillmans, *Concorde*, Cologne, 1997

Wolfgang Tillmans, *For When I'm Weak I'm Strong*, exh. cat., Kunstmuseum Wolfsburg, Stuttgart, 1996

Wolfgang Tillmans, *Soldiers*, Cologne, 1999

Wolfgang Tillmans, *Totale Sonnenfinsternis (Total Solar Eclipse)*, exh. cat., Galerie Daniel Buchholz, Cologne, 1999

Wolfgang Tillmans, exh. cat., Kunsthalle Zurich, 1995

Wolfgang Tillmans, exh. cat., Portikus, Frankfurt am Main, 1995

Neville Wakefield, 'Concorde', *Parkett*, 53, 1998

The Winter of Love, exh. cat., P.S.1 Museum, Long Island City, New York, 1994

LUC TUYMANS
Herman Asselberghs, 'Luc Tuymans. De stilte voor de storm. Opgetekende gedachten', *de Andere Sinema*, Antwerp, 119, 1994

Bart Cassiman, *The Sublime Void*, exh. cat., Koninklijk Museum voor Schone Kunsten, Antwerp, 1993

Willem Elias, *Modernism in Painting*, exh. cat., Provinciaal Museum, Ostend, 1992

Kaspar König, *Der Zerbrochene Spiegel*, exh. cat., Kunsthalle Vienna, 1993

Luk Lambrecht, 'Luc Tuymans: Sowing the Seed of a New Painting', *Flash Art*, May/June 1996

Ulrich Loock, Juan Vicente Aliaga and Nancy Spector, *Luc Tuymans*, London, 1996

Simon Morley, 'Luc Tuymans. ICA London', *Art Monthly*, 186, May 1995

Josef Helfenstein, Luc Tuymans et al., *Premonition: Luc Tuymans Drawings*, exh. cat., Kunstmuseum Bern, Berne, 1997

Adrian Searle, *Unbound: Possibilities in Painting*, exh. cat., Hayward Gallery, London, 1994

Jonathan Turner, 'Exquisite Corpses', *ARTnews*, November 1998

Luc Tuymans, *Luc Tuymans*, exh. cat., Art Gallery of York University, Toronto, 1994

Luc Tuymans and Daniel Birnbaum, 'A Thousand Words: Luc Tuymans Talks About His "Security Series"', *Artforum*, October 1998

James Yood, 'Luc Tuymans. Renaissance Society', *Artforum*, 23, 8, April 1995

ENDNOTES

APOCALYPSE
BEAUTY AND HORROR IN CONTEMPORARY ART
Norman Rosenthal (pp. 12–31)

1 Sylvia Plath, *The Bell Jar* (Heinemann, 1963; Faber & Faber, 1966), London, p. 1.
2 The Book of Revelation, 13, 1–14; 19, 11–15; 21, 1–2.
3 Sir Joshua Reynolds, *Discourses*, 1769–1790, XIII; Harmondsworth, 1992, p. 282.
4 Theodor Adorno, 'Kulturkritik und Gesellschaft', 1951; in *Prismen*, Berlin, 1955.
5 Walter Benjamin, 'Eduard Fuchs, Collector and Historian', 1937, in *One-Way Street and Other Writings*, trans. Edmund Jephcott and Kingsley Shorter, 1997, p. 359.
6 Friedrich Nietzsche, *Beyond Good and Evil*, 1886; trans. R. J. Hollingdale, Harmondsworth, 1990, p. 33.
7 Sam Rohdie, *The Passion of Pier Paolo Pasolini*, London and Bloomington, Indiana, 1995, p. 168.
8 John Cage, *I–VI*, Cambridge, Mass., and London, 1990, pp. 439–40.
9 William Wordsworth, from 'A Night-piece', 1798.
10 *Dante's Inferno: The First Part of the Divine Comedy of Dante Alighieri*, Canto XXVIII, trans. Tom Phillips, London and New York, 1985, p. 226.

RICHARD PRINCE
Nathan Kernan (pp. 34–49)

1 Richard Prince, *Why I Go to the Movies Alone*, New York, 1983, p. 3.
2 David Robbins, 'Richard Prince: An Interview by David Robbins', *Aperture*, 100, 1985, p. 13.
3 Prince, in conversation with the author, 7 April 2000.
4 Prince 1983, p. 56.
5 Prince 1983, p. 50.
6 Prince, quoted in Neville Wakefield, 'Richard Prince', *Elle Decor*, 46, 1996, p. 72.
7 Robbins 1985, p. 12.
8 Robbins 1985, p. 12.
9 Robbins 1985, p. 10.
10 Prince, in conversation with the author.
11 Prince, interview with Larry Clark, in Lisa Phillips et al., *Richard Prince*, exh. cat., Whitney Museum of American Art, New York, 1992, p. 129.
12 'They were always impressed by the paintings of Jackson Pollack [sic],' wrote Prince in *Why I Go to the Movies Alone*, turning the artist's name with a Freudian slip of a vowel into the Polish joke (Marlon Brando as Stanley Kowalski in a sweat-stained T-shirt) he always had been, as far as American magazine culture was concerned, ever since *Life* magazine's incredulous 1949 headline, 'Jackson Pollock: Is he the greatest living painter in the United States?'
13 Prince 1983, p. 150.
14 Robbins 1985, p. 12.
15 Prince, quoted in Wakefield 1996, p. 72.
16 Prince, in conversation with the author.
17 Prince, in conversation with the author.
18 Prince, quoted in Roger Taylor, 'Prince', *World Art Magazine*, 1993, p. 71.
19 Prince, in Taylor 1993, p. 71.
20 Prince, 'Bringing It All Back Home', *Art in America*, 76, 1988, pp. 29–33; reprinted in Phillips et al., 1992, p. 174.
21 Prince, in conversation with the author.
22 Robbins 1985, p. 9.
23 Prince 1983, p. 4.
24 Prince 1983, p. 74.
25 Prince 1983, p. 90.

GREGOR SCHNEIDER
Michael Archer (pp. 50–65)

1 All quotations are taken from a series of conversations between Gregor Schneider and Ulrich Loock, published as Ulrich Loock, 'Junggesellenmaschine Haus ur' ('Bachelor Machine Haus ur'), *Kunstforum*, 142, October/December 1998, pp. 202–11.

LUC TUYMANS
Michael Archer (pp. 66–81)
Unless otherwise stated, all quotations are taken from conversations with the artist.

1 Jonathan Turner, 'Exquisite Corpses', *ARTnews*, November 1998, p. 147.
2 Luc Tuymans and Daniel Birnbaum, 'A Thousand Words: Luc Tuymans Talks About His "Security Series"', *Artforum*, October 1998, p. 107.
3 Tuymans interviewed by Juan Vicente Aliaga in Ulrich Loock, Juan Vicente Aliaga and Nancy Spector, *Luc Tuymans*, London, 1996, p. 20.
4 Josef Helfenstein, Luc Tuymans et al., *Premonition: Luc Tuymans Drawings*, Kunstmuseum Bern, Berne, 1997, p. 53.
5 Luk Lambrecht, 'Luc Tuymans: Sowing the Seed of a New Painting', *Flash Art*, May/June 1996, p. 78.
6 Loock, Aliaga and Spector 1996, p. 15.
7 Walter Benjamin, 'The Work of Art in the Age of Mechanical Reproduction', Section XI, in *Illuminations*, London, 1973, pp. 234–36.
8 Loock, Aliaga and Spector 1996, p. 146.
9 Nancy Spector, 'The Unforgiving Trace', in Loock, Aliaga and Spector 1996, p. 101.

MAURIZIO CATTELAN
James Hall (pp. 82–97)

1 Germano Celant, *Arte Povera: Notes for a Guerrilla War*, 1967; also *Arte Povera*, Milan, 1985, p. 35.
2 Robert Descharnes, *The World of Salvador Dalí*, Lausanne, 1962, p. 93.
3 Interview with Nancy Spector in Francesco Bonami, Nancy Spector and Barbara Vanderlinden, *Maurizio Cattelan*, London, 2000, p. 15.
4 Enzo Cucchi, *Sparire*, New York, 1987, unnumbered pages.
5 Pier Paolo Pasolini, 'Analisi linguistica di uno slogan', 1973, in *Scritti Corsari*, Milan, 1975, p. 38.

MARIKO MORI
Nathan Kernan (pp. 98–113)

1 Cited in Murasaki Shikibu, *The Tale of Genji*, trans. Edward G. Seidensticker, New York, 1978, p. 278.
2 Villiers de l'Isle-Adam, *L'Eve future*, 1886; *Tomorrow's Eve*, trans. Robert Martin Adams, Urbana, 1982, pp. 61–64.
3 Norman Bryson, 'Cute Futures: Mariko Mori's Techno-Enlightenment', *Parkett*, 54, 1998–99, p. 77.
4 Mariko Mori, Shin'ichi Nakazawa and Takayo Iida (conversation) in *Mariko Mori: Dream Temple*, exh. cat., Fondazione Prada, Milan, 1999, n.p.
5 Mori 1999.
6 Germano Celant and Mariko Mori, 'Eternal Present', in Mori 1999.
7 Mariko Mori, quoted in Thyrza Nichols Goodeve, 'Mariko Mori's Cyborg Surrealism', *Parkett*, 54, 1998–99, p. 98.
8 Saigyo (1118–1190), *Poems of a Mountain Home*, trans. Burton Watson, New York, 1991, p. 142. The phrase 'western hilltops' refers to the Western Paradise of Amida Buddhism.
9 According to Mariko Mori in Mariko Mori, Shin'ichi Nakazawa and Takayo Iida (conversation) in Mori 1999.
10 Conversation in Mori 1999.
11 Henri Michaux in David Ball, *Darkness Moves: An Henri Michaux Anthology, 1927–1984*, Berkeley, 1994, p. 320.
12 Mariko Mori in Germano Celant and Mariko Mori, 'Eternal Present' in Mori 1999.
13 Bryson 1998–99, p. 80.
14 Mariko Mori in Germano Celant and Mariko Mori, 'Eternal Present' in Mori 1999.
Also consulted: Dominic Molon, Lisa Corrin, Carol S. Eliel, Margery King and Mariko Mori, *Mariko Mori*, exh. cat., Museum of Contemporary Art, Chicago, and Serpentine Gallery, London, 1998.

MIKE KELLEY
James Hall (pp. 114–129)

1 John Elderfield, *Kurt Schwitters*, London, 1985, p. 162.
2 Quoted by Germano Celant, 'Claes Oldenburg and the Feeling of Things', in *Claes Oldenburg: An Anthology*, Solomon R. Guggenheim Museum, New York, 1995, p. 14.

WOLFGANG TILLMANS
Nathan Kernan (pp. 130–145)
All statements by the artist, unless otherwise noted, are taken from telephone conversations with the author on 29 and 30 April 2000, and a studio visit on 7 July 2000.

1 Frank O'Hara, *The Selected Poems of Frank O'Hara*, New York, 1974, p. 174.
2 Carlo McCormick, 'Talking Pictures', *artnet.com*, http://www.artnet.com, 25 November 1998, n.p.
3 McCormick 1998.
4 McCormick 1998.
5 'disteso e apio', Leonardo da Vinci, *Treatise on Painting*; cited in Michel Laclotte et al., *Léonardo de Vinci: Les Études de draperie*, Paris, 1989.
6 Wolfgang Tillmans, *Totale Sonnenfinsternis* (*Total Solar Eclipse*), exh. cat., Galerie Daniel Buchholz, Cologne, 1999.
7 Burkhard Riemschneider, ed., *Wolfgang Tillmans*, Cologne, 1995.
8 *For When I'm Weak I'm Strong*, exh. cat., Kunstmuseum Wolfsburg, Stuttgart, 1996.
9 Wolfgang Tillmans, *Burg*, Cologne, 1998.

DARREN ALMOND
Michael Archer (pp. 178–193)

1 Martin Herbert, 'Darren Almond', *Camera Austria International*, 67, 1999, p. 39.
2 Darren Almond interviewed by Louisa Buck, *The Art Newspaper*, 101, March 2000.
3 Robert Smithson, 'Entropy and the New Monuments', *Artforum*, June 1966.
4 Michel de Certeau, 'Spatial Stories', in *The Practice of Everyday Life*, Berkeley, 1988.
5 Buck 2000.
6 In a fortuitous parallel to Almond's provision of new bus stops to Oswiecim, Beuys's work was recently returned to his home town of Kleve (Cleves) where, as a boy, he waited at the tram stop that stood next to a monument commemorating the Thirty Years War.

ANGUS FAIRHURST
Michael Archer (pp. 194–209)

1 This text formed the basis of Fairhurst's contribution to Liam Gillick and Andrew Renton, eds, *Technique Anglaise: Current Trends in British Art*, London, 1991.
2 Interview with Angus Cook, in Yilmaz Dziewior, Angus Cook, Jörg Heiser and Dorothea Strauss, *Angus Fairhurst: The Foundation*, exh. cat., Ursula Blickle Stiftung, Kraichtal, and Kunsthalle St Gallen, 1999, p. 44.
3 Dziewior, Cook, Heiser and Strauss 1999, p. 44.

JAKE AND DINOS CHAPMAN
James Hall (pp. 210–225)

1 Rainer Maria Rilke, *Rodin and Other Prose Pieces*, trans. G. Craig Houston, London, 1986.
2 Gilles Deleuze, 'The Schizophrenic and Language', 1979, in *Textual Strategies*, Josue V. Harari, ed., London, 1980, p. 286.
3 Stephen Jay Gould, *Finders, Keepers*, London, 1992, p. 13ff. Peter the Great formed one of the greatest natural history collections of the time. It included numerous 'freaks of nature', such as two-headed sheep, live and stuffed exhibits of deformed people, and a collection of tableaux made from foetuses and body parts, with landscape backgrounds constructed from gallstones, arteries and lung tissue.

PHOTOGRAPHIC CREDITS

4 Etienne-Maurice Falconet, cited in Rudolf Wittkower, *Sculpture: Processes and Principles*, London, 1977, p. 219.
5 Edgar Wind, *Art and Anarchy*, London, 1985, p. 42.

JEFF KOONS
Nathan Kernan (pp. 226–241)

1 Marcel Proust, *Remembrance of Things Past*, trans. C. K. Scott Moncrieff and Terence Kilmartin; and by Andreas Mayor: vol. 3: *The Captive*; *The Fugitive*; *Time Regained*, New York, 1981, pp. 902–03.
2 Anthony Haden-Guest, 'Interview Jeff Koons – Anthony Haden-Guest' printed in Angelika Muthesius, ed., *Jeff Koons*, Cologne, 1992, p. 33.
3 Haden-Guest 1992, p. 27.
4 Haden-Guest 1992, p. 13.
5 Haden-Guest 1992, p. 17.
6 Jeanne Siegel, 'Jeff Koons: Unachievable States of Being', *Arts*, October 1986, p. 68.
7 Siegel 1986, p. 68.
8 Siegel 1986, p. 69.
9 Siegel 1986, p. 68.
10 Haden-Guest 1992, p. 27.
11 Marcel Proust, *The Guermantes Way*, trans. C. K. Scott Moncrieff and Terence Kilmartin, New York, 1981, p. 338.
12 Jeff Koons, *The Jeff Koons Handbook*, London, 1992.
13 Thyrza Nichols Goodeve, 'Euphoric Enthusiasm', *Parkett*, 50–51, 1997, p. 91.
14 Helena Kontova and Giancarlo Politi, 'Jeff Koons Ten Years Later', *Flash Art*, Summer 1997, p. 108.

INDEX

Page numbers in *italic* type indicate illustrations

Mr Monty Freedman
Mrs Helena Frost
A Fulton Company Limited
Mr and Mrs Richard Gapper
The Robert Gavron Charitable Trust
Jacqueline and Michael Gee
Jacqueline and Jonathan Gestetner
Mme Michel Goldet
Sir Nicholas and Lady Goodison's Charitable Settlement
David and Maggi Gordon
Lady Gosling
David and Catherine Graham
Mrs Mary K Graves
Mrs Michael Green
Mr Robert Alan Green
Mrs Maro Hadjipateras
Charles and Karen Hale
Mrs Sue Hammerson
David and Lella Harris
Mr and Mrs Jocelin Harris
Mrs Alexander F Hehmeyer
Michael and Morven Heller
Mr and Mrs Alan Hobart
Anne Holmes-Drewry
Sir Martin and Lady Jacomb
Mr and Mrs Ian Jay
Mr and Mrs Harold Joels
Mr and Mrs David Josefowitz
Mrs Gabrielle Jungels-Winkler
Mr and Mrs Donald P Kahn
Mr and Mrs Joseph Karaviotis
Mr and Mrs Laurence Kelly
Mr and Mrs James Kirkman
Mr and Mrs Henry L R Kravis
The Kreitman Foundation
Mrs Thomas Kressner
Mr and Mrs Irvine Laidlaw
The Kirby Laing Foundation
Mr George Lengvari
The Lady Lever of Manchester
Mr and Mrs John Lewis
Susan Linaker
Sir Sydney Lipworth QC and Lady Lipworth
Miss Rosemary Lomax-Simpson
Mr Jonathon E Lyons
Fiona Mactaggart
Sir John and Lady Mactaggart
Mr and Mrs Eskandar Maleki
Mr and Mrs Michael (RA) and José Manser
Mr and Mrs Aldo Mareuse
Mr and Mrs M Margulies
Marsh Christian Trust
R C Martin
Mrs Jack Maxwell
Mrs Annabella McAlpin
Mrs M C W McCann
Sir Kit and Lady McMahon
The Mercers' Company
Lt Col L S Michael OBE
Nancy Miller Jong
Mr and Mrs Peter Morgan
Mr and Mrs I Morrison
Mr Thomas F Mosimann III
Mr Harry Moss
Jim Moyes
Mr and Mrs Carl Anton Muller
Paul and Alison Myners
John Nickson and Simon Rew
Sir Peter Osborne
Mr Michael Palin
Mr and Mrs Vincenzo Palladino
Lord and Lady Palumbo
Mrs Chrysanthy Pateras
John Pattisson
Lynda Pearson
The Pennycress Trust
The P F Charitable Trust
Miss Karen Phillipps
Mr Godfrey Pilkington
George and Carolyn Pincus
Mr and Mrs William A Plapinger
Miss Victoria Provis
HE The Ambassador of Qatar
The Quercus Trust
Barbara Rae RA
John and Anne Raisman
Sir David and Lady Ramsbotham
The Rayne Foundation
Mrs Jean Redman-Brown
Mr T H Reitman
Mr and Mrs Robert E Rhea
Sir John and Lady Riddell

Mr and Mrs John Ritblat
Mr John A Roberts FRIBA
Mr and Mrs Nicholas Rohatyn
Mr and Mrs Ian Rosenberg
Alastair and Sarah Ross Goobey
Mrs Coral Samuel CBE
Mr and Mrs Victor Sandelson
Mr Adrian Sassoon
Ms Pierrette Schlettwein
Dr Lewis Sevitt
The Cyril Shack Trust
The Countess of Shaftesbury
Mr and Mrs D M Shalit
Mrs Stella Shawzin
Mr and Mrs Clive Sherling
Mrs Lois Sieff OBE
Mr and Mrs Richard Simmons
Mr Peter Simon
Mr and Mrs Harvey Spack
Mrs Roama Spears
James and Alyson Spooner
Mr and Mrs Nicholas Stanley
Mrs Jack Steinberg
Mr and Mrs David Stileman
Mr and Mrs R Strang
David and Linda Supino
Swan Trust
Mr James W C Swartz
Mr and Mrs David Swift
Mr and The Hon Mrs Richard Szpiro
Sir Anthony and Lady Tennant
Eugene V and Clare E Thaw Charitable Trust
Mr and Mrs Julian Treger
Mr and Mrs Max Ulfane
Mrs Catherine Vlasto
Mrs Claire Vyner
The Walter Guinness Charitable Trust
John B Watton
Mr and Mrs Jeffrey M Weingarten
Edna and Willard Weiss
Mr and Mrs Anthony Weldon
Mrs Gerald Westbury
Mrs Linda M Williams
Mr and Mrs Ami Wine
Roger and Jennifer Wingate
Mr and Mrs Rainer Zietz
Mr and Mrs Michael Zilkha
and others who wish to remain anonymous

SCHOOLS PATRONS GROUP

The Charlotte Bonham-Carter Charitable Trust
The Clothworkers' Foundation
The Ernest Cook Trust
Mr Simon Copsey
Crabtree & Evelyn
Mr and Mrs Keith Dawson
The D'Oyly Carte Charitable Trust
The Gilbert & Eileen Edgar Foundation
P H Holt Charitable Trust
Dr and Mrs Robert Lefever
The Hon Charles Low
Stuart and Ellen Lyons Charitable Trust
The Mercers' Company
The Henry Moore Foundation
Robin Heller Moss
The Worshipful Company of Painter-Stainers
Pickett Fine Leather Ltd
Edith and Ferdinand Porjes Charitable Trust
The Radcliffe Trust
Rio Tinto plc
Mr Charles Saatchi
Pauline Denyer Smith and Paul Smith CBE
The South Square Trust
Mr and Mrs Michele Sportelli
Mr and Mrs Denis Tinsley
The Celia Walker Art Foundation
The Harold Hyam Wingate Foundation
and others who wish to remain anonymous

GENERAL DONORS

Mr Charles Akle
Mr Keith Bromley
Miss Jayne Edwardes
Mr and Mrs Joseph Karaviotis
Lady Sainsbury
The Schneer Foundation Inc
and others who wish to remain anonymous

AMERICAN ASSOCIATES OF THE ROYAL ACADEMY TRUST

BENEFACTORS

American Express
Mrs Russell B Aitken
Chase Manhattan Bank
Mr Walter Fitch III
Mrs Henry Ford II
The Honorable Amalia L de Fortabat
Glaxo Wellcome
The Horace W Goldsmith Foundation
Mrs Henry J Heinz II
Mr and Mrs Donald Kahn
Mr and Mrs Jon B Lovelace
Mr and Mrs John L Marion
Mrs Jack C Massey
Mr and Mrs Michael Meehan II
Mr Charles J Meyers
Mrs Nancy B Negley
Mrs Arthur M Sackler
Mrs Louisa S Sarofim
The Starr Foundation
The Honorable John C Whitehead
Mr and Mrs Frederick B Whittemore
Mrs William W Wood Prince
and others who wish to remain anonymous

SPONSORS

The Honorable and Mrs Walter H Annenberg
Mr and Mrs Samuel R Blount
Mrs Jan Cowles
Mrs Donald Findlay
Mr D Francis Finlay
Mr James Kemper
Ms Stephanie Krieger
Mrs Linda Noe Laine
Mrs Janice H Levin
Mr and Mrs Vernon Taylor Jr
Prince Charitable Trusts
Mrs Sylvia Scheuer
US Trust Company of New York
Mr Lee Weissman
and others who wish to remain anonymous

PATRONS

Mr and Mrs John W Annan
Mr and Mrs Robert J Arnold
Mr and Mrs Stephen D Bechtel Jr
Mrs Helen Benedict
Mr and Mrs James Benson
Mrs Bette Berry
Mr Donald A Best
Ms Jan Blaustein Scholes
Mr and Mrs Henry W Breyer III
Mrs Mildred C Brinn
Mrs Caroline Chapin
Mrs Helene Chiang
Mr William L Clark
Ms Dorothea F Darlington
Ms Anne S Davidson
Mrs Charles H Dyson
Mrs John W Embry
Lady Warwick Fairfax
Mrs A Barlow Ferguson
Mrs Robert Ferst
Mr Ralph A Fields
Mr Richard E Ford
Mr and Mrs Lawrence S Friedland
Mrs Roswell L Gilpatric
Mr and Mrs Ralph W Golby
Mrs Betty N Gordon
Mrs Melville Wakeman Hall
Mr and Mrs Gurnee F Hart
Mr and Mrs Gustave M Hauser
The Honorable Marife Hernandez
Mr Robert J Irwin
Ms Betty Wold Johnson and Mr Douglas Bushnell
Ms Barbara R Jordan
The Honorable and Mrs Eugene Johnston
Mr William W Karatz
Mr and Mrs Stephen M Kellen
Mr Gary A Kraut
Mrs Katherine K Lawrence
Mr and Mrs William M Lese
Dr and Mrs Peter Linden
Mrs John P McGrath
Mrs Mark Millard
Mr Achim Moeller
Mrs Robin Heller Moss
Mr Paul D Myers

Ms Diane A Nixon
Mr and Mrs Jeffrey Pettit
Mr Robert S Pirie
Dr and Mrs Meyer P Potamkin
The Honorable and Mrs Charles H Price II
Mrs Signe E Ruddock
Mrs Frances G Scaife
Mrs Frederick M Stafford
Mr and Mrs Robert L Sterling Jr
Mrs Kenneth Straus
Mr Arthur O Sulzberger and Ms Alison S Cowles
Mrs Frederick Supper
Mrs Royce Dean Tate
Mr and Mrs A Alfred Taubman
Ms Britt Tidelius
Mrs Susan E Van de Bovenkamp
Mrs Bruce E Wallis
Mrs Sara E White
Mrs Joseph R Wier
Mrs Mary Louise Whitmarsh
Mr Robert W Wilson
Mr and Mrs Kenneth Woodcock
and others who wish to remain anonymous

FRIENDS OF THE ROYAL ACADEMY

PATRON FRIENDS
Mr Z Aram
Mr Paul Baines
Mrs J V Barker
Mrs Yvonne Barlow
Mr P F J Bennett
Mr and Mrs Sidney Corob
Mr Michael Godbee
Dr and Mrs Alan J Horan
Mr David Ker
Dr Abraham Marcus
Mrs Maureen D Metcalfe
Mr R J Mullis
Mr and Mrs David Peacock
Mr Keith M Reilly
The Hon Sir Steven Runciman CH
Mr and Mrs Derald H Ruttenberg
Mr Nigel J Stapleton
Mr Robin Symes
Mrs K L Troughton
Mr and Mrs Timothy Vignoles
Mrs Cynthia H Walton
Mrs Roger Waters
The Hon Mrs Simon Weinstock
Miss Elizabeth White
Mr David Wolfers
Mrs I Wolstenholme
and others who wish to remain anonymous

SUPPORTING FRIENDS
Mr and Mrs D L Adamson
Mr Richard B Allan
Mrs M Allen
Mr Peter Allinson
Mr Ian Anstruther
Mr Brian A Bailey
Mr B P Bearne
Mrs Susan Besser
Mrs C W T Blackwell
Mrs J M Bracegirdle
Mr Cornelius Broere
Mrs Anne Cadbury OBE JP DL
Mr W L Carey-Evans
Miss E M Cassin
Mr R A Cernis
Mrs Norma Chaplin
Mr S Chapman
Mr W J Chapman
Mr and Mrs John Cleese
Mrs Ruth Cohen
Mrs D H Costopoulos
Mr and Mrs Chris Cotton
Mrs Nadine Crichton
Mrs Saeda H Dalloul
Mr Julian R Darley
Mr John Denham
Miss N J Dhanani
The Marquess of Douro
Mr Kenneth Edwards
Mrs Nicholas Embiricos
Mrs B D Fenton
Mrs R H Goddard
Mrs D Goodsell
Mr Gavin Graham
Mrs Richard Grogan
Miss Susan Harris

Mr Malcolm P Herring
Mr R J Hoare
Mr Charles Howard
Mrs O Hudson
Mrs Manya Igel
Mr S Isern-Feliu
Mrs Jane Jason
Mrs G R Jeffries
Mr Roger A Jennings
Mr Harold Joels
Mr and Mrs S D Kahan
Mrs P Keely
Mr and Mrs J Kessler
Mr D H Killick
Mr N R Killick
Mr Peter W Kininmonth
Mrs Carol Kroch
Mrs Joan Lavender
Mr and Mrs David Leathers
Mr Owen Luder CBE PRIBA FRSA
Miss Julia MacRae
Mrs Susan Maddocks
Mr Donald A Main
Ms Rebecca Marek
Lord Marks of Broughton
Mr J B H Martin
Mrs Gillian M S McIntosh
Mr J Moores
Mrs A Morgan
R Naylor and C Boddington
Mrs Elizabeth M Newell
Miss Kim Nicholson
Mrs E M Oppenheim Sandelson
Mr Robert Linn Ottley
Mr Brian Oury
Mrs J Pappworth
Mrs M C S Philip
Mrs Anne Phillips
Mr Ralph Picken
Mr D B E Pike
Mr Benjamin Pritchett-Brown
Mr F Peter Robinson
Mr D S Rocklin
Mrs A Rodman
Mr and Mrs O Roux
Dr Susan Saga
Lady Sainsbury
The Rt Hon Sir Timothy Sainsbury
Mrs Susanne Salmanowitz
Mr Anthony Salz
Dr I B Schulenburg
Mrs D Scott
Mr and Mrs Richard Seymour
Mr Mark Shelmerdine
Mr R J Simmons CBE
Mr P W Simon
Mr John H M Sims
Miss L M Slattery
Dr and Mrs M L Slotover
Mrs P Spanoghe
Professor Philip Stott
Mr James Stuart
Mr J A Tackaberry
Mrs J A Tapley
Mrs Andrew Trollope
Mrs Catherine I Vlasto
Mr and Mrs Ludovic de Walden
Miss J Waterous
Mrs Claire Weldon
Mr Frank S Wenstrom
Mr David Wilson
Mr W M Wood
Mr R M Woodhouse
Ms Karen S Yamada
Dr Alain Youell
Mrs Pia Zombanakis
and others who wish to remain anonymous

CORPORATE MEMBERSHIP OF THE ROYAL ACADEMY OF ARTS

Launched in 1988, the Royal Academy's Corporate Membership Scheme has proved highly successful. With 105 members it is now the largest membership scheme in Europe. Corporate membership offers company benefits to staff and clients and access to the Academy's facilities and resources. Each member pays an annual subscription to be a Member (£7,000) or Patron (£20,000). Participating companies recognise the importance of promoting the visual arts. Their support is vital to the continuing success of the Academy.

CORPORATE MEMBERSHIP SCHEME

CORPORATE PATRONS
Arthur Andersen
Bloomberg LP
BNP Paribas
BP Amoco p.l.c.
Debenhams Retail plc
Deutsche Bank AG
The Economist Group
Ernst and Young
GE Group
Glaxo Wellcome plc
Merrill Lynch Mercury
Morgan Stanley International

CORPORATE MEMBERS
Alliance & Leicester plc
Apax Partners & Co. Ltd.
Athenaeum Hotel
Aukett Associates
Bacon and Woodrow
Bank of America
Barclays plc
Bartlett Merton Ltd
Bass PLC
Bear, Stearns International Ltd
BG plc
Bluestone Capital Partners (UK) Ltd
Booz Allen & Hamilton International (UK) Ltd
Bovis Lend Lease Limited
BT plc
British Airways plc
British Alcan Aluminium plc
Bunzl plc
CB Hillier Parker
CJA (Management Recruitment Consultants) Limited
Christie's
Chubb Insurance Company of Europe
Clayton Dubilier & Rice Limited
Clifford Chance
Colefax and Fowler Group
Cookson Group plc
Credit Agricole Indosuez
Credit Suisse First Boston
The Daily Telegraph plc
Diageo plc
De Beers
E D & F Man Limited Charitable Trust
Eversheds
Foreign & Colonial Management plc
Gartmore Investment Management plc
Granada Group PLC
GKR & Associates Ltd
GTS Business Services
Heidrick & Struggles
HSBC plc
H J Heinz Company Limited
ICI
John Lewis Partnership
King Sturge
Kleinwort Benson Charitable Trust
Korn/Ferry International
KPMG
Kvaerner Construction Ltd
Lex Service PLC
Linklaters & Alliance
Macfarlanes
Marconi Ltd
Marks & Spencer
Marsh Ltd
McKinsey & Co.
MoMart Ltd
Newton Investment Management Ltd
Ove Arup Partnership
Pearson plc
The Peninsular and Oriental Steam Navigation Company
Pentland Group plc
PricewaterhouseCoopers
Provident Financial plc
The Rank Group Plc
Raytheon Systems Limited
Robert Fleming & Co. Ltd
Rowe & Maw
The Royal Bank of Scotland
Salomon Smith Barney
Schroders plc
Sea Containers Ltd.
SG
Slaughter and May
SmithKline Beecham

The Smith & Williamson Group
Sotheby's
Sun Life and Provincial Holdings plc
Tiffany & Co.
TI Group plc
Tomkins PLC
Trowers & Hamlins
Unilever UK Limited
United Airlines
UPC Services

HONORARY CORPORATE MEMBERS

All Nippon Airways Co. Ltd
A.T. Kearney Limited
Goldman Sachs International Limited
London First
OMAM (UK) Ltd
Reed Elsevier plc
Reuters Limited
Yakult UK Limited

SPONSORS OF PAST EXHIBITIONS

The President and Council of the Royal Academy thank sponsors of past exhibitions for their support. Sponsors of major exhibitions during the last ten years have included the following:

Allied Trust Bank
 Africa: The Art of a Continent, 1995*
Anglo American Corporation of South Africa
 Africa: The Art of a Continent, 1995*
A.T. Kearney
 Summer Exhibition 99. 1999
 Summer Exhibition 2000
The Banque Indosuez Group
 Pissarro: The Impressionist and the City, 1993
BBC Radio One
 The Pop Art Show, 1991
BMW (GB) Limited
 Georges Rouault: The Early Years, 1903–1920. 1993
 David Hockney: A Drawing Retrospective, 1995*
British Airways Plc
 Africa: The Art of a Continent, 1995
BT
 Hokusai, 1991
Cantor Fitzgerald
 From Manet to Gauguin: Masterpieces from Swiss Private Collections, 1995
 1900: Art at the Crossroads, 2000
The Capital Group Companies
 Drawings from the J Paul Getty Museum, 1993
Chilstone Garden Ornaments
 The Palladian Revival: Lord Burlington and His House and Garden at Chiswick, 1995
Christie's
 Frederic Leighton 1830–1896. 1996
 Sensation: Young British Artists from The Saatchi Collection, 1997
Classic FM
 Goya: Truth and Fantasy, The Small Paintings, 1994
 The Glory of Venice: Art in the Eighteenth Century, 1994
Country Life
 John Soane, Architect: Master of Space and Light, 1999
Corporation of London
 Living Bridges, 1996
The Dai-Ichi Kangyo Bank Limited
 222nd Summer Exhibition, 1990
The Daily Telegraph
 American Art in the 20th Century, 1993
 1900: Art at the Crossroads, 2000
De Beers
 Africa: The Art of a Continent, 1995
Debenhams Retail plc
 Premiums, 2000
 RA Schools Show, 2000
Deutsche Morgan Grenfell
 Africa: The Art of a Continent, 1995
Diageo plc
 230th Summer Exhibition, 1998
Digital Equipment Corporation
 Monet in the '90s: The Series Paintings, 1990
The Drue Heinz Trust
 The Palladian Revival: Lord Burlington and His House and Garden at Chiswick, 1995
 Denys Lasdun, 1997
 Tadao Ando: Master of Minimalism, 1998
The Dupont Company
 American Art in the 20th Century, 1993
Edwardian Hotels
 The Edwardians and After: Paintings and Sculpture from the Royal Academy's Collection, 1900–1950. 1990
Elf
 Alfred Sisley, 1992

Ernst & Young
 Monet in the 20th Century, 1999
Fondation Elf
 Alfred Sisley, 1992
Ford Motor Company Limited
 The Fauve Landscape: Matisse, Derain, Braque and Their Circle, 1991
Friends of the Royal Academy
 Victorian Fairy Painting, 1997
The Jacqueline and Michael Gee Charitable Trust
 LIFE? or THEATRE? The Work of Charlotte Salomon, 1999
Générale des Eaux Group
 Living Bridges, 1996
Glaxo Wellcome plc
 Great Impressionist and other Master Paintings from the Emil G Buhrle Collection, Zurich, 1991
 The Unknown Modigliani, 1994
Goldman Sachs International
 Alberto Giacometti, 1901–1966. 1996
 Picasso: Painter and Sculptor in Clay, 1998
The Guardian
 The Unknown Modigliani, 1994
Guinness PLC (see Diageo plc)
 Twentieth-Century Modern Masters: The Jacques and Natasha Gelman Collection, 1990
 223rd Summer Exhibition, 1991
 224th Summer Exhibition, 1992
 225th Summer Exhibition, 1993
 226th Summer Exhibition, 1994
 227th Summer Exhibition, 1995
 228th Summer Exhibition, 1996
 229th Summer Exhibition, 1997
Guinness Peat Aviation
 Alexander Calder, 1992
Harpers & Queen
 Georges Rouault: The Early Years, 1903–1920. 1993
 Sandra Blow, 1994
 David Hockney: A Drawing Retrospective, 1995*
 Roger de Grey, 1996
The Headley Trust
 Denys Lasdun, 1997
The Henry Moore Foundation
 Alexander Calder, 1992
 Africa: The Art of a Continent, 1995
Ibstock Building Products Ltd
 John Soane, Architect: Master of Space and Light, 1999
The Independent
 The Pop Art Show, 1991
 Living Bridges, 1996
Industrial Bank of Japan, Limited
 Hokusai, 1991
Donald and Jeanne Kahn
 John Hoyland, 1999
Land Securities PLC
 Denys Lasdun, 1997
The Mail on Sunday
 Royal Academy Summer Season, 1992
 Royal Academy Summer Season, 1993
Marks & Spencer
 Royal Academy Schools Premiums, 1994
 Royal Academy Schools Final Year Show, 1994*
Martini & Rossi Ltd
 The Great Age of British Watercolours, 1750–1880. 1993
Paul Mellon KBE
 The Great Age of British Watercolours, 1750–1880. 1993
Mercury Communications
 The Pop Art Show, 1991
Merrill Lynch
 American Art in the 20th Century, 1993*
Midland Bank plc
 RA Outreach Programme, 1992–1996
 Lessons in Life, 1994
Minorco
 Africa: The Art of a Continent, 1995
Mitsubishi Estate Company UK Limited
 Sir Christopher Wren and the Making of St Paul's, 1991
Natwest Group
 Nicolas Poussin 1594–1665. 1995
The Nippon Foundation
 Hiroshige: Images of Mist, Rain, Moon and Snow, 1997
Olivetti
 Andrea Mantegna, 1992
Park Tower Realty Corporation
 Sir Christopher Wren and the Making of St Paul's, 1991
Peterborough United Football Club
 Art Treasures of England: The Regional Collections, 1997
Premiercare (National Westminster Insurance Services)
 Roger de Grey, 1996*
RA Exhibition Patrons Group
 Chagall: Love and the Stage, 1998
 Kandinsky, 1999
 Chardin 1699–1779. 2000

Redab (UK) Ltd
 Wisdom and Compassion: The Sacred Art of Tibet, 1992
Reed Elsevier plc
 Van Dyck 1599–1641. 1999
Reed International plc
 Sir Christopher Wren and the Making of St Paul's, 1991
Republic National Bank of New York
 Sickert: Paintings, 1992
The Royal Bank of Scotland
 Braque: The Late Works, 1997*
 Premiums, 1997
 Premiums, 1998
 Premiums, 1999
 Royal Academy Schools Final Year Show, 1996
 Royal Academy Schools Final Year Show, 1997
 Royal Academy Schools Final Year Show, 1998
The Sara Lee Foundation
 Odilon Redon: Dreams and Visions, 1995
Sea Containers Ltd
 The Glory of Venice: Art in the Eighteenth Century, 1994
Silhouette Eyewear
 Egon Schiele and His Contemporaries: From the Leopold Collection, Vienna, 1990
 Wisdom and Compassion: The Sacred Art of Tibet, 1992
 Sandra Blow, 1994
 Africa: The Art of a Continent, 1995
Société Générale, UK
 Gustave Caillebotte: The Unknown Impressionist, 1996*
Société Générale de Belgique
 Impressionism to Symbolism: The Belgian Avant-Garde 1880–1900. 1994
Spero Communications
 Royal Academy Schools Final Year Show, 1992
Texaco
 Selections from the Royal Academy's Private Collection, 1991
Thames Water Plc
 Thames Water Habitable Bridge Competition, 1996
The Times
 Wisdom and Compassion: The Sacred Art of Tibet, 1992
 Drawings from the J Paul Getty Museum, 1993
 Goya: Truth and Fantasy, The Small Paintings, 1994
 Africa: The Art of a Continent, 1995
Time Out
 Sensation: Young British Artists from The Saatchi Collection, 1997
Tractabel
 Impressionism to Symbolism: The Belgian Avant-Garde 1880–1900. 1994
Unilever
 Frans Hals, 1990
Union Minière
 Impressionism to Symbolism: The Belgian Avant-Garde 1880–1900. 1994
Vistech International Ltd
 Wisdom and Compassion: The Sacred Art of Tibet, 1992
Yakult UK Ltd
 RA Outreach Programme, 1997–2000*
 alive: Life Drawings from the Royal Academy of Arts & Yakult Outreach Programme

* Recipients of a Pairing Scheme Award, managed by Arts + Business. Arts + Business is funded by the Arts Council of England and the Department for Culture, Media and Sport.

OTHER SPONSORS
of events, publications and other items in the past five years:

Asia House
Atlantic Group plc
Elizabeth Blackadder RA
BP AMOCO p.l.c.
Champagne Taittinger
Corona Beer
Country Life
Foster and Partners
Green's Restaurant
HSBC Holdings plc
Hulton Getty Picture Collection
IBJ International plc
John Doyle Construction
Allen Jones RA
KLM UK
The Leading Hotels of the World
Met Bar
Michael Hopkins & Partners
Mikimoto
Morgan Stanley Dean Witter
Old Mutual
Polaroid (UK) Limited
Richard and Ruth Rogers
Royal & Sun Alliance Insurance Group plc
Strutt & Parker
ZFL